Entering Time

Also by Colin Browne

Entering Time

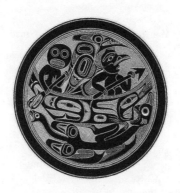

THE FUNGUS MAN
PLATTERS OF
CHARLES EDENSHAW

COLIN BROWNE

TALONBOOKS

Talonbooks
278 East First Avenue, Vancouver, British Columbia, Canada V5T 1A6
www.talonbooks.com

First printing: 2016

Typeset in Arno
Printed and bound in Canada on 100% post-consumer recycled paper

Interior and cover design by Typesmith
Cover illustration by Claude Davidson, silkscreen print based on Charles Edenshaw platter in the Field Miseum, Chicago, 1978, Estate of Claude Davidson
Interior illustrations by Cindy Mochizuki

Talonbooks acknowledges the financial support of the Canada Council for the Arts, the Government of Canada through the Canada Book Fund, and the Province of British Columbia through the British Columbia Arts Council and the Book Publishing Tax Credit.

LIBRARY AND ARCHIVES CANADA CATALOGUING IN PUBLICATION

Browne, Colin, 1946–, author
 Entering time : the Fungus Man platters of Charles Edenshaw /
Colin Browne.

Includes bibliographical references.
ISBN 978-1-77201-039-8 (PAPERBACK)

 1. Edenshaw, Charles, 1839–1920 – Criticism and interpretation. 2. Haida sculpture. 3. Haida mythology. 4. Canadian poetry – British Columbia – Pacific Coast – Native authors – History and criticism. 5. Art and mythology. I. Title.

E99.H2B76 2016 704.0397'28 C2016-905802-6

In memory of

Kythé Browne
(1917–2011)

&

Alexander Hutchison
(1943–2015)

Everything is an attempt
To be human

—WILLIAM BLAKE
First Book of Urizen
Plate 10 (1796)

CONTENTS

LIST OF ILLUSTRATIONS

Where then *are we*? Where do we find ourselves? With whom can we still *identify* in order to affirm our own identity and to tell ourselves our own history? First of all, to whom do we recount it? One would have to construct oneself, one would have to be able to *invent oneself* without a model and without an assured addressee.[1]

—JACQUES DERRIDA
Monolingualism of the Other;
or, the Prosthesis of Origin

PROLOGUE

For my mother, Kythé, and her extended family – her mother, her sisters, her aunt and uncle, their son and daughter – 1939 was the year that everything changed, irrevocably. For years they had clung to an economically precarious existence on the southeast coast of Vancouver Island, in a village on the edge of a circular bay that enthusiastically promoted itself as the Salmon Capital of the World. The village was supported by logging and commercial fishing, but the few men in my mother's family did not labour in these industries. They were all, to one degree or another, like her father, my grandfather, a man who appeared to have had the wind permanently knocked out of him.

An educated Scot, he had sailed to Canada in the first decade of the twentieth century, clerked in a bank with his brother, and by 1914 had established a small, thriving ranch in the hills above Kamloops. He was married, with children, and with another on the way, but when news came of his brother's death in France, he felt pressure to do his part. In 1917, he took the train to Vancouver and joined the Seaforth Highlanders, listing his occupation as "Gentleman," a title that carried little

weight in western Canada but which would have been the first step toward obtaining a commission as an officer. He had sciatica, which often laid him up behind the lines. My grandmother told me he was buried alive and that his sergeant had dug him out. When he returned from overseas, he was a different man. He found it impossible to return to the log cabin he'd built with such pride. It was too small and dark. The land, as beautiful as it was, would never yield a decent living. A series of failing enterprises and short-term moves with his family followed, and by the early 1930s he had returned alone to Scotland to eke out a life on a bleak family estate. The only time he spoke about his experience in France was when a son-in-law asked him, years later, what he recalled: "The worst thing," my grandfather said, "was to watch the men hesitate as they climbed over the top and fall back into the trenches, shot by their own officers."

I spent hours as a child looking through the old black-paged family albums, fascinated by the sticky corners, as if they were somehow able to stop or contain time. Most of the snapshots commemorate picnics on blankets with Thermoses of tea and a clutch of children in saggy bathing suits with sun in their blond hair. My mother and her three sisters are often shown standing single file, youngest to the eldest. On the reverse side their names are written in ink with the wide nibs popular in fountain pens at the time. Occasionally there is a visit to a horse. The mothers are in charge. If there are men, they are usually off to the side in tweed jackets, their minds elsewhere, perhaps worried about money, or carpenter ants, or filling the woodshed by September. There is a sense of proprietorial ease, but also a feeling of contingency, of self-conscious provisionality, as if this family group, roosting in a far corner of the Empire, as much as it claimed the sweet air and the natural beauty for its own, is not entirely at home.

My people were cuckoos, laying their eggs in another's nest. They spoke with British accents. The mothers had been sent to Roedean School in England, recently established to prepare girls

for entry to the new women's colleges. The husbands had fought in France, where just about everything had been shaken out of them. And if they lived in genteel poverty, my family was also blessed with abundance. They built board and batten cottages and fertilized their roses and berry patches with Pacific kelp. Hollyhocks thrived in the sea air, along with beans and marrows and carrots. Salmon rushed up the rivers from early summer until the fall and could be coaxed to take a fly. Firewood was plentiful, and the woodshed a good place to cache a bottle. In their gumboots and heavy sweaters, this family appears before me now like startled characters who left the stage at intermission and who were later discovered in another country, heading west. They would not have thought of themselves as colonists – colonials, maybe, though it may be a fine distinction. They regarded themselves not as masters but as grateful subjects, a condition that allowed them to exempt themselves from responsibility for exploitation and inequality. Although she was born in Nevada of British parents and eventually returned to the U.K. to live with her husband, my grandmother thought of herself as Canadian. "You were free," she exclaims in my film *Strathyre* (the name of my grandfather's ranch), "really free to come and go as you pleased." Indeed, as a British subject she had every right to live and travel freely in Canada. All Canadian citizens were British subjects at that time.

When Canada declared war on Germany in 1939, my family submitted once again to the unforgiving twentieth century. The Depression, which had seemed to drag on forever, was suddenly over. There were jobs. Gloom and compromise were overwhelmed by a sense of purpose, or indignation, or vengeance. The time for conciliation with despots and demagogues was over; there was a job to be done. Sworn pacifists became patriots almost overnight, as did the province's lumber and cannery barons, who had a keen nose for new business. The two-faced mother country was under siege, and the sons and daughters of its distant empire, in an ancient act of fealty, flocked once more to the railway stations, moved by the timbre of the King's voice.

My great-aunt and -uncle operated a rustic fishing lodge overlooking the bay. It had crocheted counterpanes and worn carpets and lots of ashtrays, and a reputation for being the sort of place where well-heeled guests, sometimes movie stars or the occasional duke or lord, would check in quietly and spend a week out on the water in a clinker-built dinghy. With a woodstove in the kitchen, my great-aunt made bread every day and prepared the meals. Her husband saw to travel arrangements and repairs. My mother, who had an admirable reputation for aggressive play on the tennis court and grass-hockey pitch, often worked as an unpaid chambermaid or by helping my great-aunt in the kitchen. Extra girls were hired during the high season to rush plates, glasses, and silverware in and out of the dining room, and to wash and return them as quickly as possible.

On Labour Day weekend, 1939, the fishing lodge filled up quickly. A few miles north, the annual Maple Bay Regatta was in full swing. The sun was high, the sky clear, sails twisted in the blue sea. As the fish stopped biting, fishermen brought their catch to the kitchen to be served up for their dinner. My great-aunt told me that on that weekend "everyone's ears were glued to the radio."

There was to be a banquet on Saturday night for some of the visiting yacht-club commodores. And as the sun went down, the young people gathered on the veranda with cases of beer. They stayed up all night talking politics, dancing, whispering, and watching the shooting stars. In the dining room, the whisky flowed and the yacht-club commodores traded improbable assertions about troop strength and naval readiness. In my mind I see the young ones on the veranda curled up on couches and asleep on the floor as the sun rises over Salt Spring Island. I can taste the air. A light fog hovers on the surface of the bay. The radio is playing softly. A confident male voice with a slight British accent reports on stiff resistance in Poland, followed by the marine weather forecast and anticipated temperatures in the low seventies.

My great-aunt's only son swore that night he would never fight in a European war. A few days later he drove into town to

enlist in the Royal Canadian Air Force. His friends went off to work in the cities or mills, or they disappeared, only to show up a few weekends later in ill-fitting battledress. My mother also paid a visit to the recruiting office. She joined the RCAF and within a year was working in an underground war room in London charting the flight paths of incoming German aircraft. She and her colleagues, billeted in a dormitory, were forbidden to walk together and were required to choose a different route each day to the unidentified door that concealed the entrance to their workplace. My mother was certain that one afternoon she was approached by a young man who was a spy. Having been entrusted with sensitive intelligence information during the war, she refused to speak about her experiences and took her secrets to the grave.

After Pearl Harbor, the old and middle-aged men in the Salmon Capital of the World joined the Pacific Coast Militia Rangers and patrolled logging roads, half-hoping to find signs of enemy encroachment. My great-aunt, along with the other women and girls in the family, was prepared for the sight of Japanese commandos landing on the rocky beach below the lodge. One by one the women would submit to being shot by the great-aunt, who would then turn the gun on the dog, and, finally, on herself. When I quizzed her about the gun, she seemed to recall that it was a Thompson submachine gun issued to her husband for the purposes of civil defence.

Like their fathers before them, those who returned from the war after VE Day and VJ Day kept their silence. They did not speak about the anxiety that had lodged in their hearts, and even if a vocabulary had existed at that time with which to speak about what they'd seen and heard, no questions were asked. In 1945, my great-aunt turned fifty. Her beautiful son, my mother's favourite cousin, lay buried in a British cemetery, the result of an accident during pilot training. She and my great-uncle loaded everything onto a barge and had it towed to Salt Spring Island. There, in a rambling old house on a tidal inlet

teeming with butter clams, returning young men and women were given a bed and three meals a day. They earned their keep by fencing and tilling the garden, building sheds and wharves, fixing equipment, splitting and stacking wood. They moved as if among ghosts. Each year families from Penelakut (formerly Kuper Island), who had been harvesting the tidal estuary for centuries, returned to the clam beds, taking shelter in the brand new boathouse. There was a semblance of normalcy to the daily and the seasonal round, but I can't help thinking that both the clam diggers and the new people in the house moved through each day with a sense of dislocation, and that the air, which was as bright and fragrant as ever, must have felt a little thinner.

A person reading the newspaper in the summer before the war might have been tempted to think, all things considered, that human beings were innately good. After 1945 no one would make that mistake again. I suppose this loss of innocence was a kind of freedom, although freedom is not distributed equally, and if one had wanted to learn a lesson from the war it was that one's own freedom is always at the expense of another's. The fishing lodge, where the guests had gathered, on the veranda with a gin and tonic and toasted to "God's country," was torn down and replaced in the 1960s by a shameful brick monstrosity. The only thing the two structures share is the piece of land they were built on, a rise above the village that, like the entire village and its surroundings, is on the unceded territory of the Hul'qumi'num-speaking Qu'wut'sun (Cowichan) people. During the nineteenth century, the colonial and Canadian governments seized Qu'wut'sun land for settlement, confined their families to reserves, denied them citizenship, and subjected them to punitive programs aimed at erasing their language and their culture. The goal of these morally contemptible policies, passed by an elected parliament in Ottawa, was "eventual assimilation

into the white race."[2] What was meant by this program of human engineering was for the most part left to local interpretation, often with grievous consequences.

Along with other Indigenous communities in British Columbia, the Qu'wut'sun have not ceased to petition Canadian authorities on behalf of their Indigenous right to their own territory. I'm ashamed to say that my mother's family does not appear to have had much curiosity about its Indigenous neighbours, nor does it appear to have felt guilt or remorse about settling on their land. Their existence was simply never mentioned. (I've often wondered what the compartmentalized settler mentality would reveal under the lens of psychoanalysis.) The fact is that one could not drive to the fishing lodge without passing through First Nations communities. The notorious Kuper Island Indian Residential School, with its heartbreaking history of abuse and neglect, was a familiar sight to local boaters and fishermen and less than an hour away by car. What did my family imagine was going on in those lonely hallways, or when pneumonia became an epidemic? My mother claimed that as a young woman she was barely aware of her Indigenous neighbours, although the lodge was adjacent to a reserve that shared the beach. Qu'wut'sun families would have walked by every day. Their children would have played in the sea below the lodge, but apparently they existed in a parallel world. My mother's cousin recalled drumming during the winter nights, as if it were in a dream.

The 1930s were a time of reduced financial circumstances for most people in British Columbia. A Penelakut elder once told me that the Depression was especially hard on Indigenous people. The lodge managed to pay its bills but there was little money left over. My great-aunt and -uncle scraped by, but the thread of colonialism divides everything in this part of the world and my people had the courts, the legislature, and the police on their side. Theirs was the side that had summarily hanged two Qu'wut'sun men, *Sque-is* and *Siam-a-sit*, in 1852, as an example to all who dared to oppose the colonial regime.[3] The patrolling

of coastal waters by well-armed British gunboats was still fresh in the memories of elders and old-timers.

What different worlds the settlers and the Qu'wut'sun inhabited. Men in the logging and the fishing industries would have developed working friendships, but I suspect that socializing among families would have been difficult and complicated by issues of race, privilege, and wealth. Was this further complicated by the fact that many Qu'wut'sun were devout Roman Catholics whereas the colonists were overwhelmingly Protestant? Certainly it appears that socializing did not occur to my mother or my grandmother, and I've wondered if their hesitation wasn't a function of shame encountering shame. The imposed imperatives of class and racial superiority would have conspired against recognizing what they shared in common as mothers and daughters.

As she grew older, my mother became angry about her role in enforcing the institutionalized hypocrisy and the prejudices she'd grown up with. She had been told that her survival depended on the kindness of powerful men, so she had stifled her own observations and opinions about a system in which rights and privileges were meted out according to make-believe constructs of gender and race. The invisible structure of social control is like a spider's web; when one changes one's angle, it's all too apparent. My mother came to see that she had, unwittingly, become both a defender and a victim of injustice and inequality. She became angry about the sacrifices she'd made that had once seemed so noble, and she began to speak out against racism, hypocrisy, and willed ignorance. In 1939 she had been twenty-two, and afraid of losing her job with a local company if she did not play by the unwritten rules. Her only hope of saving herself then was to make the most of her aggressive skills on the nearby grass tennis court.

As an athlete, my mother was ambitious, and blessed with a competitive spirit. Encouraged by local tennis instructors, and with a reputation for ferocity on the court, she was something of a local phenomenon. She would have to prove herself against

the best. The next step, people said, was Wimbledon, where you could see the best tennis in the world. Did she picture herself there, a colonial girl, on the grass courts, dazzling in her white skirt, winning every match with ease? In the Canada she grew up in, the things that mattered occurred in England. The best newspapers, the best tinned food, the best pens and paper, the best shirts and trousers, the best shoes, the best skirts and blouses, the best books, the best silverware, the best tableware. The best and brightest left for London and didn't come back. Why would they return to the periphery, where everything was so drearily and insistently provincial, where life was dull and predictable and there was no grandeur or nobility? In truth, my mother was no Anglophile, but she understood how the world operated and where the opportunities lay. I can imagine her planning her escape.

In Paris, a young man was feeling much the same way about his own situation. His name was Wolfgang Paalen, he was thirty-four, and he was a member of André Breton's Surrealist circle. He had won the respect of his fellow Surrealists, but he had been growing restless. North America beckoned, in particular the Pacific Northwest Coast. In May 1939, he left Paris with his wife, Alice Rahon, and their companion, Eva Sulzer, for New York. They travelled by rail to Prince Rupert and spent the next three months visiting Indigenous communities from Juneau, Alaska, to Vancouver Island. In mid-August, in a rented car, they would have passed by the grass tennis court and the fishing lodge on their way to Victoria.

Frustrated with the Surrealist hothouse in Paris, fearing for his life as a Jew in Europe, and haunted by the ancestral presences in his paintings, Paalen had come to seek, in the landscapes of the Northwest Coast, evidence of social, cultural, and aesthetic values his own society had abandoned. In Alaska and northern British Columbia, he had marvelled at crest figures on totem and

mortuary poles raised to acknowledge ancestors with lineages that reached back thousands of years. Farther south, he encountered clusters of magnificent house posts and large sculptures that only a few decades earlier had been a presence in thriving, prosperous villages. In the company of Canadian anthropologist Marius Barbeau, Paalen, Rahon, and Sulzer sailed across Hecate Strait on a fishboat from the mainland to the Queen Charlotte Islands, the northern archipelago known today as Haida Gwaii. They made pilgrimages to legendary Haida villages, many of them abandoned, where they viewed sophisticated sculptural works that had been integrated into every aspect of life and death.[4] Paalen would later write, in appreciation, "it is only on the Northwest-Coast of America that totem poles attain the monumental power that makes them rank among the greatest sculptural achievements of all time."[5]

Wolfgang Paalen had longed to experience a culture that lived among its ancestral spirits. In Paris his new paintings had centred on sinewy, spectral figures he called "totem poles" that hovered, floated, and loomed over post-apocalyptic landscapes. "The totem poles," he wrote, "are several beings held together by the compulsion of generations."[6] In his later paintings, these ancestral beings would become figures of continuity and human consciousness through space and time. Paalen was also studying shamanism and reading ethnographic texts. By means of an automatic technique he called *fumage* – working with the smudges left by a candle's flame on the surface of a wet canvas – he had attempted to short-circuit his conscious mind in order to seek out traces of ancestral history deep within the unconscious. He trusted in premonitions. One day in 1937 he began a new painting, but it wasn't until the following afternoon that the new work revealed itself. While he was out walking, he passed a shop window where he discovered a small totem pole carved in argillite, the black carbonaceous, slate-like mineral found exclusively on Haida Gwaii. He purchased it and returned to his studio to entitle his painting *Fata Alaska*.

Like his fellow Surrealists – André Breton, Paul Éluard, Max Ernst, Yves Tanguy, and Kurt Seligmann – Paalen was intrigued by the Indigenous arts of the Northwest Coast. He admired the sophisticated visual vocabularies drawn from supernatural encounters, transformational narratives, and exchanges with the invisible world. In Paris, he and his colleagues became avid collectors of Northwest Coast and Oceanic objects. They cruised flea markets and second-hand stores looking for bargains and got to know the dealers Charles Ratton and Paul Guillaume. Indigenous artists in British Columbia and Alaska had been making objects for sale to traders, tourists, and collectors for more than a century, and although Breton argued that contemporary objects were capable of projecting an equivalent power, his colleagues were interested almost exclusively in what they regarded as "authentic" works made for traditional domestic or ceremonial use. In a sense, the Surrealists were captives of an essentialist ideal of "purity" and "antiquity," although some of the works they collected were likely carved by men not much older than themselves.

Among the Surrealists, knowledge of the Northwest Coast was limited and perhaps fanciful. Few books and images were available, and museums in France were determined to classify Northwest Coast objects as "primitive." Mostly, the Surrealists were overwhelmed with admiration for the sophistication of these objects, each one radiating its own mysterious power. They wanted to believe that the anonymous makers of these objects had lived in a pre-industrial, pre-Enlightenment era with imaginations untainted by European artistic or philosophical traditions. The objects they collected became potent symbols of possibility, messengers from an idealized, still-enchanted world where the border between the conscious and the unconscious mind was permeable.

Surrealism's potent promise was that social and cultural revolution would be ignited by the exploration of dreams and the sedimentary layers of the unconscious. Desire, the transgressor,

would be liberated; it would free men and women from the chains that bound them to a hypocritical, death-obsessed culture. So-called rationality would be exposed as a mechanism for social control, and the stifling institutions that crushed the spirit would collapse into dust. The Surrealists opposed aestheticism and colonialism in all their guises, famously picketing *L'exposition coloniale internationale* in Paris in 1931. On the Northwest Coast of Canada, in the final year of the Great Depression, Paalen became acutely aware of the institutionalized plight of the Indigenous people he encountered. He would write critically about Canada's colonial policies and punitive legislation in his essay "Totem Art," published in the art and literary journal *Dyn* he edited from his home in Mexico City during the 1940s.[7] To my knowledge, the only Canadian writer to address the Indigenous experience of colonialism in the first half of the twentieth century was Emily Carr.

By the time he arrived in North America, Paalen was ready for a change. Surrealism was too limiting, and despite its efforts the movement appeared to have had little effect on French society. Europe was clearly headed for war. His father, living in Berlin, was Jewish. In dismay, Paalen had watched the noose tightening in Germany and Austria. As a boy he had spent his summers in a forested park in Silesia where he and his brothers played "Indians," and where "he had to act as medicine man for all the tribes, because nobody else was able to make such satisfactory war-paints and tipi ornaments."[8] He had been drawn to pre-Columbian and Oceanic art, and had collected small, prehistoric Greek idols while in his twenties. In the 1946 monograph *Wolfgang Paalen*, authored by his Mexico City neighbour Gustav Regler – today most scholars agree that Paalen himself wrote much of the text – he is described as forsaking the "narrowing formalism" of abstract art, and becoming increasingly absorbed by what he called the "heterogeneous crowd of ancestors." He was identifying the crux of the Modernist artist's dilemma: how to reconcile the

figurative – the urgency of what was at the time called "primitive art" – with the heady formalism of an abstraction liberated from linguistic and aesthetic associations.

With the revolutionary aim of renewing contemporary art, Paalen spent the 1940s in the studio exploring ways to weave ancestral strands into the present. "He could not," he wrote, "keep to the simple geometrical forms of the Primitives as the Abstracts did, just as he could not follow up the 'art sauvage' of the Surrealists." He would instead "drive for a synthesis which should bring the mythological element and the humanistic tendency into a balance hitherto unknown."[9] The collecting of masks, rattles, blankets, and other sculptural objects that had so passionately engaged him on the Northwest Coast became an integral part of this synthesis.

The poet and founder of Surrealism, André Breton, freely admitted to the moral ambiguity associated with collecting. He was a connoisseur, and a beneficiary of colonialism. His foreword to an Oceanic art exhibition in Paris in 1948 describes the obsessive fervour with which he and his colleagues endowed their collecting trips:

> There was a time, for some people who used to be my friends and for myself, when our trips, out of France for instance, were entirely guided by the hope to discover some rare Oceanic object for which we would hunt all day long without respite. It brought out in us a compelling need to possess that we otherwise hardly ever experienced, and, like none other, it fanned the flame of our greed: none of the things that others might list among worldly goods could hold its own beside it … I am guilty, it seems, in some people's eyes, of continuing to be moved by the resources of the primitive soul and of having recently conveyed that feeling while talking about specimens of Indian art or the art of the polar regions, for which we had a common predilection.

I am still as captivated by these objects as I was in my youth, when a few of us were instantly enthralled at the sight of them. The surrealist adventure, at the outset, is inseparable from the seduction, the fascination they exerted over us.[10]

There is no evidence that ethical considerations around ownership, inherent rights, theft, or coercion troubled Paalen, and it's unlikely that anyone brought such concerns to his attention; shopkeepers were only too glad to sell whatever they could lay their hands on. He seems to have been curious about authorship and provenance, although often no information was available. Before he left for western Canada in May 1939, he rented a storage locker in New York for the artifacts he expected to purchase on his trip.[11] As soon as he arrived in a town or village, he made a beeline for the "curio shops" and "trading posts." Sometimes locals with something to sell sought him out. Thanks to Eva Sulzer's inheritance he was able to acquire, chiefly through purchase, between forty and fifty rare and precious objects. These included masks, frontlets, blankets, bowls, rattles, jewellery, a Kwakwaka'wakw potlatch figure, and an astonishing fifteen-foot-high Tlingit house partition that had once stood in Chief Shakes house in Wrangell, Alaska. He sought out only rare older objects that he believed had been imbued with power through use. Objects produced for the trade he regarded as being inauthentic, without virtu, no matter how well they were made.

Unable to return to Europe because of the war, Paalen, Rahon, and Sulzer moved to Mexico City and, until he sold them in the 1950s, Paalen's Northwest Coast objects constituted one of the most significant private collections in the Americas. The works travelled widely to exhibitions and, although the collection is dispersed, many of the objects are prized by the institutions and collectors that currently care for them. The complex histories of institutional and private collecting raise important questions related to acquisition,

ownership, preservation, conservation, public display, and repatriation. Paalen's collection would offer an ideal subject for a case study.

One will not find in Paalen's collection a single work in argillite, or slate as it's sometimes called. By the 1820s, Haida carvers had realized that it was an ideal medium for producing souvenirs for the influx of traders, hunters, naval officers, and government officials besieging the coast. As the market developed and tastes changed, the artists innovated to keep ahead of demand. The carving grew more sophisticated. The artists began to create intricately carved model poles, chests, and platters with hybrid decorations. Soon collectors appeared, and museums began to commission works. The celebrated Haida artist Charles Edenshaw, whose work this essay explores, worked in argillite, wood, metal, and ivory, often borrowing ideas from American and European sources. Many of his argillite works, all produced within a commercial context, are of surpassing beauty. Today he is one of the most revered artists of the Haida Nation.

Over the years, private and institutional collectors focused most of their attention on irreplaceable ceremonial and utilitarian objects from the nineteenth century. Objects of a hybrid nature, combining Western and Indigenous motifs, especially if rendered in argillite, were often deemed "inauthentic" because they were made for sale. In her introduction to the 1993 catalogue for the first solo exhibition at the Vancouver Art Gallery by Haida artist *Guud San Glans*, Robert Davidson, anthropologist Aldona Jonaitis wrote:

> Haida argillite carving presents a fascinating problem for the student of Northwest Coast art. As Ruth Phillips has demonstrated, curios made for sale to non-Natives often assume a low position within the hierarchy of Native art ...

However, because it displays the sophisticated formline style characteristic of northern Northwest Coast art, it could just as easily be classified with the best pieces made for use within the community; this gives it a stature not often granted art made for the non-Native market. Nonetheless, you still must ask whether its commoditization ... renders it somehow less authentic than the art intended to be used within the community.[12]

By way of an example, she presented a passage from Paalen's essay "Totem Art" (1943) in which he justifies his choice of illustrations:

I have not reproduced any objects [of argillite] because, although at times beautiful and of great craftsmanly perfection, they represent only the decadent stage at which a great art loses its *raison d'être* and degenerates to trifles ... To limit the creative power of these peoples to petty decorative tasks, and to confound the products of the souvenir market with their authentic expressions merely degrades their great art which was of entirely collective purpose: an art for consummation and not for individual possession.[13]

Most of the objects illustrated alongside "Totem Art" were from Paalen's Northwest Coast collection. From what I have been able to deduce, he did not purchase any argillite objects while in British Columbia or Alaska. By 1939 it would have been unusual to discover an argillite masterpiece in a curio store, although he clearly encountered items produced for tourists. As an artist, he was particular. He was looking for evidence of what he knew to be a "great art," a transformative art, and he was keenly interested in the consciousness that had produced it. Crucially, it was a consciousness that had developed far from the charnel house of Western civilization. As an artist, Paalen recognized that transformation is at the heart of Northwest Coast

art and thought. This resonated with his readings in quantum theory. If the universe is in a state of constant transformation, then change is possible and there is hope for human beings. The task of contemporary art, he believed, was to present a vision of a transformational universe. In his introduction to issue 4–5 of *Dyn*, he optimistically declared: "this is the moment to integrate the enormous treasure of Amerindian art into the consciousness of contemporary art ... Such an effort at integration prefigures nothing less than a vision that today only the most audacious dare to entertain: the abolition of the barriers that separate man from his own best faculties, the abolition of the interior frontiers without which no exterior frontier can be definitively abolished."[14]

It's regrettable that Paalen did not have an opportunity to study the frontier-abolishing practices of the nineteenth-century Haida argillite carvers. Not only did they continue to develop their art and culture without invoking the prohibitions of the missionaries – sustaining their families through the hard times – but in their hands the art was refined until it reached a sublime state. Paalen arrived too late. By the early twentieth century, most of the celebrated argillite works were tucked away in museums and private collections. Having studied argillite carvings in American museums for the purpose of illustrating them, his colleague, Mexican artist Miguel Covarrubias, recognized "the masterful technique and austere good taste of the Haida." Some of the works, he enthused, "reach the level of great works of art."[15]

What Paalen also missed was that Charles Edenshaw, his peers, and the slate-carving generations before them had established a hybrid, contemporary art form on their own terms, building on and adapting the genius of the past. Had Paalen seen Edenshaw's work in slate, he'd have encountered an artist who shared his commitment to the synthesis that brings "the mythological element and the humanistic tendency into a balance hitherto unknown."[16] Chief *'Idansuu,* James Hart, a gifted contemporary artist with a highly charged, epic sensibility, explains Edenshaw's achievement:

He was in the old supernatural times and then moved into that new time. When I do a piece, it comes through my fingers; whatever I know comes from my fingers. I think that's where he was coming from. He had a grasp on that whole way of thinking – his background, how to look at the world, the influences – it comes through. You can see the influence from the old masters that were ahead of him. He wasn't the only guy that did great stuff, but he was a guy that did great stuff, my old grandfather.[17]

Charles Edenshaw lived through a tumultuous, transitional time. He spent much of his working life moving between Haida and settler cultures. He was a disciplined artist with an irrepressible poetic imagination and deep cultural knowledge. In every medium he put his hands to, the works he created carry an inner radiance and include large and small poles, masks, boxes, jewellery, and other superbly carved and painted objects. Along with his fellow carvers of argillite, of whom there were many in the nineteenth century, he was quick to appropriate and incorporate formal and aesthetic ideas from European and American sources, although it would be a mistake to think that an artist in an earlier time would be free from outside influences. All artists seek out the new. Edenshaw also made extraordinary objects for traditional use. He was a consultant to anthropologists and linguists. He was a churchman. He accepted museum commissions and made work to order. He was often on the move, and whenever he travelled he took his carving tools. He was, by all accounts, a superb painter. He was a contemporary man, willing to explore the ideas introduced by the invaders, yet everything he achieved was intended to protect, celebrate, and advance the culture he was born into. He kept the old beliefs alive by embracing the new. If he taught us anything, it was not to fear change. If he was a master, this may be why.

And he did not work in a vacuum. As a young man he entered a powerful current of Haida carvers and artists, some of them family members who preceded him and some who followed after.

Their names and achievements deserve respect, appreciation, and celebration. "Carving," writes James Hart, "was – and is – our way of writing, recording history, showing our prerogatives, our stories, our beliefs, our Religion."[18] Those who helped to preserve and advance this knowledge in the nineteenth and twentieth centuries include, among many others, old 'Idansuu; John Cross; Duncan Ginaawaan; Gwaaygu 7anhlan, Albert Edward Edenshaw; John Gwaytihl; Tom Price; Gwaawhllns, John Robson; Simeon Stilthda; and Squiltcange.[19] Edenshaw mentored younger carvers as time went on, and those who carried the skills forward include John Marks; Skilee, Isaac Chapman; and Skilgoldzo, Daniel Stanley, the son of Simeon Stilthda.[20]

The essay that follows is an exploration of three remarkable argillite platters attributed to Charles Edenshaw. I've asked myself if it's possible to apply the aesthetic criteria to a nineteenth-century argillite carving that I am in the habit of applying to a work of Western classical or contemporary art. It may be possible, but would my old approach not be limited and perhaps misguided? These works are embedded in a history, a culture, a man's life and family, and a spiritual context I will never fully understand. They have been closely examined and analyzed by anthropologists who have told us what they know. Charles Edenshaw was familiar with the leading anthropologists of his day, and the objects were, after all, made for collectors, institutions, or both. As for the three works to be examined, there is little information about their creation. Were they commissioned, and if so, by whom? Were they conceived as a set, or did the first inspire the second and third? We may never know. I have come to believe that they are among the works by Charles Edenshaw that are deeply personal.

I have tried to learn what I can, to keep an open heart and an open mind, and to remember that there is always more to learn. I have written this essay as if its first reader were my mother, that

fair-haired young woman on the second-oldest grass tennis court in the world, serving the ball on a blackberry-scented August afternoon in 1939 as Alice Rahon, Eva Sulzer, and Wolfgang Paalen drive by on their way to Victoria. I did not ask enough questions when I had the opportunity, and she did not quiz me as she may have wished to. Our ancestors, from Scotland, Ireland, and England, were among the thousands who arrived on this continent on their own, often through circumstances beyond their control. Some were traumatized. Some came for adventure. Most came for a new start. Many never saw their families again. Was this by design? Wittingly, or unwittingly, they became the worker ants of Empire and disrupted every society they encountered. They learned to live with loneliness and protected themselves by keeping their counsel. One could receive a nasty rebuke if one approached too closely. We had much to discuss, my mother and I, but our vows of silence remained in place. Were she still here, perhaps we could begin to dismantle the system that remained invisible to us for so long.

You may be wondering: what do the Surrealists, and Paalen, and my mother have to do with Charles Edenshaw? Conventionally, very little. But in a profound way their experiences of this place were shaped by a colonial culture in which dispossession and inequality were enforced by law. The way that each of them navigated within a system that mendaciously promoted assimilation as a gesture of benevolence allows us to examine the nature of privilege and power, for it was the intention of the Dominion of Canada to withdraw privilege and power from Indigenous nations and to usurp them for itself. I do not see that this objective has been tempered or abandoned. The struggles in the past century for universal rights, and an end to arbitrary detention, remind us what is at stake in this century as the old borders are increasingly incapable of providing shelter or support for their people. As the climate changes and resources are pushed to the limit, every person and every creature on earth will be affected. Remedies will depend on local knowledge

and people working together, finding common cause. The old histories have much to teach us about how to conduct ourselves as we move forward.

Before going further, I should acknowledge that what follows is chiefly based on my reading of books, exhibition catalogues, and other written material. I'd like to express my gratitude to the Haida artists who have spoken and written so eloquently and generously about their work and their lives. I have approached my subjects – Charles Edenshaw's three Raven-and-bracket-fungus platters – because they enchanted me. I wanted to know more. To the scholars of Haida art and culture whose names appear throughout these pages, thank you. Your care and your thoughtful interpretations have contributed to my understanding. I'm thankful too for the learned friends and colleagues who have so willingly helped along the way.

I cannot lay claim to any specialized knowledge of Haida culture or language. Like many before me I've been intrigued, instructed, and moved by the Raven stories that are not restricted to the Pacific Northwest Coast but which flower here in profusion. Raven is the spark of life; he is the ego and the id, alternately generous, greedy, compassionate, and dismaying. He is amoral, impatient, oversexed, and impulsive. His contradictions are ours, his appetites are ours. Yet within Raven's universe – he is not a god – honour, dignity, love, and loyalty are possible. Humans may find solace in the arms of another, but Raven is existentially alone. We feel for him. We know him too well.

The oral history concerning Raven, _Xuuya Kaagang.ngas_ – translated as _Raven Travelling_, or _Raven Kept Walking_ – is a work I know only in translation, and on the page. I'm grateful that a seventy-two-year-old Haida storyteller named _Sgaay_ agreed to dictate a version of the narrative to a young American linguist named John Reed Swanton in the village of _Hlgaagilda Llnagaay_ (Skidegate) in the fall of 1900. _Xuuya Kaagang.ngas_ begins with the creation of Haida Gwaii, and some of Charles Edenshaw's most enduring works revisit moments from Raven's

amoral, tempestuous life during the time of origins. I've been particularly absorbed by the episode that involves Raven and a guileless bracket fungus pressed into service for the perpetuation of the world. It's an incident that takes up only a few lines in the story and which this essay examines in detail.

Xuuya Kaagang.ngas is one of the world's treasures, a history with cultural, biological, psychological, and philosophical insights one would be a fool to ignore, and even in the written texts we possess – transcribed and translated from the oral tradition – its wisdom, humour, poetry, and provocative economy shine through. To live on the west coast of North America without exploring its cultural riches is to dwell in a kind of darkness. In his introduction to John Enrico's translation in _Skidegate Haida Myths and Histories_, Haida artist and leader _Guujaaw_, Gary Edenshaw, makes the point that these mythic stories "represent incorporeal properties, valued above material wealth."[21] I offer the following with respect, admiration, and gratitude for the wisdom of the storytellers, the artists, and all those whose have contributed to the enviable accomplishments of the Haida Nation.

On the completion of her wartime posting to London, my mother returned to Vancouver Island and found a job in Victoria. In late 1944 she was persuaded by a friend to go on a double date. Reluctantly, she agreed. She met a young naval officer, fell in love, and took him up the island to meet the family at the old fishing lodge. Seven days later they were married in a formal ceremony, walking out of the church and down the steps under a canopy of glittering swords held high by fellow officers. He left the next day. They did not see each other for nine months, and after a short time together he left again. I was born while he was at sea.

My father was an officer in the Royal Canadian Navy. During the late 1940s and 1950s, when wartime fleets were still

intact and the Cold War had replaced the Second World War, he and his colleagues spent months at sea training with allied navies and participating in diplomatic visits around the world. It was not easy on their wives and children, and that is another story. The most hysterical and emotionally fraught days each year occurred when the ships returned and families crowded the wharves looking for their husbands and fathers. On those early mornings in Halifax, often rainy and blowy, two alien tribes faced one another, squinting, filled with expectations, looking for assurance, and trying to remember who they had been when they were not who they had become.

When I was almost nine years old my father became the commanding officer of one of the most beloved ships in the Royal Canadian Navy. She was a Tribal Class destroyer, built in the U.K., and she had seen active service during the war. Tribal Class destroyers served in the British, Australian, and Canadian navies, and were named, in the fashion of the day, for warrior tribes of the British Empire. The British destroyers were named after tribes in Africa and on the Indian subcontinent; Canada's Tribal Class destroyers were named for Indigenous nations across Canada.

For eighteen months, between 1954 and 1956, my father commanded the HMCS *Haida*. I loved her best of all his ships. Her lines were beautiful. She was especially graceful cutting through the water. I will never forget the perfection of her bow wave. She was painted a warm, dark grey, and the number 215 appeared in black on her hull. Two plus one plus five equals eight, my lucky number! I did not wonder about her name. It was Canadian, and that made me feel proud. If I'd asked my father's fellow officers, they'd have told me that naming a ship after powerful, respected warriors was a naval tradition. Sailors are superstitious and do everything they can to court good fortune; a ship's name that invokes fear in the enemy is a powerful talisman.

Canada's colonial history makes the choice of Indigenous names for warships immediately complicated. The idea of a "Tribal

Class" of destroyers was conceived in Great Britain, although one can imagine Canadians approving of it without hesitation. In the Canadian mind, "Indians" had an enviable reputation for courage and ferocity, although the "Indians" imagined were Indigenous people of the eighteenth or nineteenth century defending their land against usurpers. On this coast, Indigenous villages were actively subdued by warships during the nineteenth century; to name the new destroyers in honour of Indigenous cultures must have seemed, at best, a recklessly perverse mix of respect and appropriation. Tribal Class names were intended to be a powerful evocation of the noble savage, a stereotype reinforced in the movies we loved. It is difficult to square this image with the experience of Indigenous people in Canada during the 1950s.

Today I am left with a delicate watercolour of the HMCS *Haida* on our wall at home. My father must have bought or commissioned it in the 1970s. It stirs up complicated thoughts of my childhood and the histories of this coast each time I look at it. My father also collected the painted crests of each of the ships he served on. I remember studying them in my parents' houses, as if they were religious icons. As my parents moved to smaller apartments, the crests began to disappear into cardboard boxes – all but one, to my eyes the most beautiful, the ship's crest of HMCS *Haida*. It is the one I am looking at now. An informal heraldic note describes it showing a "Thunder Bird, all black, with two heads, wings unfolded and above wavy black." For as long as I can remember, I have always seen a two-headed Raven, an emblem of bifurcated human consciousness.

1 | FOR THE PERPETUATION
OF THE WORLD

Charles Edenshaw's achievements have been revered for more than a hundred years in his own community and by anthropologists, curators, collectors, and those with an interest in Northwest Coast art, but are not widely known or appreciated by the general public. The opening of the comprehensive Edenshaw exhibition at the Vancouver Art Gallery on October 26, 2013, was thus a necessary corrective. It revealed for all to see that his carving and painting transcend the specialist categories to which his reputation, for the most part, seems to have been consigned. He is one of the rare artists whose work, embodying the complexities and the genius of its time and culture, holds up a mirror to everyone who cares to look. The exhibition's three-month run allowed devotees to return at will to revisit individual pieces. When I moved through the galleries I experienced a kind of enchantment, and was each time drawn into Edenshaw's profound meditations on the mystery of being and the nature of the divine.

What struck me immediately was how magnificently contemporary these works are. His probing, lyrical line, his curiosity, his sense of humour, his dramatic sensibility, his philosophical subtlety, and his gift for giving form to the vain and fragile psyche navigating uncertainty all spoke of a Modernist sensibility. Every room in the gallery teemed with beings shifting between animal, human, and supernatural forms and works that spoke of the quicksilver intelligence of beings in flux. Transformation is a little death and an auspicious rebirth. I'm accustomed to thinking of artists in Europe and on the American continents in the late nineteenth and early twentieth centuries responding to the contagions of nationalism, colonialism, urbanization, and industrial capitalism. The same concerns must have been even more urgent for Charles Edenshaw and his family. How did he manage to navigate through these shattering changes? How was he, as an artist, to address the present, a time of expansion, resource appropriation, and technological acceleration? In periods of stress and transition, artists often look to the past. Edenshaw returned to the earliest histories, to the epic narratives he'd listened to as a boy. He'd have learned the stories in X̱uuya Ḵaagang.ngas, along with their glosses, through many tellings.

During his lifetime, Charles Edenshaw appears to have been the best-known Indigenous artist on the Northwest Coast. The 1909 *Guide to Anthropological Collection in the Provincial Museum*, "prepared" by the Victoria-based physician, field naturalist, and museum collector Dr. Charles F. Newcombe, lists only one Haida artist by name: "Chief Edensaw, of Masset." ("Edensaw" is a faithful reproduction of an early variant of Edenshaw's name.)[1] Like other turn-of-the-century collectors, Newcombe knew Edenshaw personally, having commissioned work from him, and acquiring from him a settee, carved boxes, and other objects. In the employ of Chicago's Field Museum in 1902, Newcombe sent a letter to the museum's curator of anthropology, George A. Dorsey, describing Edenshaw as "the best carver in wood and stone now living."[2] In anthropologist

Franz Boas's influential study *Primitive Art*, first published in 1927, "Charles Edensaw" is described as being "the best carver and painter ... among the Haida." [3] The young Haida carver Jaalen Edenshaw attributes the flowering of Edenshaw's art to circumstances that resulted from radical changes within Haida culture in the 1860s:

> There were obviously great artists before Charles, but for the most part, those artists probably made their living doing things for the community or for trade with the mainland. It might have been a by-product that they traded to the ships, but not the main focus. Starting with Charles' generation, there would have been a large [shift]. Trade [with Europeans] was huge then and would have gone along with the work of carving for the community.
>
> It was really when smallpox hit that there was a great lessening of carving. Midway through his life, most of his work would have been for the [European market] – anthropologists were going crazy for everything. This market created the freedom to be an artist in the Western sense of the word. Now you were creating things, not for utility *and* beauty, but *just* for beauty. It would have been an interesting time. [4]

Epidemics, beginning in 1862, altered Haida life forever. What must it have been like to experience waves of smallpox, measles, influenza, and tuberculosis without any remedy? Thousands perished. What of the survivors and their grief? What psychic wounds did they carry forward? To this day, many Haida believe that the smallpox epidemic was the result of biological warfare. The invaders also infected the region with their languages. Many people learned to get along in the trade language known as Chinook Jargon, but it was a stopgap. I have tried to imagine the chasm between the subtle poetry and precision of one's maternal language and the need to make oneself understood in

the conqueror's tongue, a language of unfathomable allusions signifying submission. Fortunately, the Haida were accomplished artists. "Art is our only written language," writes Robert Davidson. "It documented the histories of our families; it documented our progress as a people. Throughout our history, art has kept our spirit alive." [5] Every work that left Edenshaw's hands throughout his career was a declaration of political, philosophical, and artistic sovereignty, an invaluable teaching that helped sustain the culture through years of hardship. "You can feel that he took it upon himself to carry it through," says Davidson. "Everything that was banned, he was doing. Smallpox was killing everybody off. You're losing *villages*, and for him to carry our art into today, doing all the stories in wood and in argillite – there's just a passion!" [6] His commitment to carving and painting, writes James Hart, the inheritor of Edenshaw's chiefly position, "was even more important than before the smallpox epidemic, the annihilation of his people." [7]

In his contribution to the exhibition catalogue, Robert Davidson, a rigorous and thoughtful explorer of Haida forms – and Charles Edenshaw's great-grandson – likens his great-grandfather's accomplishments to those of the being with supernatural powers known as "Master Carpenter," who was, he writes "*yahgid*, or one with status and knowledge … His work was the culmination of centuries of development of the Haida art form. When I look at his work I see great joy. The feeling I get is that he was smiling the entire time he created." [8] I also found myself smiling when I moved through the Edenshaw exhibition, returning over and over to objects that called me back into the room I'd just left behind. To abandon these objects without returning seemed like an act of betrayal. They radiated the powerful and mysterious energy that certain objects possess: the energy of their making. Haida artist Bill Reid described it this way: "When we look at a particular work of Northwest Coast art and see the shape of it, we are only looking at its afterlife. Its real life is in the movement by which it got to be that shape." [9]

I found myself returning again and again to three argillite platters attributed to Edenshaw and created around 1885 – the year Louis Riel was hanged, Irish nationalists blew up the Tower of London with dynamite, and the Dominion of Canada made attending a potlatch illegal. Each of the circular platters is approximately thirty-three centimetres in diameter and illustrates, with a bawdy sense of humour, an apparently comical moment in the epic narrative Xuuya Kaagang.ngas. In a burst of theatrical imagination, each depicts the instant before Raven sets in motion the amorous adventures for which he's known, including his randy peregrinations in the world of human beings. Like many objects that were acquired by collectors, museums, souvenir hunters, and traders on the Northwest Coast in the nineteenth century and carried away, by chance or by design, to the far-flung corners of the world, today the three platters are separated by thousands of miles. One resides in Seattle, one in Chicago, and one in Dublin.

The episode Edenshaw chose for each of the platters may be said to be taken from the Mother of all Haida origin stories, for it has everything to do with the creation of mothers. In each of the tableaux, Raven, in both human and supernatural form, looking distinctly hesitant, stands erect in the bow of a canoe a moment away from spearing something attached to a reef known as Tsaw Gwaay.yaay, located just south of what is known today as Newberry Point in Juan Perez Sound.[10]

.On each of the three platters, a character with a human body, a round head, wide-open eyes, and an oval mouth lined with pointed teeth, mans the stern of the canoe. He is Raven's helmsman, or t'aan Gaad.[11] On the Chicago platter, he grips a paddle on which has been carved a salmon-trout's-head.[12] On the other two platters, the paddle has vanished; the helmsman's arms have been thrown up into the air in a gesture of dismay. On each platter he stares directly at the viewer. As Raven gazes forward, apparently oblivious to the disruption in the stern, the steersman seems desperate to catch our attention. Is he seeking

help? Maybe he's in the throes of an experience that has caught him off guard, a trauma that has unmoored him somehow. Has he peered into the annihilating abyss? Is he intoxicated? Dramatically speaking, in calling attention to his predicament, he has breached the fourth wall. His expression suggests that this quest is not his idea, and that what is happening is rather alarming. He is, after all, a bracket fungus, accustomed to growing quietly on a tree in the middle of the forest.

On Haida Gwaii, this figure is known to those familiar with the oral histories as Fungus, Fungus Man, or sometimes Biscuit Man, a name derived from the bracket fungus's likeness to the round pilot biscuits or hard tack imported by Europeans in the nineteenth century. I have wondered if Edenshaw chose the pilot biscuit as the model for the Fungus Man's circular head. The likeness might be enough to make one smile. According to Mabel Williams, mother of lawyer, composer, and singer *Gid7ahl-Gudsllaay, Lalaxaaygans,* Terri-Lynn Williams-Davidson, of the *Gak'yaals Kiigawaay* (Skedans Ravens), Fungus Man is often called *Galaga snaanga,* which translates as "ugly biscuits."[13] The Haida word *galaga,* related to *gilg* or *gilgaay,* is used interchangeably for pilot biscuits (or pilot bread), crackers, and bracket fungus. *Snaanga* may be related to the Alaskan Haida word for "scab,"[14] and, if so, this may suggest an indirect association with the epidemics of the nineteenth century. Charles Edenshaw may have been the first artist to represent him visually. If so, *Galaga snaanga* is the graphic equivalent of what in literature is the rarest of fictional creations: an "original character." It's as if one has been offered a privileged place at the birth of a long-awaited redeemer. But just exactly who is he, and why is he here?

And why do these two worried-looking figures in the canoe look so anxious? They resemble a couple of comical amateurs on a vaudeville stage. (Who will play the stooge?) Their anxiety relates to their mission. According to *Xuuya Kaagang.ngas,* the islands known as Haida Gwaii were populated long before Raven and Fungus Man set out in their canoe. Terri-Lynn

Williams-Davidson of the G̲ak'yaals K̲iigawaay clan notes that the ancestress of her clan, and other Raven clans, "emerged from a cockle shell" on the island of Ata'na (House Island), which is to say that she was the first of the ancestral line.[15] The powerful Haida ancestresses who came into being at that time conceived and gave birth to children without men and without sex. But Raven has been dispatched to Tsaw Gwaay.yaay with explicit orders from two women on the shore. Famous for his pursuit of all things sexual, he has been sent out to the reef to fetch the tsaw, the Haida word for female reproductive organs. He is no doubt enthusiastic. The reef is only a few metres from the shore, yet the powerful waves of female sexuality generated by the presence of the genitalia are capable of overwhelming a man, or a bird, or a fungus, causing them to lose control before they even get there.[16]

If the expressions on these two faces make us smile, it's because Edenshaw appears to be making an observation about sexual anxiety and the male psyche. Their important task is fraught with peril. The two are rank amateurs, and the closed circumference on each platter suggests that their condition is inevitable and inescapable. The tableau within each platter depicts the circumscribed world of male experience; beyond the edge lies the unknown. Edenshaw has perched them on the border; they cannot return whence they came. When Raven launches his spear, it will shatter the braided circumference of the platter's edge and enter time, the dimension in which women and men will discover the sweet, urgent, sorrowful intimacies of love, birth, and aging – and the aching knowledge that these are fleeting. Raven, however, is only after one thing. Driven by his libidinous appetite, he will plunge in after his spear to see what he can make of this new opportunity.

This episode can be found in the version of X̲uuya K̲aagang. ngas recited to Henry Moody and John Swanton in 1900 by the gifted Skidegate storyteller Sgaay, whose baptismal name was John Sky. On none of the platters do we catch a glimpse of Tsaw

Gwaay.yaay, the reef Raven and *Galaga snaanga* are headed for. *Sgaay* did not not spend much time on description, but he did tell his translators that the *tsaw* or "short objects lay one upon another on [the] reef." [17] People familiar with rocky foreshores have likened these "short objects" to the marine molluscs known as chitons, which are plentiful on the Pacific Coast. As a result, several versions of the story about how women got their *tsaw* suggest that Raven collected chitons and that these somehow transformed into female genitalia when placed on or thrown at early humans. In their instructive telling of the oral history, "How Raven Gave Females Their Tsaw," Terri-Lynn Williams-Davidson and her mother, Mabel Williams make it very clear that Raven found female genitalia on the reef. The force emanating from *Tsaw Gwaay.yaay* was powerful because so many vaginas were gathered together in one place. [18] The story, Williams-Davidson writes, "teaches the power of female sexuality." [19]

In *Sgaay*'s account, Raven and *Galaga snaanga* are the only characters mentioned, yet three figures animate each platter, proposing a kind of narrative triangulation. Edenshaw has taken it upon himself to introduce a mysterious figure below the canoe. On the Chicago platter, the creature is about to take a bite out of the cutwater. On the other two it looks directly into our eyes, almost leering. Sharp teeth fill its mouth, possibly waiting to consume the canoe's occupants. But why has it shown up at this moment? It somewhat resembles the figure of the Sculpin found on other argillite platters, but cannot be. Robert Davidson explains that the figures illustrate the spirit of *tsaw*: *tsaw sgaanagwaay*. The *tsaw*'s power is so strong, it seems, that it can dislodge *Galaga snaanga* from his place. [20] But what does one make of the teeth? I would like to look at this in more detail later on, but the teeth suggest to me that there is something about these figures that is frightening and irresistible at the same time. It appears that Raven and *Galaga snaanga* do not see the figures, although they feel their power as a physical manifestation. But Charles Edenshaw has made sure that we see them. The horizon

line that supports the canoe is not simply the surface of the sea. It represents the porous boundary between the imagination and the metamorphic machinery in the unconscious mind, where the spirit of women's sexual power can be transformed into a complex visual representation.

A glimpse at the three platters tells us that Charles Edenshaw has taken great delight in depicting his two hapless and improbable figures in the canoe. A bird and a bracket fungus, an unlikely pair. But they are destined to take part in the greatest adventure of all: an encounter with "the origin of the world." If they complete their task, the world as we know it will begin to wear a human face. Raven will enter history, and the offspring of the families that will follow him will begin to shape the unknowable future. If I have alluded to the misgivings of Raven and his helmsman, it is equally true that they appear to be fully alive at the moment we encounter them. As they brave the frigid waters, with danger all around them, are they aware that they may be fulfilling a prophecy that was set in motion at the beginning of the world?

The year Charles Edenshaw died, in an unpublished fragment concerning the "categories of aesthetics," twenty-eight-year-old Walter Benjamin set down some thoughts about narrative. Every story, he realized, no matter what its form or provenance, is a story of origin, what poet William Carlos Williams called a "rolling up out of chaos, / a nine months' wonder."[21] In composing a narrative, Benjamin wrote, "What is decisive is that the act of creation is directed at the perpetuation of creation, at the perpetuation of the world."[22] The function of narrative is to keep the world rolling along. In 1963 filmmakers Pierre Perrault and Michel Brault created a documentary portrait of the people of Île-aux-Coudres in the St. Lawrence. The small island community, along with its history, culture, economy, dialect, and spiritual mysteries, was on the verge of being overwhelmed by modernization and homogenization. Harnessed to the industrial prerogatives of the postwar nation state, the islanders were in danger of becoming

secondary to themselves. The break would be irreparable. Their dialect and the oral histories would be lost. A community that cannot recall where it came from, that cannot remember its beginnings, will have no defence against economic servitude and cultural collapse. Perrault entitled the film *Pour la suite du monde*, or "for the perpetuation of the world." Its innovative *cinéma direct* sequences and its re-creations of the once-profitable fishing industry were devoted to renewal of the island's language and culture, and, by extension, to renewal throughout Quebec, where dreams of cultural and political sovereignty were in the air. Charles Edenshaw transformed the oral histories of Haida Gwaii into works in silver, argillite, and wood for the perpetuation of Haida culture and the Haida world he hoped his grandchildren and great-grandchildren would inherit and perpetuate in turn. They have not let him down. The world must ever be imagined into being.

Perpetuation extends not only to the visible and audible world, but also to the boundary where the quick encounter the dead. It is the task of the storyteller and the artist to pull back the veil, to rediscover the epic transactions between ancestral and supernatural figures whose conflicts and amours continue to reverberate in the present. A shaper of shifting forms, Charles Edenshaw spent his life rendering visible a fluid universe in which everything is always becoming. Every being, as it enters into itself, transforms into another. Presence and absence are synonyms for the same ache. Giving shape and form to the exuberant and mysterious moment of creation is an act of renewal and rebirth, a declaration of love for the world. This is how I understand the work of Charles Edenshaw.

2 | RAVEN

Works attributed to Edenshaw are scattered throughout the world in public and private collections. For most of his life he made objects for sale or trade, but he also produced pieces for traditional and ceremonial use, making work for family and friends and taking special orders. In his sixty-seven years of carving and painting, he did not sign a single piece, nor was it the custom to do so at the time. Artists and scholars have tentatively come to recognize a set of Edenshaw gestures and techniques, but certainty of attribution remains elusive. In 1967, the Vancouver Art Gallery broke new ground with an exhibition called *Arts of the Raven: Masterworks by the Northwest Coast Indian*. Having devoted a separate section to "Charles Edenshaw: Master Artist," curators Wilson Duff, Bill Holm, and Bill Reid had to make some difficult decisions. In the end, after much discussion, they chose to exhibit sixty-six works in wood, argillite, and silver, including three walking sticks, four examples of Edenshaw's crest designs painted on baskets, and three woven spruce-root hats. Their final choices came with this caveat: "we have not reached the point where we can always be

certain that a carving or a painting is from his hand. Many of them are firmly attributed to him by the collector; others we can confidently attribute by recognizing his personal style. But we do not always agree with the attributions of previous scholars. The full range of his work is still unknown, and it is very likely that the exhibit contains other Edenshaw works which we have not yet recognized."[1] Forty-five years later, Edenshaw scholar Robin K. Wright noted that "at least twenty – and possibly twenty-five" of the objects in the special Edenshaw section, "nearly half of the total – were probably not made by Edenshaw" but by other Haida artists.[2] This ongoing research into attribution has provided the welcome opportunity to recognize and celebrate the achievements of many extraordinary Haida artists who were at one time overlooked.

Edenshaw's multi-dimensional visual intelligence had an eye for the way light falls onto surfaces. In terms of proportion, finish, and subtlety, every plane reflects his early training as a jeweller. In the 2013 Vancouver Art Gallery exhibition, ancestral figures from the sky, the earth, and the sea, often in supernatural guise, crowded the rooms, recurring on frontlets and masks, on boxes, blankets, and bracelets, on platters, rattles, and poles. Their appearances relate to historical events, to a family's lineage with deep tendrils in a world before time. The exhibition also brought together a number of the finely woven spruce-root hats attributed to Edenshaw's wife, Isabella. Her exemplary weaving, with its expanding diamond pattern that recalls intercepted and reflected wave interference, provided tapering cylindrical planes for her husband's two-dimensional crest figures. His paint follows the curves of the hats to create an illusion of three-dimensionality. In their tapering, each hat resembles a topographical model of the universe. Inverted, each hat becomes a basket, a bowl, a seine, a vessel in which to sail the starry sea. Woven with roots from deep within the earth, each resembles a top that with a well-turned spindle might spin without a wobble. Charles's four-pointed compass rose, painted in black and red on the flat peak or

plateau of many of the hats, is divided into constituent triangles, acknowledging the union of contraries from which the winds, the seas, and all beings disperse and recombine.

By the time John Swanton met the storyteller *Sgaay* in Skidegate in 1900, many Haida people would have been familiar with the Old Testament account of the creation of the world. *Sgaay's* account of the dim, watery beginning, in his recitation of *X̱uuya K̲aagang.ngas*, bears similarities to that found in Genesis, except that in Sky's narrative the "rushing-spirit ... hovering over the face of the waters" is not the Judeo-Christian God. He has black wings and a long shiny beak. Swanton writes, "[Raven] was not the only originator of all these things, but he was the principal, and for that reason he was known as Nañkï'lsLas ('He-whose-voice-is-obeyed')." [3] Raven is all appetite. He consumes. If he originates something it's because he's greedy, or vengeful, or aroused. He is supremely selfish and self-interested; there is no question of altruism or selflessness. In the supernatural world, as in the human world, discipline, loyalty, and reverence for the intricate and radiant fabric of existence ought to govern one's behaviour, but temptations are many, and often prevail. Transgression becomes a catalyst for transformation. Out of disorder a new order is born. Raven's exuberant trespasses counterbalance power, arrogance, and the hubris of those who declare themselves gods. Edenshaw's works possess the grace that comes from knowing that the border between the supernatural and the human worlds is porous, and that the Other – be it four-footed, two-footed, winged, or finned – is also Oneself.

Raven is transformation incarnate. He is never still, shifting from bird to human to any other form that will, in a blur of endlessly fluid metamorphoses, satisfy his insatiable desires. He can take any form. He is a cosmos. He is the hunger of the natural world. He speaks all languages and no language.

He is merciful and thoughtless. He is an ardent lover and an enthusiastic deceiver, although not without occasionally sincere but temporary regrets. He stirs things up among humans to amuse, indulge, or otherwise satisfy himself and to stave off boredom. There is no peace in Raven's world; he is the change of light from one moment to the next. In an early essay devoted to the three platters, anthropologist Alan L. Hoover notes that Edenshaw may have learned the story cycle from his uncle *Gwaaygu 'anhlan,* Albert Edward Edenshaw, who, according to Marius Barbeau, "made the Raven his own culture hero … and his nephew (and heir) Charley was the first to express it in sculpture."[4] Anthropologist George F. MacDonald claims that Edenshaw "could recount several hundred different Raven stories from memory."[5]

Raven is often thought of as simply a trickster, but he is far more complex and interesting. Because he relies entirely on his impulses and his senses, he is the one arbiter we can trust. In the beginning, according to the oral histories, when he discovers the first rocks jutting out of the sea, the world is in a moribund state. It is Raven's curiosity that animates this primeval, listless scene. He discovers supernatural beings and releases them from their tidal nurseries, and eventually they make their way to what we now call Haida Gwaii and the mainland of British Columbia. The world develops for eons, and then there is a great flood. Slowly the waters recede. One day, according to a familiar story, as Raven is flying over the land, he spies a promising beach. He drops down onto the shingle to look for a glistening morsel to eat, and as he struts along the tideline, he hears, over the surf, an unusual, high-pitched noise. Inspecting further, he discovers a clamshell wedged into the sand, clamped shut. My guess is that prior to his approach it had been open a crack. He pecks on it with his beak; perhaps he pokes it inside a bit. The lips of the shell part and tiny faces appear. Raven coaxes them out into the light. This will be fun, Raven thinks, and he proceeds to entertain himself by playing with them. Some accounts have it that when Raven tired

of these little people he tried to encourage them back into the shell, but they refused and scattered down the beach. In another account, he flies them to the North Island, where they make their home. These first humans are said to have been the ancestors of some of the Haida people.

Raven's injection of himself into the clam releases human consciousness from its shell. Literary scholar Ralph Maud has written about the combustion required to release consciousness. Raven, he observes, "is a force which needs both human and bird form in order to complete the creation of the polymorphous perverse world as we know it."[6] I imagine the combustion to be equivalent to the energy released by fission. The release of human consciousness was a declaration of independence from the world. Yet its glories, and they are many, are matched by an intense yearning to re-enter and dissolve into the timeless flow of universal Oneness. Like the timeless humans in the clamshell, however, one cannot go back. Raven unleashed the self, and like its liberator it will not be denied. Human consciousness is creative and destructive in equal parts. The enduring concern of Hasidic master Yehudah Leib Alter was with how a people might return to the state of Oneness that existed at the beginning. It would require something like another act of fission. The perpetuation of the human world, he believed, was entirely dependent on the ability of human consciousness to return to the state of universal Oneness, to the seamless moment of creation. This, he said, would require nothing less than the union of human and divine energies.[7]

A clamshell is a section of a circle. Its lip is the arc of an incomplete circumference. Each carries a metonymic charge. "If we look at the world in the form of a circle," writes Robert Davidson, "let us look at what is on the inside of the circle as experience, culture and knowledge: let us look at this as the past. And if we look at the circle as the edge of a knife, the edge is the present moment. It is that thin line that we live on, it is that thin line that divides the past from the future. What is outside

the circle is yet to be experienced."[8] The shape of Edenshaw's three Fungus Man platters may not be a coincidence, for what is outside each of their circles is more important that what is within them. Their circumferences exist solely to be breached by the amorous Raven and his harpoon. As a corollary, perhaps, to the vision of the Hasidic master, sexual desire – embodied in Raven – will become the chaotic, anarchic, subversive machinery of perpetuation. Songs of love, after all, are filled with images of the divine.

Does Raven have an inner life? I have wondered about his solitude. He is, in the beginning, entirely alone. Might he have been looking to liberate from that reef, *Tsaw Gwaay.yaay*, a complement, a counterbalance to his own impulsive nature: a wily adversary, a rival, and an ally? Perhaps one can learn something from a transformation mask made by Charles Edenshaw and collected by the Anglican minister Charles Harrison in Massett in 1891. Harrison described it as a raven "with an Indian standing on top and a human face in miniature in the centre of the forehead. The symbolism it was intended to convey being the raven as the creator or perhaps the original ancestor of man, and the raven's male slave." The figure on top of the mask that rises up when the beak is opened is not a slave, according to John Swanton, but a revered chief. In *Contributions to the Ethnology of the Haida* (1905), also published as *The Haida of Queen Charlotte Islands*, Swanton confirms that the mask was made by "Charlie Edensaw of Masset," and writes that "The outer figure is Raven as a bird; the inner, Raven in human form." The inner figure wears a labret. As Robin Wright has noted, it is a female face. In *Contributions to the Ethnology of the Haida*, Swanton describes three horn spoons in which Raven is depicted "when he went about in the shape of a woman, his feminine character being shown by the labret."[9] The figure revealed when the beak opens on the transformation mask implies that Raven's complementary female self is within; Raven is male and female, with the power of each – and how could Raven's female aspect

be anything but sympathetic to the pleas of the two women on the shore, and to quest for the *tsaw* on *Tsaw Gwaay.yaay*?

As a carver, Edenshaw was a sophisticated master of the northern formline, a travelling, shaping, enclosing line that generates and contains while providing thrust and movement. His work is often identified by twinned formlines that bring contraries into harmonious tension through a ceaseless exchange of energies. Writing about the work of Robert Davidson, curators Bill McLennan and Karen Duffek observe that he "views the formline as the 'skeleton' of the composition, within which 'energy fields' can be directed by creating and balancing positive and negative spaces." They continue: "[Davidson's] awareness of space – either defined within a shape or surrounding one – extends beyond formal concerns to the cultural and ceremonial space within which the composition is meaningful." [10] This is a critical insight. Davidson's work, and by extension the work of all Haida carvers going back to Charles Edenshaw and long before, is never created in isolation. Davidson's formal investigations, which can be regarded as lessons in philosophy, engage the past and expand the frame of contemporary Haida art, but he is aware that the work's reception in the community will determine its meaningfulness. Harmonious forms act physically and spiritually upon the mind and body, helping to return balance to the individual and to the community.

A glance at the platters reveals that Edenshaw was guided by similar principles. Each platter is divided horizontally with the sky above and the sea below. The horizon line corresponds to the waterline of each canoe. The canoe acts as an intercessor between the sea and the sky, a role for which it is well suited, being a fusion of nature (cedar) and culture (the human hand, eye, and will). It's a vessel made for crossing boundaries – through all dimensions – and in each case it has been carved with the slightest hint of three-dimensional perspective so that the bow appears to be approaching the onlooker. While the figures in the canoe may be said to reveal naturalistic elements, Edenshaw

has engraved each canoe in the formline tradition with the faces, limbs, and fins of actual and supernatural creatures. The bow of each canoe is carved with the head and body elements of an aggressive animal that bares rows of fierce teeth. Each vessel is charged with the power of these guardian creatures; all are implicated in the journey dedicated to bringing male and female together for the first time.

In the Haida world, creatures with supernatural powers shift from one being to another ceaselessly and can assume aspects of multiple creatures simultaneously. Raven on the three platters is a marvel of multivalence. He is bird *and* human; when he takes off his scales and feathers, he assumes human form. His arms on the Dublin platter, for example, are human with eye ovoids at the shoulders. His hands and his chest are human, but his legs and wings are fledged and he has talons. He has human eyes and eyebrows, and a long beak. On each platter he wears a complex hat that becomes a killer whale's dorsal fin. The dorsal fins have circles or rings on them – three on the Seattle platter, four on the Dublin platter, and on the Chicago platter the ring may double as an eye, or may only represent an eye, of a killer whale.

On the same platter, Edenshaw has provided Raven with thick, swirling hair. His hat floats on the hair and its brim is a grinning mouth filled with upper and lower teeth, suggesting the killer whale whose fin completes the headpiece. On the Seattle platter, what appear to be the snout and beak of two animals form the brim; they share the same two eyes and ears. The brim of the Dublin platter is shaped partly by the head and beak of a bird which resembles Raven himself. Curiously, the Seattle and Dublin platters suggest that Raven has tresses, or tight curls such as one would find on a magistrate's wig. On the Seattle platter, Raven has two thick streaks running down his right cheek, which likely represent face paint applied to ensure the success of his voyage. Two similar streaks appear on the left cheek of a mask acquired in 1879 by British Columbia's first Superintendent of

Indian Affairs, Israel Wood Powell. It is said to have belonged to a Haida shaman, although it may have been made for sale.[11]

Powell appears to have been particularly interested in Haida masks. He may have been drawn to their participation in ceremonial events and their role in secret societies because he was himself a high-ranking member of a secret society, the Masonic Lodge. The Haida masks he acquired in 1879 are preserved in the Canadian Museum of History in Ottawa,[12] as are two striking silver bracelets he purchased, attributed to Charles Edenshaw and featuring Raven.[13] Powell also acquired argillite pieces for the Geological Survey of Canada that were later transferred to the National Museum in Ottawa.[14] Between 1880 and 1885 he assembled a staggering 791 Northwest Coast objects for the American Museum of Natural History (AMNH), including a sixty-four-and-a-half-foot canoe. Among the pieces in the AMNH collection, catalogued by Franz Boas, were an additional twenty-three Haida masks.[15] Powell also acquired for the museum works by Edenshaw, including a Beaver frontlet and a much-admired cane with a carved ivory elephant's head.[16] It's significant that Powell did not create any further collections for the museum. Is it possible that he recognized a conflict of interest between his official duties and his collecting activity? He did come to believe that "ethnological specimens" should remain in Canada. In a letter to the director of the AMNH he wrote, "I should not like to undertake another work of this kind, and when looking at them this morning I rather felt guilty of want of patriotism in sending the collection out of the country."[17]

When the Governor General, the Marquess of Lorne, and his wife, Louise, were planning a tour of British Columbia in 1882, they expressed a wish to visit Indigenous villages on the coast. Powell was asked to arrange a trip, and when they arrived in Massett he introduced them to Charles Edenshaw. As the daughter of Queen Victoria, Princess Louise was treated as royalty. According to Thomas H. Ainsworth, she was presented with "Chief Edensaw's acknowledged masterpiece, a wonderfully

carved casket, wrought with hoop iron and the spokes of an old umbrella." Ainsworth reprints an account originally published by anthropologist Charles Hill-Tout in 1932:

> In conversation with Chief Edensaw of that settlement, Her Royal Highness expressed a wish to possess some specimen of his workmanship; Dr. Powell thereupon purchased two black slate caskets from the Chief, paying him $400.00 for the pair.
>
> One of the caskets he presented to the princess, and the other he gave to his wife. Unfortunately the casket given to the princess, owing to imperfect packaging, was broken into several pieces on its way to Ottawa, and was so badly damaged as to be quite beyond repair.[18]

In fact, the casket, or chest, as it's now called, was repaired in London in 1891–1892 and is now in the Glenbow Museum in Calgary. The one belonging to Mrs. Powell was given to the Museum of Vancouver. Although the lid on the Museum of Vancouver chest was carved by someone else, the lion motif on the two long sides suggests the British Imperial lion as well as the lions rampant of the Governor General's personal coat of arms.[19] With dimensions of twelve inches by twenty inches, the chests are substantial, and if one or both of them, were commissioned for the viceregal couple, it would suggest that by this time a relationship was in place between Edenshaw and the Superintendent of Indian Affairs.

As early as 1873 Powell had recommended that the B.C. government acquire Haida art and establish a provincial collection. His suggestion was rejected.[20] A small, underfunded museum was eventually established in Victoria in 1886, which, "from time to time … afforded space for the safe-keeping of donations to the Ethnological Collection."[21] Thousands of significant works in the meantime left British Columbia for museums in Berlin, New York, Chicago, and elsewhere. Over the years small

amounts of money enabled the provincial museum to purchase a few collections, including several objects belonging to "Chief Edensaw." In the 1909 guide to the museum's collection, the curator pleads for resources: "Since the last Catalogue was issued, in September, 1898, there have been added over three hundred and ten specimens, many of them valuable exhibits. It is difficult to display these specimens as they should be, as the collection is greatly crowded, and has outgrown the space allotted to it." [22]

Given the frantic scramble by collectors and institutions to remove every article considered to be of monetary or cultural value from the Northwest Coast, it is tempting to see Raven's firm stance in the bow of the canoe as a defiant reaction to the Haida's loss of cultural heritage during the nineteenth century. After all, Raven is the progenitor and defender of the realm. When we encounter him, however, he is preoccupied with his mission. As if to enhance its effect, his spear has an oversized blade. From platter to platter, it is subjected to only minor alterations, although the hands or claws holding it are in each case in a different attitude. On the Chicago platter the spear is carved with a pleasing sense of perspective and the angle of the shaft rhymes with the angle of the Fungus Man's paddle. Raven's wings, inscribed with Northwest Coast formlines, U forms, and ovoids, are reminiscent of the outstretched wings of an angel on a medieval religious panel. On the other two platters the wings spread out to the side. Only on the Seattle platter do we see Raven's realistically engraved tail. He approaches his prey with his long pointed harpoon or spear raised at an angle – the carnal joke is surely intentional – and his consternation, as he nears the reef, is palpable. In the stern, temporarily forgotten, the helmsman has apparently lost control.

3 | DA.A XIIGANG

The outline of Charles Edenshaw's life may be familiar to many. He was born in the village of Skidegate on the north island of Haida Gwaii in about 1839, and died in 1920, the year the first commercial passenger flight took place in Canada, a nation that did not exist when he came into the world. His mother was _Ḵàaw kuunaa_ of the _Staa'stas_ Eagle clan. His father, _Tl'aajaang ḵuuna_ of the _Naay Kun Ḵiigawaay_ Raven clan (Those Born at Rose Spit), was the son and grandson of a chiefly family.[1] By means of a series of potlatches, the boy received ten names, the first of which, _Da.a xiigang_, can be translated as Noise in the Housepit. He was also called _Sk l'wxan jaas_, which translates as Fairies Coming to You as in a Big Wave. The tenth name, _Nang ḵwi.igee tlaa.ahls_, means They Gave Ten Potlatches for Him.[2] It was during these potlatches that _Da.a xiigang_ received the tattoos of his crest figures. His daughter Florence Edenshaw Davidson recalled, "He had no clean skin he was so tattooed. Even his back, his arms, his legs, his chest, his hands were tattooed. I don't remember all the crests he's got tattooed, just eagle, sea wolf, and frog."[3]

Da.a xiigang's father, who was reputed to have been a fine carver and canoe maker, died while *Da.a xiigang* was still young. As a teenager, in the Haida village of <u>K</u>'*áayang* (*Kayang*), *Da.a xiigang* apprenticed himself to his uncle, Albert Edward Edenshaw, and his uncle's brother-in-law, Duncan *Ginaawaan*, both highly accomplished carvers and workers of metal.[4] Florence Edenshaw Davidson recalled the year that her father first took up the carving tools:

> My father started carving one winter when he was sick. When he was about fourteen he was sick all winter long. He was in bed, but he got some argillite and started carving a totem pole. He was so sick he didn't want to eat anything, but his mother had an iron pot and she put hot water, seaweed, and grease in it, and she made my dad eat it. In May he got better. He took a walk and something came out from his chest right up his throat. He spit it in the creek. It looked like a devilfish with legs on it. That's what made him sick, and as soon as he got rid of it he got better. After that he carved his first bracelet, out of five silver-dollar pieces melted together. Later, after he married my mother, but before my time, he used to go to Victoria and carve all winter long.[5]

In his early thirties, *Da.a xiigang* married a fifteen-year-old girl named <u>K</u>*wii.aang*, later also known as Isabella, who was born into the Yahgu'laanaas Raven clan in the Kaigani Haida village of *Hlan<u>k</u>wa'áan* (Klinkwan) on Prince of Wales Island, Alaska, in 1858. <u>K</u>*wii.aang* had encountered sorrow early in her life; both parents died when she was four years old. In her memoir, her daughter Florence Edenshaw Davidson describes the harrowing sequence of events:

> Smallpox came from Victoria. On the way home where the people camped overnight, some would get sick and they'd leave the sick ones there. It spread all over the islands. Both

of my mother's parents died in the smallpox epidemic and my grandmother's [Amy's] parents, too. They were going home to Kiusta from Masset. My mother's parents were on one canoe, my grandmother's on the other. There were some other people from Kiusta with them. They stayed overnight at Jalun River and put up cedar-bark tents. They were supposed to leave right away the next morning, but they took sick. They all got sick at once … When [my mother's mother] Ílsgide took sick, she went into the water up to her chest. Then she went back to the lean-to where they had built a big fire. She went underneath her blanket and right away she went to sleep and died.

My "grandmother," Amy, was about ten years old then. She was really Ílsgide's sister, but ever since I can remember my mother never told us Amy was her aunt; we used to think Amy was her mother. Amy and my mother and Wiba, my mother's playmate, were the only ones who didn't take sick. My mother's parents bought a playmate for my mother because she's alone, the only child. Wiba's parents were slaves, but my mother's parents bought her so my mother would have someone to play with; they didn't buy her for a slave. They were going to adopt her. The little girls were playing on the beach when their uncles, Gináwen and Kilgúlans, came by from Masset on their way to Klinkwan [Alaska]. Amy's father saw the canoe landing and told them not to stop because they were all sick; he didn't want them to catch smallpox. The uncles grabbed the two little girls, my mother and Amy. Wiba was a little ways from them, and they couldn't get to her because [Amy's] father had a gun. He was shooting at them, trying to kill them because they took the two girls. When my mother talked about Wiba she used to cry. Wiba ran after them but they couldn't rescue her because Amy's father had the gun. She got left there and she wasn't even sick. I guess she died with the rest. They

were all wiped out; no one was saved from there. [Amy] used to tell me the story of it when I was little.[6]

When they grew older, the girls were taken to live with relatives in _Ḵ'áayang_. Florence Edenshaw Davidson recalled that "Albert Edward [Edenshaw] potlatched for the girls because they were orphans. He married my grandmother [Amy] and adopted my mother [_Ḵwii.aang_/Isabella] as his daughter. He had a big pole raising and _waɫaɫ_ [potlatch] for the young girls." It was at this potlatch that _Ḵwii.aang_ was tattooed with her crests: "she had a long dogfish on one leg, a grizzly bear on the other, and a quarter moon and lady on each arm. The tattoos were done in red and blue."[7]

Soon after their marriage in the mid-1870s, _Da.a xiigang_ and _Ḵwii.aang_ moved from _Ḵ'áayang_ to the village of Massett so that he could continue his apprenticeship with his uncle Albert Edward Edenshaw and where he had inherited a longhouse. According to notes provided by Marius Barbeau, he'd already held a potlatch where he'd declared his intentions: "Massett is our ancestral home. All my people died away from here. That is why I returned to Massett. I wish to be one of your people, to marry and live here … All my people were hunters, but I am a silversmith (_ladzoolá_). To be a silversmith is my trade."[8] In time, _Da.a xiigang_ also inherited the chiefly position and with it the name _'Idansuu_, or Edenshaw.[9]

In 1884, _Ḵwii.aang_, _Da.a xiigang_, and _Da.a xiigang_'s uncle and mentor, who was known by the name _Gwaaygu 'anhlan_, were baptized into the Anglican Communion. _Gwaaygu 'anhlan_ chose the Christian name Albert Edward. In an address delivered in Massett on July 7, 1991, _Da.a xiigang_'s great-grandson Robert Davidson describes how the other names were chosen:

> Our chiefs at that time equated themselves with the royalty
> of England. When Charles was baptized and given his Eng-
> lish name, he asked to be named after one of the princes,

Bonnie Prince Charles. His wife was named after Isabella, and they used Charles's Haida name, "7IDANsuu" as his surname and it became the derivative Edenshaw. And when his wife was given the name Isabella Edenshaw, she did not accept Edenshaw as her surname. She said, "How can a Raven woman have an Eagle name?" Isabella was from the Yahgu 7laanaas, Raven moiety, and Charles from the Sdast'ass, Eagle moiety. There are many other stories like this, where when the two cultures came together, there was confusion.[10]

Florence Edenshaw Davidson recalled that the Anglican missionary, Rev. Charles Harrison, played a crucial role: "My mother didn't read so Mr. Harrison mentioned lots of names to her. When he said 'Isabella,' she said 'yes.' He told her it was a queen's name; that's why she likes it, I guess." Indeed, she was not enthusiastic about taking her husband's name: "When the missionary called my mother Isabella Edenshaw, she wouldn't take the 'Edenshaw' for a long time. She couldn't understand it; 'How can I take Eagle's name?' she kept asking. Finally she gave up."[11]

Kwii.aang gave birth to eleven children; four lived to become adults. The loss of their son Robert through drowning in 1896 at the age of eighteen was by all accounts a terrible blow.[12] _Kwii.aang_ typically spent the winter in Massett making hats, baskets, and other woven objects. _Da.a xiigang_ would design and paint crest figures on the hats, exacting work on an uneven surface. Then, according to Florence Edenshaw Davidson, "What my mother wove all winter long she sold in June when we went to the mainland to work in the canneries. She sold her work at Cunningham's store in Port Essington [_Spaksuut_]. She used to get five dollars for a finely woven, painted hat. Mr. Cunningham paid her cash for her work and she bought our winter coats there. Mr. Newcombe used to come here from Victoria to buy things from my parents, too."[13] _Kwii.aang_ reserved the best hats for Newcombe, who was purchasing for museum collections. In the words of James Hart,

"Charles carved; Isabella wove. This was their station in life. They were both born into these very treasured, very guarded and very prestigious responsibilities. These things were not open to the public to do. They both witnessed the beginning of the breakdown of Haida Way, Haida Law, Haida Prerogatives." [14]

Among his peers, and in the generations before and after his, there were superb carvers, but when *Da.a xiigang* died in Massett on September 12, 1920, at the age of eighty or eighty-one, his name had become synonymous with Haida art. His work had earned him an international reputation. His "slate carvings" had been invited to the groundbreaking *Exhibition of Canadian West Coast Art: Native and Modern* at the National Gallery of Canada in 1927, and were featured the same year at *L'Exposition d'art canadien* at the Musée du Jeu de Paume in Paris. [15] After his death, *Da.a xiigang*'s carving tools were passed on to his nephew Charles Gladstone, a carver of silver and argillite and, it's said, an expert boat builder. He was also the artist Bill Reid's grandfather. In 1943, when Reid was a young man in his twenties, he visited Gladstone for the first time. As their relationship developed and they grew closer, Reid became increasingly absorbed by Haida culture, and by 1951 he'd committed himself to becoming a designer of contemporary jewellery. It was soon after, when his great-aunts showed him two silver bracelets made by his great-granduncle *Da.a xiigang*, that he began to turn his mind toward the formal ingenuities of Haida art. [16]

During their long lives, K̲wii.aang and *Da.a xiigang* survived a relentless series of colonial assaults that tested the resilience of Indigenous people up and down the Pacific Northwest Coast. Their communities experienced the full impact of a mechanized, legitimized, rapacious imperialism that reached around the planet. [17] At the time that *Da.a xiigang* was working on the Fungus Man platters in the late 1880s, the Japanese journalist Tokutomi Sohō published a bestseller entitled *The Future Japan* in which he warned his readers about what they could expect from

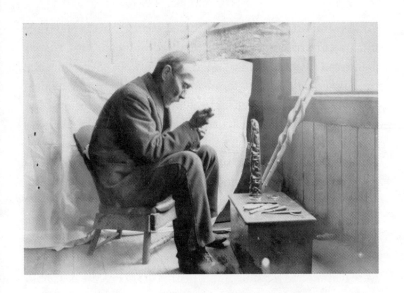

Illus. 1. Charles Edenshaw at work, Massett, Haida Gwaii, n.d., RBCM PN 5168

Westernization: "Those blue-eyed, red-bearded races will invade our country like a giant wave, drive our people to the islands in the sea."[18] For the Haida, the giant wave of imperialism included the aggressive thrust of gunboat diplomacy, territorial dispossession, industrial capitalism, religious conversion, the invasion of European and North American migrants, and the relentless efforts of legislative governments to extinguish Haida language and culture. In the 1860s, smallpox, followed by measles epidemics, reduced the Haida population from approximately twenty thousand to six hundred souls, a loss of more than 90 percent.[19]

When, in 1912, Emily Carr visited the abandoned Haida village of *Hlkinul Llnagaay* (Cumshewa), she marvelled at "a great wooden raven mounted on a rather low pole; his wings were flattened to his sides," and, nearby, its mate. She describes the scene in her memoir *Klee Wyck*: "His mate had sat there but she had rotted away long ago, leaving him moss-grown, dilapidated, and alone to watch dead Indian bones, for these two great birds had been set, one on either side of the doorway of a big house that had been full of dead Indians who had died during a small-pox epidemic."[20] The great bird was memorialized in a studio watercolour entitled *Cumshewa* (1912) produced soon after Carr returned to Victoria. Its haunting presence must have remained with her. Almost twenty years later she revisited the memory of the catastrophe to produce one of her iconic Modernist works, *Big Raven* (1931).[21] She wrote in her memoir, "The memory of Cumshewa is of a great lonesomeness smothered in a blur of rain."[22]

After the epidemics, many of the survivors moved to Massett and Skidegate, where they began to reconstruct their lives. Missionaries were by this time active on the coast, and when the community invited an Anglican minister to establish a congregation in Massett in 1876, many were introduced to the Church of England doctrine and the material advantages of late Victorian culture.[23] The Methodists in turn founded a mission at Skidegate, and by 1894, to one degree or another, the Haida were nominally

Christian. The potlatch – central to their social, legal, and cultural continuation – had been outlawed by the Dominion government's "Potlatch law" of 1885, and the churches actively discouraged any sign of its renewal. Looking back on this period, Florence Edenshaw Davidson recalled: "Before I was born they did away with all the totem poles, just one standing by the road, a great big one. I saw a few others, too, but I don't remember where. The minister came around and made everyone cut all the totem poles down and burn them." [24] Families became more integrated with and dependent upon the new economy and the old ways went underground. Large public ceremonies gave way to smaller feasts. The protocols required by the mortuary potlatch were met within the Anglican memorial service. The last memorial pole of *Da.a xiigang*'s generation was erected in 1890. [25]

Although they did not learn to speak English, *Da.a xiigang* and *Kwii.aang* became devout Anglicans and attended services at St. John's Anglican church in Massett, where Florence attended Sunday school. The religious impulse in the family was strong. *Da.a xiigang*'s cousin Henry Edenshaw (*Kihlguulins*) – Albert Edward Edenshaw's son – was a lay reader, a Sunday school teacher, and the missionary's assistant. He taught at the Massett Indian School and contributed significantly to a Haida translation of the New Testament. [26] (A note by Henry Edenshaw affixed to the back of one of the Fungus Man platters, discussed later, provides compelling evidence that the platters are by *Da.a xiigang*'s hand.) *Da.a xiigang* was also active in church affairs. In 1901 he showed John Swanton a copy of Rev. John Henry Keen's *The Gospel According to Saint Luke in Haida* that he carried in his pocket. [27] *Kwii.aang* was fond of singing the English words to Anglican hymns while weaving her spruce-root hats. [28] In her memoir, Florence remembered her father warning her, "Someday the world's going to end and the bad ones are going to get punished." [29] I've looked to see if this apocalyptic idea is evident or implicit in any of his works, but his theological beliefs do not appear to have entered into his carving and painting. Still,

he practised his devotions every day. Florence recalled her father beginning each morning with a prayer:

> Ever since I can remember I'd go with my dad to watch him carve. Wintertime he used to work in the shed behind our house. When we were all grown up he started carving in the house. As soon as he finished breakfast he'd be ready to go out and I'd be ready to go with him. He sat on a little armchair with the legs cut off so it was low to the ground. He had a little box beside him where I used to sit. Soon as he sat down at his carving table, he'd take off his cap and he'd pray every morning. That's why I used to go out with him; I enjoyed his praying so much. When he was through, he'd start carving. I'd sit there for a while and I'd say, "Dad, I'm going now," and he'd say, "Oh." Kindly, he said it.[30]

4 | TRADE

In the minds of nineteenth-century colonial settlers fleeing poverty, dispossession, and persecution in England, Scotland, Ireland, and Europe, western Canada appeared to be both a vast, uninhabited territory and a land of opportunity. An industrious young man, it was said, could establish a healthy, prosperous life for himself and his family in its forests and on its prairies. A new nation promised a new beginning. The British Empire needed a secure supply of food, so farmers were welcome. Overseas investors in resource extraction were looking for cheap labour. A system based on British customs, culture, and laws would be introduced. English would be spoken. Social position would be respected – and quite possibly enhanced. An ideal immigrant from the Old Country would understand these sorts of things.

Canada's future, as envisioned by the Dominion government and the provinces, did not include Indigenous people. Ottawa established a Department of Indian Affairs, whose goal, as evidenced by legislation passed over the years, was cultural assimilation of the First Nations. Indigenous people became wards of the state. Beginning with the pre-Confederation Gradual

Civilization Act of 1857 – which offered an Indigenous person citizenship in exchange for his or her status – the government sought to accelerate the process of assimilation by establishing reserves, hiring Indian agents, illegally limiting freedom of movement, and, in collaboration with the religious establishment, building residential and industrial schools dedicated to eradicating language, culture, and family ties. Concurrently, a settler economy driven by commerce, individualism, and wage labour introduced Indigenous men and women to capitalism. Dominion and provincial governments promoted the exploitation of natural resources and a system of legally entrenched inequality and racism. By the time *Da.a xiigang* was in his fifties, the Indigenous nations of Canada were living on reserves that offered few opportunities for economic development, trade, or traditional hunting and gathering. Stewards of an ancient culture with its own systems of governance, its own spiritual practices and, on its own terms, active economic ties to its neighbours, the Haida found themselves increasingly dependent on imported commodities marketed by an aggressive, globalizing economy. Wealth was becoming concentrated in the hands of families and corporations that actively exploited the labour of immigrant and settler populations on land that had once belonged to Indigenous communities.[1]

Haida culture did not disappear; memory and knowledge do not work that way. It is clear that many Indigenous people kept the old ways and beliefs alive in their hearts and minds. The body does not forget how to dance. Florence Edenshaw Davidson recalled that when she was a girl in Massett during the first decade of the twentieth century there were many occasions when dancing, often with masks, took place: "Wintertime when I was small they used to dance so much: The *s'aʕgá* [shaman], they called the dances. They just did them for fun so they don't forget them. Some used to wear masks but after white people come around here they cleaned out all the masks. Too bad I didn't learn the songs."[2]

As carvers and painters, *Da.a xiigang* and his peers took it upon themselves to preserve the Haida genius for formal invention and with it the intellectual legacy of Haida thought. Storytellers passed on the oral histories to their families and communities, and, through translators, or via the trade language known as Chinook Jargon, to linguists and anthropologists. These exchanges, often undertaken on behalf of museums, were recognized as being mutually beneficial and led to early orthographical strategies and publication in prestigious anthropological journals. Is it not perverse, however, that a system bent on assimilating and erasing Indigenous cultures would also rush in to seize their children, "salvage" their ceremonial objects, their teachings, their poetry, and their customs, all the while expressing disgust and asserting moral superiority? Or was this simply a matter of the victors opportunistically accumulating cultural, personal, and financial capital? Certainly, the transition from the old ways to the new was irreversible. In Indigenous communities throughout Canada, the experience of betrayal and feelings of deep grief persist.

Human beings are also resilient. Along with gunboats, discrimination, and disease, the settlers introduced trading opportunities, wage employment in resource industries, and new technologies. By the end of the nineteenth century, the Haida had equipped their largest canoes with masts and sails made of cedar bark or canvas. Their journeys took less time and the big canoes were able to transport up to twenty thousand kilograms of goods.[3] Gasoline engines soon transformed coastal travel – and along with it the fisherman's existence.[4] Communities were no longer as isolated as they had been. Canneries, mills, and salteries appeared, as did towns with stores, churches, and hospitals. Tourists and merchants arrived, and Haida artists immediately took advantage of their hunger for trophies and souvenirs. The skills associated with the production of clothing, tools, boxes, baskets, weapons, totem poles, ceremonial regalia, and masks that had once blended utility

and beauty with crest figures soon found another outlet in the burgeoning tourist and collector's market.

By the early decades of the nineteenth century, Haida artists were actively producing goods for sale to British, European, and American traders, sailors, and naval officers. The delicately carved and painted masks of a high-caste woman produced on Prince of Wales Island in southeastern Alaska by an artist known as "the Kaigani Master," sold to ship's captains and merchants in the 1820s, are now prized by the few museums that hold them.[5] The most popular trade item in the early days was the slate or argillite pipe. The Haida had cultivated their own tobacco for ceremonial purposes, but it wasn't until after contact that they began to smoke it in wooden pipes. Before long, because the material was easier to carve and because it responded so well to a playful imagination, the pipe carvers shifted from wood to the black slate. Once visiting merchants, traders, seamen, and other travellers laid eyes on these ingenious, extravagantly carved pipes, they immediately wanted them for themselves. The Rev. Jonathan S. Green, anchored off Rose Point at the northern tip of Rose Spit aboard the barque *Volunteer* in June 1829, offers us a glimpse of a meeting with the Haida:

> Here they manufacture, from grass, hats of an excellent quality, some of which they value as high as two dollars. Their pipes, which they make of a kind of slate-stone, are curiously wrought. They are fierce for trade, bringing for sale fish, fowls, eggs, and berries, and offering them in exchange for tobacco, knives, spoons, carpenter's tools of various kinds, buttons, and clothes.[6]

The carbonaceous shale known as slate, or argillite (_kwaa s'alaa_),[7] is found only on Haida Gwaii, and the location of the seam, near *Tllgaduu Gandlaay* (Slatechuck Creek)[8] is carefully concealed from outsiders. By order-in-council on May 7, 1941, the Dominion government, responding positively to a petition by

the Skidegate band, set aside a 43.81 acre reserve on the side of Slatechuck Mountain for their exclusive use.[9] As black as a raven's back, argillite takes on a deep, lustrous polish and is both soft and hard enough to carve the most delicate lines. Anthropologists Peter Macnair and Alan Hoover note in *The Magic Leaves: A History of Haida Argillite Carving* that early ceremonial argillite pipes were "shaped like either a cockle or a clam shell, sometimes with a personified siphon extending beyond the shell as a stem. The earliest documented example is in the Peabody Essex Museum, accessioned in 1829, in the form of a clam shell with a human face, surrounded by a winged corona on either side."[10]

The clamour for more inventive designs, including the ingenious incorporation of the stem and bowl, led to ever more elaborate and fantastic tableaux. The carvers began to include supernatural creatures from the Haida narratives, establishing a figurative form that soon manifested itself in amusing representations of the colonial customers – men with top hats, missionary ladies, sailing ships, and other examples of the fractious, entitled, and invasive Other. Robert Davidson was struck, when he studied these pipes, by the wave of radical innovation in the mid-nineteenth century, and the lost momentum with the arrival of smallpox, telling Karen Duffek, "I don't know if they had a dialogue about what they were doing, but they were developing these new ideas, these new directions, and then the rug was pulled out from under their feet."[11]

Those who survived kept going. Their skills and the market kept evolving. Sailing ships and wooden steamboats disappeared. Marine technology improved and a fleet of mail and supply boats established regular runs among the coastal communities. Some carvers turned to the production of argillite bowls and platters modelled after British and European china and silver

tableware. Victorian floral and border designs offered new challenges and generated hybrid works made to appeal to buyers in search of souvenirs or gifts. *Da.a xiigang* found inspiration in images from newspapers and magazines. The collector James G. Swan purchased an elephant-headed cane from him in 1883, noting in his diary that he had paid ten dollars. *Da.a xiigang* had carved the head from walrus-tooth ivory, adapting it from an illustration in the *London Illustrated News* published on February 25, 1882. In a later diary entry Swan noted: "I found on questioning Charley that … the elephant was from a picture of Barnum's Jumbo, representing the hoisting on board a steamer when bound to New York." [12]

By the mid-1880s, tourists were cruising up the coast to Alaska on their holidays through the coastal villages. Each summer, as the ships arrived, women waited on the wharves with carvings, baskets, and a range of "curios" as passengers poured down the gangplank looking for souvenirs. Those venturing farther afield would find a "trading post" or "curio store" where dealers bought and sold year-round, often to customers in the south, or a trading company like Cunningham's in Port Essington where *Kwii.aang* and *Da.a xiigang* sold their work. Woven baskets were immensely popular with European and North American tourists and, as the Arts and Crafts movement extended its reach, they became fashionable in certain well-appointed homes – and for good reason. They were intricately and carefully made by hand using traditional techniques and traditional dyes. Their shapes were organic and harmonious; their patterns were sophisticated and symmetrically pleasing. They carried the scent of natural fibres; they could be used to store yarn or other goods. Promoting the sale of "traditional handicrafts" by Alaskan Tlingit women in the 1880s, missionary Carrie Willard noted that, "The large basket which they use for carrying water makes a good waste-paper basket." [13] Because travellers were told that they were encountering the last generation of weavers trained in the old ways, the baskets were regarded as collector's items. While this may have

increased their value, the cost was still low. And while travellers on the Alaska cruises that put into small ports and cannery towns were hungry for authenticity, they were also hungry for bargains.

How the French Surrealists would have loved to walk those wharves and scan the "trading posts" in search of masks, rattles, bowls, spoons, blankets, baskets, and ceremonial objects. This was a vision that sparked Wolfgang Paalen's mission to the Northwest Coast. From my remove, however, I can only guess at the experience of a basket maker or carver of tourist commodities during the late nineteenth and early twentieth centuries. For many women, producing and selling baskets and other goods provided the cash they needed to support their families. The seemingly relentless technologies of the newcomers had irrevocably altered Indigenous people's way of life, and yet what the tourists wanted most desperately were trophies and souvenirs of their domestic and ceremonial lives prior to the appearance of the white man. What must it have been like to be told that the best argument for purchasing your goods was that you, your children, and your skills were expected to soon disappear?

The example of the Frohman Trading Co., located in Portland, Oregon, provides an insight into the commercial side of the "curio" business. Operated by Mrs. F. C. Frohman, supplied in part by her husband's trading store in Wrangell, Alaska, and selling wholesale and retail, the store's 1902 catalogue is peppered with promises of authenticity.[14] The foreword notes that the company's "basket room" always has on hand "from 1000 to 1500 baskets." It does appear that the "old baskets," those made for use and not for sale, were becoming scarce. In 1903, Charles Newcombe told the director of the Field Museum in Chicago that old Salish baskets had become "an extreme rarity." At the time, the Indian agent at New Westminster, British Columbia, was buying every basket he could find in the Fraser Valley and selling them directly to Mrs. Frohman.[15] In the words of the catalogue:

The Alaskan baskets, which are a specialty with the Frohman
Trading Co., are the most artistic and decorative of all Indian
handiwork; being quaint in color and wonderful in design.
The Indians of the present day are making but few baskets,
the art of weaving is dying out with the younger genera-
tion and it is only a question of a few years when it will be
impossible to obtain desirable specimens ... Any article of
disputed authenticity is immediately discarded.[16]

The final note is significant. The proliferation of cheap fakes
is a long-standing tradition in the curio trade, and must have
posed a serious threat to Frohman's business. In the days of
Apollinaire and Picasso, for example, French sailors returning
from the colonies were known to have passed their days at sea
carving and polishing fake African sculptures to sell when they
arrived back home.

In the 1902 Frohman catalogue, Haida baskets with covers
were priced from $4.00 to $8.00 (all figures in U.S. dollars). Many
had rocks woven into the knobs on the tops so that they would
rattle. The company also offered painted and carved cedar "Pot-
latch or Ceremonial Boxes" ($10.00–$50.00). The list of "Alaska,
Esquimaux, and British Columbia Indian Curiosities" include
"Stone Pipes" ($1.00–$5.00), "Alaska Silver Bracelets and Rings"
($1.00–$2.00), "Alaska Seal and Bear Teeth" ($.25–$.50), and
"Carved Slate – Doctor's Charm" ($3.00–$5.00). A "Carved Slate
Totem Pole" would sell for considerably more: $15.00–$20.00.
It's not clear if these are retail or wholesale prices, but they give
us a sense of how much – or how little – the makers of these
objects would have earned from a sale. Thomas H. Ainsworth,
in a 1950 article, notes that in 1905 the going rate paid to a Haida
carver for an argillite totem pole was thirty-five cents an inch.[17]
Many of the "curios" manufactured for tourists were adapted for
the trade, some based on conventional or traditional designs,
like "Arrow Heads" and "Alaska Halibut Hooks," and others, like
the "Ivory Cribbage Board" and the "Indian Heads, painted on

leather," in response to the novelty market. Carved and painted wooden paddles were evidently popular, as were totem poles carved and painted in wood.[18]

We get a glimpse into the curio trade in an illustrated journal created by Emily Carr during a journey to Alaska with her sister Alice in 1907. It was on this passage north that Carr encountered totem poles for the first time and conceived of the project that consumed over twenty years of her life: the painting and sketching, in situ, of every remaining totem pole on the Northwest Coast. This ambitious artistic undertaking allowed Carr to gain a certain understanding of the Indigenous cultures of Alaska and British Columbia. The 1907 journal, however, reveals the profound separation that existed between Indigenous and non-Indigenous cultures at the time, a separation that continues to this day in many respects.

The journal also shows how silly and punchy one can become with a beloved sibling or friend when on vacation. Before leaving Sitka, Alaska, Emily and Alice decided to shop for "curios." The two were often giddy in each other's company and took great pleasure in conspiratorial inside jokes. The journal makes fun of the eccentric guests and travellers the women met, but almost no mention is made of the Indigenous people whose home territories they were visiting. I have retained Carr's spelling and punctuation:

> As the day of our departure from Sitka drew near, we betook ourselves to the Indian village, and procured a curio or two as momentoes of our happy trip, and offerings for our friends; sister purchased a bird of melancholy mein so resembling herself she had difficulty in restraining her emotions, a sad faced seal-dish, and other trifles: while an Indian tom-tom, a brow strap of bears claws, a deer-hide, and eagles leg, rendered me joyously hillarious; my chiefest delight being a hollow bear's tooth, through which I could whistle tunes, secular when surrounded by ordinary mortals, sacred when in the presence of "St. Juno."[19]

As she began visiting Indigenous villages on the coast, Carr became more sensitized to the experience of the people she met. *Da.a xiigang* would have been sixty-eight when Emily and Alice sailed past Haida Gwaii in 1907, and it's possible that she caught a glimpse of him in Massett when she returned to paint in the villages of *K'áayang* and *Yaan 'Lngee* in the late summer of 1912.[20] It's impossible to know if she was aware of *Da.a xiigang*'s renown, or that his generation of carvers had raised Haida art to a sublime level. She does not record meeting with contemporary Haida artists. She did, however, depend upon missionaries on her early journeys up the coast, and often expressed a low opinion of their narrow-mindedness. Dedicated to eradicating all forms of what they regarded as devil worship, resident missionaries often expressed their concern to the Indian agents when carvers turned to the commercial production of painted and decorated masks. The agents, in response, argued that the carving and painting of souvenir masks enabled a man to make a living. A compromise was finally reached. As the Haida carver Freda Diesing explained to anthropologist, curator, and art historian Peter Macnair: "My granny told me the missionaries encouraged [my great-granduncle *Stilthda*] to make masks [to sell] on the condition that they would never be used at dances or potlatches."[21]

During what is considered to be his most productive period, between about 1880 and 1910, *Da.a xiigang* was regularly in communication with anthropologists Franz Boas and Marius Barbeau, linguist John Swanton, and museum collectors George Dawson, Lieutenant George T. Emmons, and Charles Newcombe. He produced a number of model argillite poles at the request of the Indian agent at Massett, Thomas Deasy.[22] Alan Hoover notes that Newcombe would commission works in argillite for *Da.a xiigang* to carve during the winter months, and

return to pick them up in the spring: "[Florence Edenshaw] Davidson is recorded as saying that Newcombe used to tell her father 'what to make and [when] he was coming for it.' She is emphatic about the fact that her father never carved argillite for Haida people."[23]

Throughout his life *Da.a xiigang* produced jewellery for sale to travellers and visitors, and regularly carved special pieces of jewellery for family members and others in the community, obtaining the silver by hammering out American silver dollars.[24] Jewellery making was a dependable way to make a living, especially when he and *Kwii.aang* began to have children. Barbeau quotes a recollection of Charlie Thompson of Massett: "When he started to raise a family, silverwork is all he was doing, carving silver, making bracelets, rings, ear-rings. He never used to do that work here, but did in Alaska, sometimes in Victoria, in Rivers Inlet once in a while."[25] Florence Edenshaw Davidson recalled that her dad:

> used to get orders for things, poles, and jewellery, and he would work on them all the time. When my mother went to work in the cannery my dad would stay home to work on his carving. When I was little we went to Ketchikan summers so my dad could carve and my mother work at the saltery there. When my dad finished his work he'd always tell me, "I'm going to sell my things," and I'd wash my hair and put clean clothes on. I'd get ready real quick and I wouldn't play around after so I could be clean when I went to town. The people would give him money for his work and we'd go to the grocery store. "Dad, can you give me five cents?" I would say. He always gave me a quarter.[26]

Margaret Blackman tells us that *Da.a xiigang* and *Kwii.aang* often passed the summers in Juneau, Alaska, where he carved and sold his work. When they travelled with children, it was more common to move to one of the cannery communities

such as Port Essington or Inverness on the Skeena River, or to the Alaskan canneries at New Kasaán and Ketchikan. In the words of Robert Davidson, *Da.a xiigang* "spent his whole life carving, his whole life creating. Wherever he went, he was creating. When they went fishing he brought his work. He had such a mastery of all mediums that it was a joy, it still is a joy to look at his work."[27]

5 | THREE ARGILLITE PLATTERS

Da.a xiigang's three *Galaga snaanga* platters are rarely exhibited together. The 2013 exhibition at the Vancouver Art Gallery provided a glorious opportunity to study them side by side.[1] Comparing the faces of the three startled helmsmen, I was reminded of *The Scream*, by *Da.a xiigang*'s contemporary, the Norwegian Edvard Munch. Painted in 1893, shortly after the platters were carved, Munch's expression of his own distress has come to represent the suppressed anguish and rage lying beneath European civilization. Like the helmsman, Munch's wraith-like figure addresses the view directly. I would nominate as well Wolfgang Paalen's wood sculpture *Projét pour un monument* (*Project for a Monument*) of which there are two examples. The first, made in 1945, is taller than the other, which was carved in 1948.[2] Each sculpture consists of an elongated, upright ellipse fixed to a semi-elliptical wood stand as if balancing on one of its pointed ends. Although the works are formally abstract, the eyes and mouth, which forms a long oval scream, are not, creating a powerful tension in each piece – and an undeniable expression of dismay.

The opportunity to look from one *Galaga snaanga* to the other raises a question about chronology. Which platter came first? There is no evidence that they are sequential. Although they are clearly variations on a theme, there is no indication of a formal progression. The Seattle and the Dublin platters share similar elements; one might guess they were carved in proximity, at much the same time. The Chicago platter is unlike the other two in terms of the formal organization of the figures in the canoe and the nature of the creature beneath it. Those who have considered the chronology have tended to assess formal sophistication, the assumption being that *Da.a xiigang* would have become more adept over time at solving the formal problems presented by each of the tableaux. Perhaps he gained a deeper insight into the nature and the motives of his characters from platter to platter.

Two scholars – Bill Holm of the University of Washington's Burke Museum in Seattle, and an artist in his own right, and anthropologist Alan Hoover, who worked for many years at the Royal British Columbia Museum in Victoria – believe that the platter at the Field Museum in Chicago shows the most maturity.[3] A case can also be made that the Chicago platter is the earliest, although the choice of which of the two remaining platters is more recent – the platter in the Seattle Art Museum, or that in the Ethnographic Collection of the National Museum of Ireland in Dublin – will depend on highly refined observations, and, I would imagine, personal experience as a sculptor or jeweller. The chronology might be more apparent if we had a clear idea of why he carved each of the three platters. Was it his initial intention to make three?

The Chicago platter was donated to the Field Museum in 1894, and is identified, cautiously, as being "pre-1894" in the Vancouver Art Gallery's exhibition catalogue.[4] Peter Macnair provides a date of ca. 1890.[5] Poet Robert Bringhurst identifies its date of completion as ca. 1880, and adds a title: *The Raven and His Bracket-Fungus Steersman*.[6] The platters in Seattle and Dublin

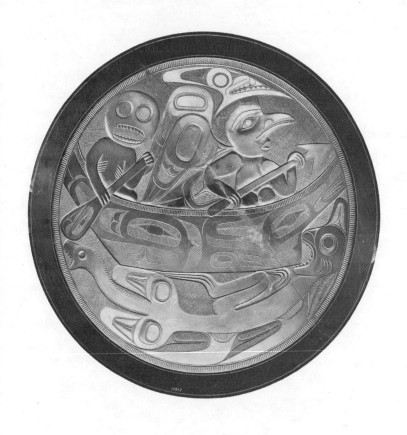

Illus. 2. The Chicago Platter: Charles Edenshaw, argillite platter, 35.2 × 5.8 cm,
 Field Museum, Chicago, 17952

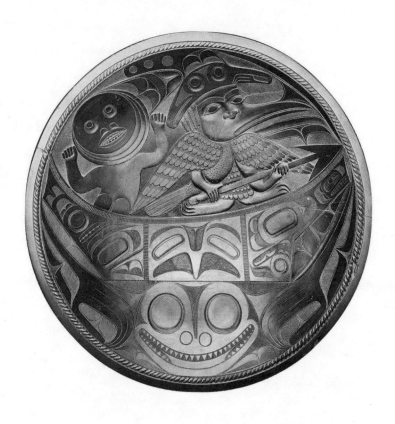

Illus. 3. The Seattle Platter: Charles Edenshaw, argillite platter, 32.9 × 5.7 cm,
Seattle Art Museum, Gift of John H. Hauberg, 91.1.127

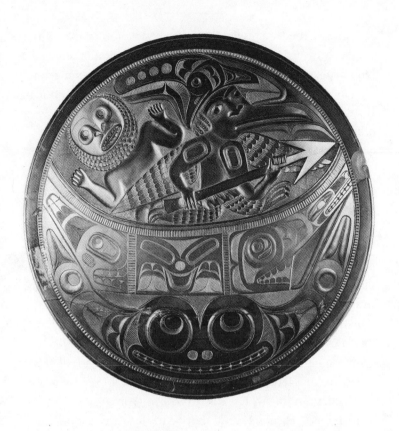

Illus. 4. The Dublin Platter: Charles Edenshaw, argillite platter, 31.8 × 5.7 cm,
National Museum of Ireland, Ethnographic Collection,
Dublin, AE:1894.704

are dated in the Vancouver Art Gallery catalogue ca. 1885, a date which agrees with Macnair's assessment.[7] Bringhurst places the Dublin platter at ca. 1892.[8] On the evidence of its catalogue number (1894.704), one may assume that it entered the collection in Dublin in 1894.[9] Bill McLennan and Karen Duffek settle for "late nineteenth century" for each of the platters.[10]

Also attributed to *Da.a xiigang*, and worthy of our admiration, is the wonderful little engraving of Raven and *Galaga snaanga* on the silver ferrule of a cane in the Pitt Rivers Museum at the University of Oxford. The miniature scene shares several elements found on the platters. The gunwale of the canoe is illustrated, and stamped for effect, but the canoe itself is without decoration. The winged Raven, who wears a hat that becomes a killer whale's dorsal fin, has raised his spear. Beneath the bow and the stern of the canoe as they meet on the cylindrical sea is a strange and threatening creature. It has a circular head, round eyes, and a fierce mouth filled with teeth, and like the helmsman it stares at the viewer, breaking the fourth wall. It has a long, narrow, tapering body, and what at first appear to be four petals surrounding its head. Are these fins, or rays or haloes of light? If it is a talisman, could they be the leaves of a four-leafed clover? *Galaga snaanga* is wedged in the stern with his knees tucked up as on the Seattle platter. His bony ribs are visible, as they are on the Chicago platter, and his arms appear to be flapping, as if to say, "I may be doomed," and perhaps to catch our attention.[11] Is he grimacing, or smiling, or possibly both at the same time? Who, in his position, would not be equally terrified, elated, and perplexed?

Alan Hoover's intriguing 1983 article "Charles Edenshaw and the Creation of Human Beings" proposes a chronology based on *Da.a xiigang*'s formal achievement in terms of design integration and narrative cohesion. He argues that the Chicago platter is the most accomplished and therefore the most recent. In the following passages, Hoover refers to the *tsaw* as a combination of chiton and female genitalia, an English equivalent

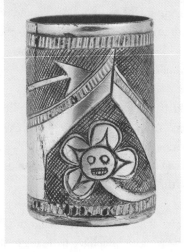

Illus. 5. Three views, Charles Edenshaw, cane ferrule, pre-1929,
silver, 2.7 × 1.8 cm, Collection of Pitt Rivers Museum,
University of Oxford, 1929.7.1

for the Haida expression. The supernatural aspect is implied:

> The design of the [Chicago platter] is more integrated, dem-
> onstrating a high degree of narrative interconnectedness
> among the major images: Raven is inside the canoe; Fungus
> Man is paddling the canoe; the Chiton/Vulva is attacking
> the canoe. This cohesiveness of design is contrasted in the
> separatedness of the same images that comprise the design
> of the plate in the National Museum of Ireland: Raven here
> is on top of the canoe, not in it. Fungus Man has no paddle,
> and his function as steersman is not stated; the Chiton/Vulva
> is not clearly connected with the canoe or its two occupants.
> Although closely connected imagistically to this artifact,
> the [Seattle] plate illustrates a more advanced degree of
> design integration. The most noticeable, and perhaps only,
> improvement in overall design integration is the placement
> of the Fungus Man solidly in the stern of the canoe, clearly
> separated from the Raven figure.[12]

He concludes with the certainty that the Chicago platter "is
a more mature composition than either of the other two arti-
facts." He also draws attention to Bill Holm's observation that
over time *Da.a xiigang* further integrated the design by moving
toward abstraction:

> On both the National Museum of Ireland and [the Seattle]
> plates, Raven's wings are depicted naturalistically, their sur-
> faces covered by feather motifs, whereas the wings of the
> Field Museum Raven exhibit typical abstracted Northwest
> Coast designs. The legs of the Raven figure on the plate in
> the National Museum of Ireland are fully feathered and
> one foot exhibits scaled claws. In contrast, the legs of the
> Raven figure on the [Seattle] plate are unfeathered and the
> claws are portrayed in a more abstract fashion. The abstract
> quality of the claws of the Chiton/Vulva image was also a

factor in Holm's judgement that [the Seattle] plate is later than the artifact in Dublin.[13]

McLennan and Duffek rate the three platters according to "relative complexity of detail and the relationship of elements within each composition." In their estimation the Chicago platter is regarded as being the least complex. They reserve special admiration for the Dublin platter, writing, "Here the carved image is at its most complex, both in the overall composition and in the elaboration of detail,"[14] although they do not hazard a guess at the chronology. Leslie Drew and Douglas Wilson, in *Argillite: Art of the Haida,* also draw attention to the Dublin Raven, observing that "greater emphasis has been placed on the transformation aspect of the harpoon-holding, supernatural figure."[15] One of the anatomical puzzles faced by *Da.a xiigang* on each of the platters was how to accommodate wings and arms on the supernatural Raven's body. He is human and bird simultaneously, and his wings and limbs must be contained within the circumference. This problem is partly solved on two of the platters by providing Raven with more human attributes.

Raven on the Chicago platter is more man than bird. He has a beak and a mouth, and no feathers on his body, although an abstracted feather shape extends from his right elbow consisting of a U form followed by tapering lines that meet. His hands are talons. Attached to his neck or back are the two angel-like wings with ovoid eyes – one eye parallel to the horizon and the other vertical. His knees appear above the gunwale.

On the Dublin platter the wings extend from his back and on both platters one can see his arms and shoulders clearly, although as McLennan and Duffek note, "the Raven's shoulders continue to be represented as though both arms were attached to the front of the body."[16] He has feathered legs and claws.

On the Seattle platter, Raven is more bird-like than mortal. He seems to have a double chest, one of which is feathered, one of which is spotted. He has a bird's tail and bird's claws, although

he is equipped with a human nose as well as a beak. In keeping with the avian manifestation, *Da.a xiigang* places his wings more or less where they would be on a bird; the human arms appear rather mysteriously from beneath the wings, a solution we must accept, for Raven is supernatural. He is transformation incarnate. His touch is an apocalypse.

Holm's observation that the abstraction on the Chicago platter represents a chronological step beyond naturalism is intriguing, and accords with Tahltan-Tlingit artist Dempsey Bob's belief that "all great art goes into abstraction."[17] In some respects the Chicago platter is the most conventional, which may suggest that it represents *Da.a xiigang*'s first engagement with the narrative material. *Galaga snaanga*, for example, is where one would expect him to be, hunkered down in the stern with his paddle. The figure below the canoe is depicted as a threat only, whereas on the other two platters its intentions are more ambiguous, inviting a more subtle interpretation of Raven's situation, which is to say that the round, grinning face, echoing the rings on the dorsal-fin hats and the shape of the platters themselves, is not an immediate threat to the canoe but an existential threat to the fragile foundations of masculinity and paternity.

Formally, while the wings on the Chicago platter are carved with abstract designs, they resemble transposed angel's wings, and though they fill the space allotted they remain static and separate and are not yet integrated into the flow of the overall design. The formline carving on the wings and the canoe is elegant and spare, it's true, and beautiful to behold, but it does not feel integrated into the narrative. Similar elements are recombined to much more dramatic and interpretive effect on the Seattle and Dublin platters. On the Chicago platter, Raven's face is a slightly awkward combination of human and avian features – he has a mouth and a beak – whereas on the other two platters the face seems to be more resolved with human forehead, eyes, and nose, and a long beak below them. The Chicago *Galaga snaanga* sits nervously in the stern.

The blade of his paddle is about to strike the posterior head of the creature below the canoe. Graphically speaking, the expression on his face is by far the most memorable of the three. The formal arrangement of the characters is perhaps the most pleasing as well, less chaotic, if slightly static. It is a portrait frozen in time, and in this it resembles a photograph taken with a flash. On the Dublin and Seattle platters, *Galaga snaanga* has lost his paddle and is about to tumble overboard, which adds a dramatic touch to the tableaux. The narrative has advanced slightly in time. This creates a feeling of motion, of a story unfolding. The reappearance of the winged, finned, leering creature below the canoe on both platters, along with the similarities in the other figures and details, suggests that *Da.a xiigang* was during their creation refining rather than altering his ideas. This may be an argument for the Dublin and Seattle platters – along with the more complex, integrated, and subtle carving on each of them – as the more recent. It is difficult not to see them as a pair.

Each of the platters excites its own moments of wonder and recognition in those who see them. The subtlety and dynamism of the carving on the Seattle platter suggests to me that it is the "finest" in terms of workmanship, while the graphic power of the Chicago platter is admirably direct and unforgettable. The Dublin platter is the only one to show Raven glancing at the struggling *Galaga snaanga* in the stern. This look establishes an emotional connection between the two, and because it suggests character development, should it be an argument for the Dublin platter as the most recent? As an artist returns to a subject in a series, and resolves formal problems, the implications of the relationships portrayed become increasingly apparent. With Raven's backward glance on the Dublin platter, we catch an unexpected glimpse of that supremely independent and confident bird's self-conscious vulnerability. It is a moment of truth, an unsummoned admission that even Raven – the boaster, the incorrigible thief and seducer – must learn to trust and depend on the goodwill of others.

6 | BELOW THE CANOE

"All Raven lineages," writes anthropologist George MacDonald in *Haida Art*, "use forms of the Killer Whale as a crest; one of them, the Raven-Finned Killer Whale, refers to the myth in which Raven pecked himself out of the body of a Whale through the end of its dorsal fin." [1] In Haida culture, killer whales are chiefs of the sea. Each is associated with a specific village in the ocean, and identified by certain markings or, often, by rings on the dorsal fin. On each of *Da.a xiigang*'s platters, Raven's beaked hat becomes a killer whale's dorsal fin; on the Seattle platter it has three rings, on the Dublin platter it has four rings, in each case signifying an important undersea chief. The undersea world, which was present long before the first rocky wedges of land broke the surface of the waters, is similar to the terrestrial world. When the killer whales, salmon, seals, and other sea creatures return to their marine abodes, they slip out of their skins and assume their human forms.

MacDonald notes that among the Haida the killer whale's dorsal fin has been symbolically regarded as a world axis. [2] The implication, as McLennan and Duffek propose, is that

the backs and fins of killer whales are "mediating zones that rise above and submerge beneath the surface of the water, and so unite the cosmic zones of underworld, earth, and sky world."[3] Each of these cosmic zones is represented on the platters: Raven is of the sky, *Galaga snaanga* is of the land, and the figure below the canoe is of the underworld, more particularly the undersea world. The concept of the world axis is central to each of *Da.a xiigang*'s tableaux, for Raven is like a dorsal fin himself, rising symbolically out of the sea in his canoe in order to unite the three zones through the union of male and female. In their cleaving together, male and female will assure the perpetuation of the human race.

I'd like to look closely at the figures beneath the canoes. Robert Davidson has said that they embody the spirit of *tsaw*, or *tsaw sgaanagwaay*, the power of female sexuality, and one must understand them in this light.[4] The grinning faces on the Dublin and Seattle platters do seem to be taking great delight in the experiences of the two "males" in the canoe above them. Terri-Lynn Williams-Davidson explains that, while this story is meant to be amusing, it has an important instructional purpose; it is told by women "to teach about the power of female sexuality, and therefore, respectful conduct of men to female sexuality."[5] The "men" in the canoe are feeling the full impact of this power. *Galaga snaanga*, who should be safely tucked in, is about to be blown overboard by its force.

Da.a xiigang's interpretations of *tsaw sgaanagwaay*, however, pose intriguing questions. The figure on the Chicago platter is frightening. It has claws and fins, two heads – one with dogfish cheeks – a tail, and a quasi-human body. Its mouths are wide open and reveal rows of rounded teeth, reminiscent of those on Raven's killer-whale hat. One of the mouths is about to take a bite out of the canoe's cutwater. The two pointed fins on its back are compressed against the edge of the platter, and a dorsal fin rises from its larger head. Its tail has two prominent whale-like flukes, and the long serpent or phallic eel with a mouth emerging

from between the flukes, as if they were legs, is alarming to say the least. Interestingly, the "serpent" is trying to bite the inside edge of the platter, perhaps trying to escape. This may be a scary kind of men's joke, a familiar joke in which the penis, as the lone character on the male sexual proscenium, is indiscriminate, headstrong, and, some would say, endowed with a mind of its own, while being fearful of physical and emotional rejection in the force field of women's sexual and matrilineal power. Taboos around menstruation in Haida culture provided women with powers that were said to be capable of hampering a man's skills as a hunter or a fisher, affecting his ability to provide for his family. "Once women change their life," Florence Edenshaw Davidson observes, "they [men] are scared of them." [6] *Da.a xiigang*'s image of *tsaw sgaanagwaay* on the Chicago platter seems to contain all the old ambiguity of men toward female sexuality. This may explain why the figure possesses both female and male attributes. *Da.a xiigang*'s image of *tsaw sgaanagwaay* on the Chicago platter seems to contain all the old ambiguity of men toward female sexuality. This may explain why the figure possesses both female and male attributes.

The Seattle and Dublin platters each offer a provocatively grinning face, defined by wings or fins on either side outstretched along the circumference of the platters. At first glance, with their big round eyes, these creatures appear to be related to frogs, but they have prominent teeth, like sculpins. The creature on the Seattle platter grins directly at the viewer, and, like the bracket-fungus steersman, breaks the theatrical fourth wall. The Dublin platter's creature has more of a frog-like face, with clenched teeth, very pronounced pectoral fins on either side, and eyes that glance up at the scene in the canoe, bringing a wicked sense of mirthfulness to the proceedings. After all, there is something ridiculous about the solemnity of the quest. Significantly, the Seattle and Dublin creatures each have a *V* carved into their foreheads. Above them, amidships on each of the canoes, *Da.a xiigang* has carved what appear

to be associated faces contained within rectangular frames. On the Seattle platter, the beaked face within the rectangle may represent a bird; its eyes appear to be crying. On the Dublin platter, the face in the rectangle appears to be laughing, perhaps at the expense of the two characters in the canoe.[7] Tellingly, perhaps, each of these two faces also has a *V* cross-hatched into the brow.

What is one to make of these mysterious creatures? I have wondered if *Da.a xiigang* took inspiration for his representations of *tsaw sgaanagwaay* from a mutable undersea figure whose appearance portends good luck. His motif can be found on food containers, chests, house fronts, bowls, and on other surfaces such as screens and partitions, often in very different design styles. He has existed since the beginning of the universe, and his name, borrowed from the Tlingit *Gunaakadeet,* is *Konankada,* the Master of Souls and the Chief of the Undersea World.[8]

Unlike the supernatural manifestations of familiar birds and mammals who can remove their pelts and feathers to reveal human forms, *Konankada* appears to exist only on the supernatural plane. His image often bears simultaneous attributes of terrestrial, avian, and marine animals. He is many in one, and one in many. In *Haida Art*, George MacDonald quotes the museum collector Lieutenant George Emmons who recorded narratives among the Tlingit on the north coast in the early part of the twentieth century:

> The belief in the mythical being Gonaqadet [*Konankada*] occurs along the whole coast. He lives in the sea, and brings power and fortune to all who see him. Sometimes he rises out of the water as a beautifully painted house-front inlaid with much-prized blue and green haliotis-shell (abalone), again as the head of an immense fish or as an elaborately painted war-canoe. In decorative art he is generally represented as a large head with arms, paws and fins.[9]

In Haida narratives, \underline{K}onan\underline{k}ada is also the grandfather who has been present since the beginning of the world. In the version of \underline{X}uuya \underline{K}aagang.ngas told by Haida storyteller Sgaay, the world in the beginning is nothing but ocean. Soaring over the waves, Raven spies a place to perch on what today is called Flatrock Island, or k'il, at the southern tip of Haida Gwaii. There he discovers supernatural beings with long necks lying on top of one another. The weaker ones are fast asleep, like orphaned babies; they seem listless and dozy. He leaves them there and flies up into a village in the sky, skins an infant, and conceals himself in its skin. As a baby he's well loved and coddled, but yearns for solid food, so he steals out at night to pluck eyes out of the faces of his neighbours. Returning each night to the house of his unsuspecting parents, he drops an eyeball into the ashes of the cooking fire, and later, when he bites into the lightly roasted delicacy, it makes a distinctive popping sound. One night he sneaks in with a juicy one, warms it up, and when he takes a bite, it bursts! His family is awakened, and having discovered the ruse, they toss their false infant into the waves below.

Soon, Raven hears a voice. A "pied-billed grebe" invites him to meet his "mighty grandfather" at the bottom of the sea. Grebes are accomplished divers. In Henry Moody and John Swanton's translation of this story, the grandfather says, "Enter my son. Word has arrived that you come to borrow something from me." The old man sends him for a box that contains five smaller boxes. Handing Raven two stick-like cylinders from the smallest box, the grandfather turns to him and says, "I am you." Raven doesn't follow the old man's instructions at first, but when he does, placing the sticks into the ocean, the cylinders spread out to form large land masses. One of these is \underline{X}aayda\underline{g}a Gwaayaay, or in the Massett dialect, Xaayda Gwaay ("The Islands at the Boundary of the World"), and the other is the mainland of what is now British Columbia.[10] The supernatural beings on k'il immediately spring into action and swim over to Xaayda Gwaay, where they make their home.[11]

The grandfather who sent the grebe to fetch Raven also manifests himself as the Chief of the Undersea World and is identified as *suu sgaa.n*, a name associated with the Sea Wolf, or Wasgo (*'waagu*).[12] He is a consumer of whales, and he takes on attributes of beavers, grizzly bears, humans, killer whales, wolves, and sculpin. Portrayed with fins, he is related to the Sea Wolf or the Sea Grizzly, a figure seen on several of *Da.a xiigang*'s silver bracelets and one of the crests tattooed onto his skin when he was young.[13] The two-headed figure on the Chicago platter manifests a number of these attributes simultaneously. On chests, boxes, and on house fronts, *Konankada* often appears, in George MacDonald's words, as a looming being "with a small body and an inordinately large, broad head that has a cleft in the forehead."[14]

We know that *Da.a xiigang* was familiar with *Konankada* because in 1901, to fulfil a commission, he created a detailed model of his uncle Albert Edward Edenshaw's "Myth House" (*K'iigangng*) for John Swanton. The figures on the frontal pole are associated with the story of *suu sgaa.n*; the interior house screen with its circular entrance hole depicts *Konankada*. Swanton's field notes read: "the painting on the house screen is of a kind of sk.il that was called qo'nequde [a Tlingit word, *gunaakadeet* meaning 'wealth giver from under the sea']. Something shaped like a house appeared out of the water to one who was going to become wealthy."[15]

The figures looming below the canoe do not resemble house fronts, but the *V*-like clefts in their brows – echoing the cleft in the forehead of the figure on *Da.a xiigang*'s model interior house screen – may imply that they are meant to be seen as manifestations of *Konankada*. If *Da.a xiigang*'s intention on the platters was to associate the spirit of *tsaw* with *Konankada*, then their double appearance must be regarded as the best possible omen. If *Konankada* is present in these tableaux, it may suggest that Raven is fulfilling a prophecy set in motion when he visited the grandfather at the bottom of the sea, a prophecy that anticipates the coming of human beings as the completion of

creation. Should Raven enter time, the power of *tsaw sgaanag-waay* that attracted him will be released. A nation will be created, houses will multiply, names and lineages will be declared, laws will be promulgated, ceremonies will begin, minds will process memories, and the voices of little ones will ring out on the beaches. The faces in the rectangular frames on the canoes may anticipate the joys and woes to come.

On each of the platters, Raven, the bracket-fungus helmsman, and the spirit of *tsaw* may be seen as three vertices of an inverted equilateral triangle. Their triangulation, or theatre of three, determines the platter's circumference, which is to say the bounds of the known universe. With the potential strength and steadiness of a tripod, they hold the fate of the world in their hands, claws, talons, teeth, and fins. They are all that stand between creation and oblivion. On two of the platters, the figure who is meant to keep the canoe steady is losing his balance. Should he tumble overboard, the quest will fail. The Haida world will be stillborn. I have a sense, however, that the spirit of *tsaw*, with its powerful force, is a kind of talisman, a reminder of the enduring reciprocal bond between the human and the supernatural worlds.

The appearance of *tsaw sgaanagwaay* as talisman may have meant something more urgent and immediate to *Da.a xiigang*. He carved the first *Galaga snaanga* platter less than twenty years after the first devastating waves of smallpox, and the disease had not yet been eradicated. In a letter to Franz Boas in June 1901, John Swanton wrote, "I have just learned that small-pox has broken out in Alaska, and has been brought to the Skeena. Charlie Edenshaw has been quarantined." Families were still in peril. The few hundred who survived the first epidemics had been struggling with depopulation and the collapse of family, social, and governance structures. In order to reconstitute themselves within the transition to colonial modernity, they

needed strong sons and daughters. The scenes on the platters may have raised knowing smiles, but *Da.a xiigang*'s themes of fertility and renewal would surely have resonated with those striving to rebuild their communities. Seen in this light, the platters themselves may be seen as talismans dedicated to the perpetuation of the Haida Nation. *Da.a xiigang* cannot have carved them without thinking of his family and the children he and *Kwii.aang* had grieved for over the years.

And what is one to make of the idea that the perpetuation of humanity depends on the interplay between a randy bird (*Corvus corax*), an anthropomorphic bracket fungus without a paddle, and a manifestation of female sexuality so powerful that it feels like a supernatural force? The scenario implies that evolution is governed by hazard, caprice, and unbridled appetite. And yet *Da.a xiigang*'s platters project a sense of bemusement. To be bemused is to find oneself overtaken by a muse, by enchantment. And in the deep river of enchantment that is *Xuuya Kaagang. ngas*, there is a profoundly distilled account of life and its origins. *Da.a xiigang* may be asking us to recognize that the renewal of the world cannot proceed or succeed without the re-enchantment of the world.

In a story told in the mid-1970s by Antone Evan, a blind Inland Dena'ina storyteller, Raven tires of walking and decides to travel by water. He draws the outline of a canoe on a sandbar and, after kicking it with his big toe, a canoe appears.[16] Transformation becomes transportation. In *Sgaay*'s version of the quest for the *tsaw*, *Galaga snaanga* comes into being when Raven makes a series of marks on a bracket fungus. Raven creates something by imagining it. He transforms an inner vision into something sentient. *Da.a xiigang* may be suggesting that Raven – the transformer, the transgressor, the helper, the deceiver – is the first artist. Perhaps the Raven *Da.a xiigang* inscribed on the three platters is a self-portrait? Raven has his spear; the artist has his carving tools. *Da.a xiigang*'s platters transmit a message about the role of the artist within

the community and the responsibility of the artist to speak to the present. In their playfulness, the platters remind us that a world without enchantment will eventually succumb to the corruptions of time.

In 1978, Robert Davidson along with Reg Davidson, James Hart, Don Yeomans, and Gerry Marks carved four interior house posts for the Charles Edenshaw Memorial Longhouse in Massett and held a commemorating potlatch.[17] That same year his father, the artist Claude Davidson, produced a superb print that commemorated *Da.a xiigang*'s work in argillite. It was a reproduction of the Chicago platter that captured in two dimensions all the vitality and detail that *Da.a xiigang* had rendered in three. Speaking about the three platters in 1993, Robert Davidson reflected on *Da.a xiigang*'s achievement, the range of influences he internalized, and his formative years working as an alchemist transforming ideas from one medium into another:

> The fact that he worked in so many mediums actually helped to progress his art, like his jewellery technique, for example. Without his jewellery experience he wouldn't have been able to get such fine lines … it really affected his standard of workmanship. With Edenshaw, the fact that he did jewellery, everything was treated like jewellery.[18]

A jeweller is a miniaturist, recreating the world through analogy and metaphor. The door to the actual is through the imagination.

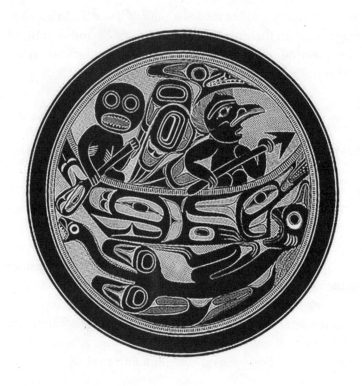

Illus. 6. Claude Davidson, print based on Charles Edenshaw
platter in the Field Museum, Chicago, 1978, silkscreen,
39.4 cm diameter, Estate of Claude Davidson

7 | THE BRACKET-FUNGUS STEERSMAN

Raven's exploits as trickster and progenitor provide plenty of opportunities for interpretation and double entendre. It's the helmsman, however – *Galaga snaanga* – who intrigues me, the one known as Fungus Man. All known visual representations of *Galaga snaanga* are the work of *Da.a xiigang* or are based on his original carvings. Like the other figures, *Galaga snaanga* undergoes transformation from platter to platter. Certain elements recur and seem fixed. He has a human body, but without nipples. (A feature of fungi?) On the Chicago platter, he has five ribs on each side of his chest; his face is a slightly flattened, slightly tapered oval, and he is seated in the canoe, using the paddle as a rudder. He has two huge round eyes without pupils and a wide-open oval mouth loaded with teeth. Teeth! If he's meant to be a newborn, which he also resembles, he's a menace to his mother. But he has no mother. *Galaga snaanga*'s face on the Chicago platter also bears a resemblance to the huge mask-like covers that were placed over the "head" on large Kwakwaka'wakw feast dishes. Representing the wide-open eyes and open mouth of the child-stealing giantess *Dzunuk'wa*, these lids were often embellished with bushy eyebrows, moustaches, and chin hair.[1]

On the Seattle platter, *Galaga snaanga*'s paddle has vanished and he appears to be falling back into the air with closed fists. His face and head are circular with what appear to be growth rings around the chin, and his pupils are rolling upward. The features on his face seem to be "drawn" on; there is no relief carving. He has nostrils, lips, and sharp teeth; his oval mouth tapers into points at the corners. This *Galaga snaanga*'s face is one-dimensional, as if he has not fully transformed into a three-dimensional figure. One might imagine him in the role of Raven's sidekick in one of Michael Nicoll Yahgulanaas's marvellous Haida mangas – and, indeed, he may already be present in a chapter of Yahgulanaas's dynamic, graphic-narrative version, "Raven Kept Walking." [2] What seems clear is that *Galaga snaanga* is signalling with his eyes that he no longer has control over the canoe – or over his own life for that matter. *Galaga snaanga* may be the first being in Haida history to experience a premonition of death – or is it a little death? For he who is charged with staying on course, who must guide the canoe across the choppy waters into the time-bound world, is experiencing an earth-shaking orgasm. His leader, in a similar state, is trying to keep his wits about him.

On the Dublin platter, *Galaga snaanga* seems to have grown a slightly Assyrian-looking fringe or beard. Terri-Lynn Williams-Davidson writes, "His chin is surrounded by a crescent halo of sparks flying from the *tsaw sgaanagwaay*, the supernatural genitalia." [3] He appears to be falling backwards out of the canoe. Raven has moved into the foreground. One of his delicately feathered wings and his equally delicately feathered legs conceal *Galaga snaanga*'s midriff and loins in a gesture of modesty. This *Galaga snaanga*'s face is carved in relief. It has an oval mouth filled with teeth that looks like a leg-hold trap, eyebrows, recessed eye sockets, bulging pupils, and a flaring nose. He continues to look at us in alarm as if pleading for help. His hands are raised, as if to recover his balance, or in surrender. Perhaps he's launching a silent scream.

On the Chicago and Seattle platters there is no interaction between Raven and *Galaga snaanga*. They appear to be independent of each other, although one could interpret Raven's expression on the Seattle platter to be something like mild disgust. He may be harbouring the suspicion that *Galaga snaanga* is not up to the job. On the Dublin platter, as mentioned earlier, Raven is alert to what is going on behind him. His pupils are directed at the stern of the canoe where *Galaga snaanga* is losing his balance, his mind, or both. I'm reminded of Haida artist Bill Reid's complex, monumental sculpture *The Spirit of Haida Gwaii, the Black Canoe*, installed outside the Canadian Embassy in Washington, D.C. In this moving work, a massive Haida canoe is stuffed to the gunwales with the supernatural figures of Haida history and headed for whatever the future may bring. Are they fleeing, or returning? It brings to mind one of the unexpectedly moving scenes in *Sgaay*'s telling of X̲uuya K̲aagang.ngas in Moody and Swanton's spare translation. Raven has been begging for companions to join him in his canoe. He turns down Blue Jay as being too old, but Blue Jay insists: "They all got then into the canoe. And it set off. It went. It went. It went. It went."[4] Raven, on this journey, is the helmsman.

If you look closely, you will find in the black canoe a solitary, pensive puller with hollow eyes, a cedar-bark hat, and a slightly bent back. He is a human figure, and Reid called him the "Ancient Reluctant Conscript," a title drawn from Carl Sandburg's poem "Old Timers."[5] The ancient reluctant conscript is the target of every tyrant's press gang, the universal grunt who cleans the stalls, gives and takes a beating, and pierces his brother's neck with a bayonet. On his weary back, the follies and glories of humanity have been achieved. His is another name for *Galaga snaanga*, who sought neither danger nor glory, who is pressed into service, who plays his part, and is never heard from again.

The apparent gravity of the quest for the *tsaw*, the omnipresence of the undersea creatures, and the nervous hilarity evoked by the vision of two "men" struggling with orgasms

as they approach the unruly "origin of the world," would have fascinated Sigmund Freud.[6] In 1885, about the time that *Da.a xiigang* was first creating the platters, Freud was in Paris at the Salpêtrière clinic studying male hysteria, the condition celebrated by poets André Breton and Louis Aragon as "the greatest poetic discovery of the late nineteenth century."[7] Then twenty-nine years old and under the tutelage of Professor Jean-Martin Charcot, Freud was an eager participant in his mentor's stimulating lectures on "the frequent occurrence of hysteria in men." Charcot had proposed that in some cases hypnosis might prove to be a promising therapy. He claimed to have produced "hysterical paralyses" in hypnotized men that revealed "the same features as spontaneous attacks, which were often brought on traumatically." Inspired by Charcot, and optimistic about using hypnosis in his own practice, Freud returned home to Vienna determined to undertake "a comparative study of hysterical and organic paralyses" in men.[8] What might he have made of the the erotic experiences of Raven and the bracket fungus? It may be worth noting at this point that the image of supernatural female genitalia with teeth has an ancient lineage in the annals of anxiety. The folkloric figure of the *vagina dentata* appears in cultures around the world, including the Maori, and may even find an echo in the chiton-like mouth of *Galaga snaanga* with its two rows of prominent teeth. I suspect that Freud might have found much to interest him on the Northwest Coast and in the laboratory of *Da.a xiigang*.

For all their technical and compositional virtuosity, and their humorous, psychologically intriguing portraits, the platters pose a vexing question. Why did Raven choose a bracket fungus to be the steersman in his canoe? Surely it was a job for a more skilled, experienced, and worldly creature, perhaps a bird or a clever mammal of some sort? And who exactly was, or is, *Galaga snaanga*, and why did a bracket fungus find himself involved in an expedition like this? Why was he successful when, as we shall discover in the oral history, each of Raven's

previous helmsmen failed? And is this a silent tableau? Is the helmsman mute, or is he crying out, and if he is, what is he saying? And who built the canoe?

The story of Raven and the Fungus, and the spirit of *tsaw*, is still passed down through the generations in Haida oral history and remains as potent today as it ever was. A silver bracelet recently made by Haida-Gitxsan artist Shawn Edenshaw, *Fungus Man Hiding in Ferns*, adds an intriguing narrative element to the story. Why is he hiding, and from whom? And why ferns? In *Sgaay*'s account of *X̱uuya X̱aagang.ngas*, as translated by Henry Moody and John Swanton, the story of the quest is reserved, appropriately, for the fifth and final section of the narrative. The fetching of the *tsaw* and the entry into time and history marks the end of one era and the beginning of another. The text concludes with Raven's marriage to Cloud Woman, his rudeness to her, the supernatural "birth" of his son named Lightning Played around his Knee Joints, and Raven's harsh rejection of the boy.[9]

In the Vancouver Art Gallery's *Charles Edenshaw* catalogue, Terri-Lynn Williams-Davidson contributes a contemporary version of the Raven and Fungus story told by her mother, *Gaajii'aawa*, Mabel Williams, who heard it from "her father, yaahl naw, Jimmy Jones, of the k̲adaasgu k̲iigawaay of Tanu." Williams-Davidson, a lawyer, the general counsel for the Haida Nation, and a celebrated singer and dancer, has written compellingly about the role of Haida origin narratives – the *K̲'aygaanga* – in identifying and determining the principles upon which to build a Haida legal system.[10] As indicated, this oral history has an instructional purpose, and I expect that it was included in the catalogue for good reason. John Swanton did not record any women's stories while he was on Haida Gwaii. I am one of those who until recently understood this story to be about creating or differentiating women and men at the beginning of time. In many accounts, the female genitalia are thrown at or attached to men and they become women. In *Sgaay*'s account, and in Mabel Williams's account, women already exist, as they

have since the arrivals of their ancestresses. So the longing for the *tsaw* is not a longing for the female gender but for something else, something that is missing. What does the story tell us?

Mabel Williams's words possess a wonderful immediacy; one can hear the whisper from eternity that hovers beneath her voice. She begins: "A long time ago women did not have a *tsaw*. All they had was a pee hole. The women asked Raven to help them and he agreed to get *tsaw* from t̲saw g̲waayaay. But after only a few paddle strokes he *xaawlagihl* – became sweet, collapsed and fell out of the canoe. The power of t̲saw g̲waayaay was too strong!" [11]

Raven enlisted help. He asked Junco to steer the canoe, but Junco, with his little dark helmet, also "became sweet" in the orbit of *Tsaw Gwaay.yaay*'s erotic tug. The same thing happened to Steller's Jay, the screecher, who likely made a terrible racket as they approached the reef and who also lost it (or found it) in the stern of the canoe. Returning to the beach, Raven was perplexed and disheartened by his failure, no doubt for mostly selfish reasons. Should he fail, the women would be hugely disappointed. They were depending on him! The humans – for whom, in a way, he was responsible – would perish without issue! More importantly, for a randy fellow like himself, life would be extremely dull without the *tsaw*. Mabel Williams continues: "Finally, Raven got galaga snaanga, or, Fungus Man, to help him. Raven wedged galaga snaanga into the back of the canoe to serve as *t'aan Gaad*, a steersman. When they approached t̲saw g̲waayaay, Fungus Man was also affected by its power, but he didn't fall overboard because he was wedged into the canoe. As galaga snaanga paddled he swayed side to side, rhythmically uttering 'unh, unh, unh, unh' and was able to get the canoe to t̲saw g̲waayaay." [12]

Mabel Williams's account is explicit about t the orgasmic consequences for the men in the boat as they approach *Tsaw Gwaay.yaay*. She includes no information about how Raven hired or acquired the Fungus Man, although she may know. We are told that despite being inert – the living part of a bracket

fungus dwells *inside* the tree – he also *xaawlagihl*, or became sexually aroused. And because he was wedged in, he didn't fall overboard, although as he paddled he "swayed side to side," rhythmically grunting, which perhaps should make us smile a little on his behalf. She continues: "When they returned to shore, two women were waiting: one Eagle Woman and one Raven Woman. One of the women immediately seized the larger genitalia. The other woman was saddened at receiving the smaller one, but Raven consoled her and told her, 'Don't worry; yours will always remain small and safe.'" [13] Raven's consoling, considerate words to "the other woman," an example of dramatic irony, will soon prove to be a false reassurance.

Mabel Williams's account is specific about Raven's early choices for a helmsman. Junco survives and is taken back to the beach; he wouldn't have survived a minute in that water. There's an indication, after the failure of Steller's Jay, that other creatures were asked to participate. All were found wanting. I've wondered why Raven chose birds to begin with. Yet it makes sense. Birds are trusted messengers between this and the other world. They're fierce, and fast, and aerial; their wings will lift them away from danger. Should the creature hovering in the sea below the canoe lunge at the boatmen, a bird would be able to take to the sky. And of course the Steller's jay is a cousin of the raven, perhaps especially the larger subspecies, *Cyanocitta stelleri carlottae Osgood*, that makes its home on Haida Gwaii. It occurs to me, however, that creatures with well-established habits and histories, despite participating in their supernatural forms, would also be limited by the abilities given to them, as often as not by Raven. Perhaps only a freshly animated being, unhindered by experience, compromise, or doubt, would be capable of bringing its full potential to the task at hand. The unpromising bracket fungus might be the most likely to succeed because, like Parsifal, the holy fool, he was the least likely candidate.

And what does the story tell us about the two women on the shore and their desires? I would say that they wanted to

experience every aspect of being women. They wanted to experience, on their own terms, the giving and taking of sexual pleasure, and the fullness of physical and emotional love. They wanted to embrace the joys and the heartbreaks that come with living in time: the thrill of anticipation, of being young and unafraid and driven by sexual desire, and of growing old in a loved body with one's children and grandchildren and great-grandchildren. For all the bawdiness that the story presents, it is meant to teach its listeners about female sexuality, about the loved and loving body. Unlike other stories in which "first men" are randomly outfitted with female genitalia, these women confidently ask for the *tsaw*. As Terri-Lynn Williams-Davidson has observed, this is a story about respecting the power of female sexuality,[14] and, I would add, about recognizing that love, not fear, is the way to mend what is broken.

8 | RAVEN TRAVELLING /
XUUYA KAAGANG.NGAS

Mabel Williams's account of Raven and *Galaga snaanga* being dispatched to collect the *tsaw* is a reminder that oral histories are not relics; they remain current and relevant. The earliest material examples of this story that exist are on *Da.a xiigang*'s three platters. It may also be found in the narrative known as *Raven Travelling*, or *Xuuya Kaagang.ngas*, recorded in 1900. Mabel Williams explained in her story why Raven chose a bracket fungus, but I have wondered if there are other attributes that might have made him a suitable helmsman. What more can be learned about him, and about his genesis? How was he transformed from fungus to Fungus Man?

Xuuya Kaagang.ngas was first transformed into a written text through the labours of linguist John Swanton. As a member of the Jesup North Pacific Expedition, sent out on behalf of the American Museum of Natural History, Swanton spent the fall months of 1900 in the Haida village of Skidegate recording the oral histories of the man known as John Sky, which was his

baptismal name. He was born *Sgaay* of the *K'una Ḵiigawaay* Eagle clan of *T'aanuu Llnagaay*, and when Swanton met him he was about seventy-two years old. He was a renowned historian and storyteller whose extended narratives, reaching back into the very beginning, were delivered with skill, subtlety, and a poet's attention to cadence and detail. His Haida name refers, appropriately I think, to the little spiral shell known as a periwinkle.[1] Swanton introduced *Sgaay* in a letter to Franz Boas, the head of the expedition, as "an old man in the village who has a crippled back but is admired on all hands to tell the old legends very correctly."[2]

In *A Story as Sharp as a Knife: The Classical Haida Myth-tellers and Their World*, Robert Bringhurst has provided a moving and detailed account of Swanton's apprenticeship among the Haida. He reproduces Swanton's first impressions on arriving at Skidegate, written to his mentor, Boas: "The island population is now shrunk to not over seven hundred, of whom three hundred are here. There is not an old house standing – all have modern frame structures with the regulation windows … The missionary has suppressed all the dances and has been instrumental in having all the old houses destroyed – everything in short that makes life worth living."[3] Soon after Swanton arrived, in the company of Charles Newcombe, he was joined by Henry Moody, a young man who came over from Port Essington on the mainland to teach and assist him.[4] Moody had been recommended by *Da.a xiigang*, who was an accomplished storyteller himself and who had been the first to instruct Swanton in the Haida language.[5]

Swanton and Moody worked together throughout the fall, listening to and recording recitations of Haida oral history. Bringhurst describes Moody's process: "His task was to listen to the poem and repeat it sentence by sentence in a loud, clear, slow voice, proving to the poet that he had heard each word and giving Swanton time to write it down."[6] Swanton listened carefully, writing down the sounds and words he recognized. Moody helped him, and translated, word by word. With Moody's

indispensable assistance, Swanton was able to transcribe 150 narratives, all by men. A portion of these, including *Sgaay*'s version of *Xuuya Kaagang.ngas*, were published in English translation in Bulletin 29 of the Smithsonian Institution's Bureau of American Ethnology in 1905 with the title *Haida Texts and Myths, Skidegate Dialect*. Moody and Swanton completed more translations, but, alas, they did not all see publication.

Prior to the labours of Moody and Swanton, those seeking an English-language account of Raven's activities at the beginning of the Haida world would have had recourse only to the brief accounts collected by visiting officials and anthropologists. Newton H. Chittenden's essay, "Hyda Land and People," appeared in the *Official Report of the Exploration of the Queen Charlotte Islands*, published by the government of British Columbia in 1884. Anthropologist Charles Hill-Tout's "Haida Stories and Beliefs" were presented in the 1898 *Report on the Ethnological Survey of Canada*. Hill-Tout includes a story in which Raven lands on the beach and piles up two towers made of clamshells. He transforms the towers into humans, and they're both females. He makes them his slaves, but they become increasingly dissatisfied with their fate. In an account that seems confused at best, one is changed into a man when Raven casts "limpet-shells" at her.[7]

Moody and Swanton's English translation of *Xuuya Kaagang.ngas* was for years the textual authority for scholars and those unfamiliar with the Haida language. (Between 1880 and 1916, eight versions were collected in Skidegate, Massett, and at Rose Spit.) In 1995, after twenty years of work, linguist John Enrico published new English translations of *Xuuya Kaagang.ngas* in a collection entitled *Skidegate Haida Myths and Histories*. He includes three out of the eight versions that were dictated in the early days, including *Sgaay*'s, which was translated from the Skidegate dialect transcript created by Moody and Swanton. Enrico chose, as the title, "Raven Who Kept Walking,"[8] which is preferred by some who tell the stories today. In the late

1980s, poet Robert Bringhurst began to annotate and publish English-language translations of *Sgaay* and of another storyteller whose work was transcribed by Swanton: Ghandl of the *Qayahl Llaanas*.[9] Three volumes appeared over three years: *A Story as Sharp as a Knife: The Classical Haida Mythtellers and Their World* (1999), *Nine Visits to the Mythworld* (2000), and *Being in Being: The Collected Works of a Master Haida Mythteller* (2001), which includes *Raven Travelling* and an image of the Chicago platter with the caption: "This work has been scraped, broken and badly mended."[10]

During the month in Skidegate when he was working with *Sgaay* and Moody, Swanton found himself thinking often about the classical epics he had read in school. He came to believe that *Sgaay*'s account of Raven's long walk through history and pre-history possessed an equivalent epic sweep. Writing to Charles Newcombe, he declared, "I have a poetic feeling about my work, as if I were constructing a nation's literature or rather like Homer collecting and arranging a literature already constructed. I have the whole saga or epic and am now adding short figurative tales, many of which are however of great interest."[11] Here is Moody and Swanton's translation of the *Galaga snaanga* passage as published in 1905 in a distinctly non-literary bulletin intended for professional and amateur anthropologists, linguists, ethnographers, folklorists, and museum personnel:

> He [Raven] then started off. He travelled about. On the way he got his sister neatly, they say. He then left his sister with his wife. And he started off by canoe. He begged Snowbird to go along with him, and took him for company. He also took along a spear. And short objects lay one upon another on a certain reef. Then, when they came near to it, the bird became different. He took him back. And he begged Bluejay also to go, and he started with him. But when they got near he, too, flapped his wings helplessly in the canoe. And, after he had tried all creatures in vain, he made a drawing

on a toadstool with a stick, placed it in the stern, and said
to it: "Bestir yourself and reverse the stroke" [to stop the
canoe]. He then started off with him. But when he got near
it shook its head [so strong was the influence].

He then speared a big one and a small one and took
them back.[12]

Sgaay's narrative economy is admirable. He withholds the infor-
mation that Raven is on a mission, and Raven himself is hardly
forthcoming; he asks the Snowbird to come along "for company."
There is no mention of potential danger. Bringing the spear
seems like an afterthought. To those familiar with the story,
Raven is obviously being strategic. The account is also playful.
Swanton's readers required explanatory notes. He explains that
the "short objects" are "feminine genitalia," and that when "the
bird became different" it was because "supernatural beings were
unable to bear the odor of urine, the blood of a menstruant
woman, or anything associated with these."[13] Was Swanton being
obtuse? Was he, at twenty-eight, an inexperienced young man?
Or did an "anthropological" explanation seem more serious
and fitting than one that openly acknowledged the potentially
embarrassing orgasm?

It's difficult to know how earnest or inexperienced Swanton
was. Given the tumult in the canoe as they approached the reef,
Raven's order to *Galaga snaanga* to "bestir" himself is pretty
funny, as is Raven's invocation to "reverse the stroke" as they get
closer. Was Swanton being playful, I wonder? As reported by
Mabel Williams, *Galaga snaanga* is not impervious to the erotic
lure of the *tsaw*; and, as indicated by Mabel Williams, he is also
made sweet as the canoe approaches the reef, swaying, crying
out, and panting suggestively. According to Williams, he did not
tumble overboard because he was wedged into the stern. Is it
possible that Raven pressed *Galaga snaanga* into service because
he was a form of natural Styrofoam? His flesh would have given

slightly when compressed and expanded again, wedging him securely into the tapering hull. No wonder he remained at his post, although on the Seattle and Dublin platters he has clearly been dislodged. Despite being tossed about, he presumably completed his task while experiencing orgasm after orgasm and Raven managed to spear two *tsaw*. Raven's achievement cannot be underestimated, but many might agree that the agitated, distracted, perhaps somewhat enlarged *Galaga snaanga* may be the real hero of this story.

Sgaay's account also mentions that Raven collects a large *tsaw* and a smaller one, and that the woman who receives the smaller one cries. He consoles her and tells her, "But yours will be safe."[14] In John Enrico's translation, square brackets foreshadow Raven's betrayal.[15] After some time, he tricks this woman into sitting down on what could be a toadstool in the forest. As one might expect, it's Raven's member sticking up into the air. Unable to resist, he has buried himself under the leaves. *Sgaay* tells us that Raven was afterwards ashamed of his behaviour.[16]

We cannot really know the shape or duration of a public recitation of X̲uuya K̲aagang.ngas as *Sgaay* might have told it on a dark night at the turn of the twentieth century. Oral histories are taught, and repeated, word for word. Audiences actively respond to and invest an occasion with their own energies and desires; storytellers build their narratives on the waves of these energies. The recitation for Swanton and Moody lasted approximately two hours.[17] Although they were familiar with one another by this time, delivering a complex, interlocking epic narrative to an anthropologist, word by word, by means of a translator, must have required a certain formality and may have been tiring for the seventy-two-year-old *Sgaay*. He would have been conscious of Swanton's unfamiliarity with Haida, and he would have been listening carefully as Henry Moody suggested English equivalents. He would have altered his vocabulary accordingly, summoning the verbal pleasures of a dramatic,

communal narrative and transforming its words and sentences for an audience he could only imagine.

In a local, communal situation, *Sgaay*'s listeners would have been waiting for familiar cadences and phrases. They'd have been paying close attention to visual and linguistic nuances, euphemisms, double entendres, and between-the-lines contemporary references. It is the twinkle in the storyteller's eye, the unspoken that makes conspirators of those listening. Locations mentioned in the story would have been familiar and recognizable. Most of *Sgaay*'s listeners would have been aware of the reef known as *Tsaw Gwaay.yaay* just south of Newberry Point.[18] Terri-Lynn Williams-Davidson notes, after Chief Dempsey Collinson, that "fishermen know its location and apparently happily announce to each other when they are passing by that the power of it causes them to wink." [19]

In his article "Charles Edenshaw and the Creation of Human Beings," Alan Hoover draws attention to a version of the Fungus Man story told by *Da.a xiigang*'s cousin Henry Edenshaw in 1901 in response to a photograph of the Chicago platter. Newcombe copied out an abbreviated version of this story in pencil, some of it very faint, and the note has been associated with the photograph since that time. The Field Museum in Chicago acquired the platter in 1894. Newcombe had quite possibly been sent the photograph and asked to provide information about its provenance. He was at the time working as a collector for the Field Museum on a monthly salary, and in October 1901 had just returned from sailing to the villages of the Kaigani Haida on Prince of Wales Island in Alaska. Henry Edenshaw, whose mother was from *Hlankwa'áan*, and who retained a house and status there, had been his assistant and guide.[20] His account, via Newcombe, confirms that the platter is by *Da.a xiigang*, and adds what might be a recalibrating tone to the narrative:

Steersman of fungus called kugu gilgai or wood [?] biscuit (Polyporus) Raven (Nankilslta –) going to first land (?xagi) to get – make a woman of the rock chitons with spear. Then all men no women. Speared the genitalia which grew on rocks – [threw?] them at the men. When caught on organs immediately grew up. When on the men got ashamed & ran to the houses.

ex. H. Edensaw
1/10/01
Made by Charlie Edensaw [21]

Newcombe's hurried note, an epic in a few lines, which is nevertheless quite particular about details, seems to combine two stories. Fungus Man, in this case, is included in a narrative from which he is usually absent. The story in which Raven throws chitons at early humans in order to differentiate male from female was often remarked on by early non-Haida observers and is connected to the creation story and the appearance of the "first men." In some cases, as in Henry Edenshaw's telling, only men exist; there are no women. Sometimes the early humans are neither male nor female.[22] In one story related by Victoria collector James Deans and published in 1899, "each of the first six humans was both male and female. Raven removed maleness from three humans, creating women, and he removed femaleness from the other three, creating men." [23] It's a little dizzying. In each of these transformation stories, the chiton analogues become female genitalia as soon as they latch onto someone, and that's it. The more subtle and layered tellings of *Sgaay* and Mabel Williams recognize that the exchange between Raven and the women who asked him to travel to *Tsaw Gwaay.yaay* is of a more profound nature, with a more complex meaning. What it teaches today is as relevant as it ever was.

I am interested in the steersman's name, *Kugu Gilgai*. Henry Edenshaw calls the bracket fungus a "wood [?] biscuit," although

the name may be unclear on the slip of paper. *Gilgai* is related to *gílg*, *gilgaay*, and *galaga*, each of which refer to bracket fungus, but also to pilot bread, or pilot biscuits, an association that makes analogical sense, although I am not sure which came first, the fungus or the biscuit. *Kugu* may be a variation on the word *k'ak'w*, which occurs in the Northern Haida dialect spoken on Prince of Wales Island in Alaska. *K'ak'w* is defined as a "bracket fungus having a face drawn on it." On the matter of gender and its fluidity, it should be mentioned that *k'ak'w* can also refer to a "bogeywoman." [24]

In Henry Edenshaw's account, once the "genitalia" have been winkled off the rock by Raven's spear (is he thereby the first impregnator?) and "[thrown?]" "at the men," the newly engendered "females" rush off to hide in their "houses," ashamed. The attribution of shame to the men who have just become women does not seem to occur in the other "first men" accounts, and echoes the moment in Genesis when Adam and Eve discover their nakedness in the Garden of Eden. This may have been a touch added by Henry Edenshaw, who was familiar with the biblical texts through his Haida translations. Is it possible that this gloss was to his mind a necessary emendation, lining up the Haida origin story with the Church's teachings about original sin, the fallen world, and the evils of women? For without sin, there would be no need for a Redeemer, or for a Satan to challenge him. There would be no Jesus Christ, no promise of eternal life. Salvation would be impossible; one would burn in hell forever.

9 | WHY FUNGUS MAN?

Approximately twenty thousand people lived and pursued their livelihoods in the fifty or more villages that thrived on Haida Gwaii before European contact.[1] Like all cultures, they were bound to the environment and the environment shaped them. They'd have recognized themselves as one of a possibly finite number of living organisms, each in a state of slow or rapid transformation into another organism, and each related through resemblance to any number of other organisms at certain stages of their existence. Close observation of these resemblances over time enables societies to identify structural and formal patterns, to notice recurrences, and to recognize the variations that in each case are related to the pressures and opportunities associated with adaptation. It's through likeness that we map the world, not as a bewildering complex of unrelated forces but as variations on and adaptations of elemental forms that combine and recombine in potentially infinite variations to shape the material, spiritual, and metaphorical universe. Analogical thinking opens the door to delight and comprehension. The poet James Reaney called this "identification" and saw the poet

and the artist as "identifiers." After returning from his North American exile in 1946, André Breton believed that analogical thinking was more necessary than ever. "The primordial links are broken," he wrote. "It is my contention that those links can only be restored, albeit fleetingly, through the force of analogy."[2]

The ability to identify the ways in which one thing is analogous to another, or to its contrary, is at the heart of being – and of all poetry and art – and will be critical to our survival. Elements that generate similar forms or patterns, whether positive or negative, are said to rhyme. In poetic thinking, metaphor stitches the world into place. Everything is known by its contrary. At the very beginning, as land is just appearing above the waves, Raven encounters beings on the flat rock known as *k'il*. They are likened to newborn sea cucumbers in a state of limp, primordial listlessness – hardly up for the challenges to come. It does not take much to see that these supernatural beings are the contraries to the *tsaw* on *Tsaw Gwaay.yaay*. "Without Contraries is no progression," wrote William Blake.[3] According to the oral histories, everything necessary for existence was present at the beginning. Raven was the catalyst. He provided the spark, intentionally or inadvertently, that brought each organism to life.

But what of *Galaga snaanga*? Raven picked the right man. Wedged into the stern of the canoe, he was able to weather the orgasmic waves that emanated from *Tsaw Gway.yaay*. But did he possess other skills or attributes? And how did he come to be released from his inert condition on a tree trunk to become a helmsman who looked like a human being, and a little like a biscuit? Mabel Williams tell us that "Raven got *galaga snaanga*, or, Fungus Man, to help him."[4] In the Swanton-Moody translation of *Xuuya Kaagang.ngas*, Raven "made a drawing on a toadstool with a stick, placed it in the stern."[5] We have yet to look at linguist John Enrico's translation of the same passage. He keeps to the two-paragraph arrangement established by Swanton:

While he was going along, they say he managed to pick up his sister. He let her off at his wife's place. Then they say he left. He asked Junco to be crew for him and took him with him. He also took a spear. The female genitalia were climbing on each other on the reef there [like chitons]. When the canoe got near it, Junco became deranged. Then Raven went back with him, they say. He asked Steller's Jay to be crew for him and set out with him, too. When they got near it, Steller's Jay too just flapped his wings around. Raven failed with everything [that he asked to go with him] and he drew a design on a bracket fungus and sat it in the stern. Then, "Keep your eyes open and backpaddle every once in a while," he said to him. Then he left with him. When the canoe got near the reef, the fungus just shook its head.

He speared a big and a little one [female genitalia] and put them aboard and went back with them.[6]

The Moody-Swanton and Enrico translations make it evident that *Sgaay*, at least in this telling, avoided any further elaboration on the crucial details of Fungus Man's creation. Raven makes marks on a bracket fungus and suddenly he's in the canoe, an unwitting coxswain. One might ask once more, where did the canoe come from? Swanton mentions a stick; Enrico does not. Drawing a stick across the fleshy side of a bracket fungus leaves a permanent bruise, which is why the fungus is sometimes called artist's conk. But what could this bruise, this drawing, these marks have resembled? Was it the likeness of a human man? Was it a stick person? A visage beyond reckoning? A face, perhaps, as may be suggested by Henry Edenshaw's name for the helmsman, *kugu gilgai*; and if it was a face (*k'ak'w*), what might it have resembled? Could it have been a magical symbol? Enrico's indication of a "design" is interesting. It suggests sophistication, a tradition, a means of perceiving with greater acuity through a pre-established practice

of visual abstraction. Could Raven's marks have carried emotion with them? Might they have been his interpretive gloss on the shortcomings of the natural world, further evidence, as if he needed it, of the existential predicament of being Raven?

I have also wondered if it is not the future that Raven inscribes on the bracket fungus. Are we not witnessing the first gestures toward a symbolic language that will, over time, develop into a consciousness so intimately braided through time that it will be indistinguishable from time? The flesh will wither and die. Suspended in a forest of symbols, and swept from revelation to revelation by their magical recombinations, the imagination in time will seek out ways to dance around the coming void. The early-twentieth-century poet Haim Nahum Bialik believed that symbolic language evolved to keep the abyss at bay. He regarded words as a brilliant diversion, as powerful talismen that served to temporarily dissipate the fear of death. He also understood that one is most fully alive when one's most secret yearnings pull one toward a glimpse of the waiting darkness. At the moment when concealing is revealing, the word or symbol becomes poetry.[7]

In marking the underside of the bracket fungus, was Raven creating a symbolic language of words, images, or both, with which to sustain human beings as they entered time and history, girding their loins to live in the shadow of death? With his unseen marks, did Raven sow the seeds of a regenerating symbolic system capable of revelation, and, after one has succumbed to time, of providing eternal life through the records of one's love and works? Of course, in devising a medium for self-consciousness, Raven introduced the forbidden. Bialik was all too aware of the alluring tug of the void: "With our very lips we construct barriers, words upon words and systems upon systems, and place them in front of the darkness to conceal it; but then our nails immediately begin to dig at those barriers, in an attempt to open the smallest of windows, the tiniest of cracks, through which we may gaze for a single moment at that

which is on the other side."[8] Is there a better description of our own Raven nature, of the capricious pride and curiosity that cannot resist testing mortality's flimsy grip on existence? Having peered into the grave, is it any wonder that Raven devotes his life to cheating and outwitting death?

Is it possible to deduce from *Sgaay*'s original Haida the specific nature of the marks made by Raven on the bracket fungus? Robert Bringhurst must have asked the same question. Interestingly, in his translations he has proposed two different possibilities. In both editions of *A Story as Sharp as a Knife* (1999 and 2011), his translation reads as follows. "He" refers to Raven:

> Then he painted the face of a bracket fungus
> and seated it in the stern.[9]

Given the scrupulous care with which Bringhurst approaches his translations, it's interesting to note that he renders *Sgaay*'s verb as "painting" whereas Swanton, via Henry Moody, describes Raven "drawing" with a stick. Does this suggest an ambiguity or indeterminacy in *Sgaay*'s narrative? Painting does not bruise the flesh as a stick would. It's additive. It covers or conceals, altering the surface, dealing in illusion. Are we to understand that the bracket fungus already had conventional facial features, a visage that might be associated with a sentient being? Alternately, or simultaneously, the word "face" could suggest a blank, inanimate fungal plane, similar to a rock face. By painting *on* the face, or a likeness of a face on the face of the fungus, did Raven release the potential energy of a being that was present but inactive or dormant? And if so, what kind of being? And what did he paint?

Two years later, in his collection of translations from *Sgaay* entitled *Being in Being*, Bringhurst offers an alternative translation:

> Then he painted a face on a bracket fungus
> and seated it in the stern.[10]

Bringhurst has acknowledged that there may be inconsistencies from edition to edition, but this adjustment might justifiably be regarded as a revision. If so, how should we understand it? In Bringhurst's interpretation, Raven clearly appears to animate the bracket fungus by painting a face on it where there was no face before. Again, I am reminded of Henry Edenshaw's expression, *kugu gilgai*, and its possible relation to *k'ak'w*, a bracket fungus with a face drawn on it. If this is what the oral histories intended, what sort of face would Raven portray? Human? Animal? Spirit? Bird? Would it be a face no one had ever seen before? Would we have recognized it as a face? Given that this is a later translation, allowing for more consideration on the part of the translator, is this the closest we may come to understanding what *Sgaay* meant when he recited this story to Moody and Swanton?

Enrico writes that Raven "drew a design on the bracket fungus." In both cases, the impression is given that the marks were thoughtful and premeditated, that Raven envisioned the consequences of his drawing or painting prior to applying it to the fungus. But did he? The variations in the Enrico and Bringhurst translations are more than stylistic, which leaves some doubt in my mind as to the storyteller's intentions. If, however, it was *Sgaay*'s understanding that Raven, with his brush, feather, or stylus, created the first representational system, then the story of *Galaga snaanga* is of singular interest to those studying the role of symbolic languages in the development of human consciousness. It marks a turning point. This episode of *X̱uuya K̲aagang.ngas* may not be so much about entering time as it is about the imperative of inventing the symbolic idea of time in order to enter it.

The pronouns in *Sgaay*'s account of *Galaga snaanga*'s journey add further complications. In all three translations, the

bracket fungus is confusingly both neuter and male. Swanton tells us that Haida "has only one personal pronoun for the third person singular,"[11] so the decision regarding gender in English is up to the translator. In Bringhurst, our first encounter with *Galaga snaanga* is with an "it." When placed in the canoe, the bracket fungus appears not to be gendered; one may surmise that it has not yet shuddered into life. Once the canoe is launched, the indication is that the male hormones begin to kick in as they approach *Tsaw Gwaay.yaay*. In the lines below, "he" refers to Raven, "him" to *Galaga snaanga*:

> Then he headed out with him.
> When they drew alongside
> The fungus nodded his head.[12] (Bringhurst)

Remaining true to *Sgaay*'s sly modesty, Bringhurst's "nodded" is a playful euphemism for the orgasmic shaking, swaying, and grunting described by Mabel Williams. *Galaga snaanga* is now unquestionably male. He is aroused – or brought to life – by the proximity of the *tsaw*. The look of alarm on his face, is very likely the startled, uncertain response of a man being reborn at the moment of orgasm. This may be one reason why *Da.a xiigang* placed him in something like an infant's body.

In the translations by John Enrico and John Swanton with Henry Moody, *Galaga snaanga* begins as a male, but when he becomes sweet – *xaawlagihl* – he is suddenly neutered. Here is Swanton, followed by Enrico:

> He then started off with him. But when he got near it shook its head [so strong was the influence].[13] (Moody-Swanton)

> Then, "Keep your eyes open and backpaddle every once in a while," he said to him. Then he left with him. When the canoe got near the reef, the fungus just shook its head.[14] (Enrico)

Bringhurst's interpretation, in which *Galaga snaanga* becomes male when approaching the reef, has a logic to it, but is there a circumstance in which the reverse is equally or perhaps more beneficial to the outcome of the journey? John Swanton, the only one of the three translators who spoke with and listened to *Sgaay*, ought to provide the most accurate transcription of *Sgaay's* intentions with regard to personal pronouns. If Swanton included the pronoun shift from "he" to "it," then it's reasonable to assume that it was with the approval of *Sgaay* and Henry Moody.

Each of the three translators has chosen to portray *Galaga snaanga's* gender as inconstant. He is presented as a fluid sort of being, a "he" and an "it." Perhaps indeterminacy is central to his being. After all, *Galaga snaanga* is a supernatural bracket fungus, presumably with transformational properties. It's possible that Raven engineered the pronoun shift. Knowing what had overtaken the previous helmsmen as they approached *Tsaw Gwaay.yaay*, he may have assumed that if the bracket fungus were neuter there would be less chance of his becoming distracted from the task at hand. A more likely scenario, given Raven's jealous, possessive nature, is that the helmsman was silently neutered en route to keep him from becoming Raven's amorous rival.

The bracket fungus upon which Raven scratched or painted is usually related to the fungal "flower" with a white fleshy underside known as *Ganoderma applanatum*. If it's healthy, *G. applanatum* looks like half or two-thirds of a circular plate or saucer attached or rooted to a tree, and, as previously mentioned, is sometimes known as a conk, or an artist's conk, because of the permanent marks a stylus makes on its fleshy white or ivory underside.[1] In a 1992 article, Robert A. Blanchette, Brian D. Compton, Nancy J. Turner, and Robert L. Gilbertson proposed an alternative to the familiar conk fungus. "Fungus Man," they wrote, "originated from a bracket fungus with a white undersurface upon which Raven drew a face. Although the bracket fungus has been previously assumed to be *G. applanatum*, it could also represent a carved basidiocarp of *F.* [*Fomitopsis*] *officinalis*."[2] Forest fungi on the Northwest Coast, they explain, including *G. applanatum* and *F. officinalis*, were and are still considered to have supernatural, spiritual, and medicinal powers. *F. officinalis* flowers resemble stacked and densely layered bracket fungi. The Tlingit, we're told, call them "tree biscuits."[3] The name Ugly Biscuits, familiar

to Mabel Williams and Terri-Lynn Williams-Davidson, may add weight to the *F. officinalis* argument, although the singular shape of the helmsman's head on *Da.a xiigang*'s platters, echoing as it may the pilot biscuit, is compelling evidence in favour of *G. applanatum*.[4] According to the article, Tsimshian and Haisla sometimes refer to bracket fungus as "ghost bread."[5] At dawn, or at twilight, passing through the forest, the sudden crescent of white flesh against a dark trunk might well look ghostly, especially in a burial place. I have not encountered any evidence that bracket fungi are related to the deceased. Does *Da.a xiigang*'s version of *Galaga snaanga* in any way resemble a ghost?

Blanchette and his colleagues suggest that *F. officinalis* was chosen as Raven's helmsman because it has supernatural fungus powers and because shamans used it for healing. "Only the Fungus Man had the supernatural powers to successfully bring Raven to his destination," they write.[6] This appears to be a reasonable suggestion, but many creatures and plants have supernatural and medicinal powers that shamans take advantage of, and none of these were, to my knowledge, brought in as coxswains for that purpose. According to the article, shamans sometimes carved *F. officinalis* into anthropomorphic figures that they enlisted as supernatural helpers who were able to enter the body where a human doctor could not.[7] But in none of the *Galaga snaanga* accounts does Raven carve the fungus into a little homunculus.

According to a study entitled *Economic Gain Spatial Analysis* and commissioned by the B.C. provincial government, First Nations, environmental groups, and forest industries, all bracket fungi have medicinal and healing properties. *G. applanatum* has shown "immune-stimulating and anti-tumour activities in a variety of studies, and RNA from *G. applanatum* has caused the production of an interferon-like substance in mice spleen and has also been found to confer protection against tick-borne encephalitis in mice." *G. applanatum* also contains steroid compounds, and in Asia is used as an antibiotic and to treat tuberculosis

and esophageal cancer.[8] These medicinal properties may well have provided a compelling reason for Raven to seek out the bracket fungus, but if *Galaga snaanga*'s medicinal properties made him such a natural, why would Raven have waited so long to enlist his services?

One must consider the shape of the fungus. *Da.a xiigang*'s steersman has a round moon-like face, quite unlike the rugged, uneven, chunky layers of the carved *F. officinalis*. *Galaga snaanga*'s head recalls the partial circumference of *G. applanatum*. On the Seattle platter, three growth rings appear to have been added to *Galaga snaanga*'s face, corresponding to the typical growth rings on the circumference of *G. applanatum*. There's also the choice of the circular platter itself to consider, echoing the circularity of the *G. applanatum*. The proposition that *Galaga snaanga* might be a carved *F. officinalis* is not, in the end, entirely convincing. *Galaga snaanga*'s visage argues in favour of the *G. applanatum*.

The suggestion in Henry Edenshaw's account that the "wood [?] biscuit" is a basidiomycete bracket fungus called *Polyporus squamosus* is intriguing, and perhaps I am wrong on this, but my understanding is that this fungus grows east of the Rockies exclusively. Bill Holm is on record as suggesting that the "toad-stool" or tree fungus in question is *Fomes pinicola* (*Fomitopsis pinicola*) also known as red belt or red-belt conk.[9] This bracket fungus, found in the forests of Haida Gwaii and southeastern Alaska, is often described as being hoof shaped because it tends to expand downward around the fringe while the top or bracket attached to the tree remains stable in size. When dried, it is also said to be valuable as tinder. According to the *Economic Gain Spatial Analysis,* which also looked at the economic opportunities associated with harvesting medicinal plants on Haida Gwaii, *F. pinicola* also contains steroid compounds and shows "tumour-inhibiting effects against sarcoma 180 in mice,"[10] although the effect is slighter than that of *G. applanatum*.

In their detailed study *The Transforming Image: Painted Arts of Northwest Coast First Nations,* Bill McLennan and Karen

Duffek observe that "the steersman, also known as the Fungus Man, is portrayed with a simple circular head. Perhaps this conceptualization ... was based on the practice of applying a protective coating of charred biscuit fungus mixed with goat tallow to the face during canoe travel."[11] I can imagine this greasy mixture protecting the puller's skin against the wind, the sun, and the constant salt spray. In conversation, McLennan, who is knowledgeable about mycology, added that he has seen a photograph of a canoe in which all the paddlers have blackened faces. It would be natural, he said, for Raven to choose for a steersman a tree fungus that has traditionally protected the paddlers from wind and sunburns.[12]

While the evidence is not conclusive, all signs seem to point to the *G. applanatum*. Its soft white under flesh at first reminded me of the skin of the inner thigh, a location associated with erotic pleasure. Perhaps the erotic suggestibility of the bracket fungus's pale underside inspired Raven to bring its spirit to life in an act of sympathetic magic. Bracket fungi can develop distinctly labial features. But if Raven drew a figure, it was a man, or an *it* – not a woman. Or so it seems. It's possible that *Galaga snaanga* is a hermaphrodite.[13] *G. applanatum* typically reproduces sexually, but under certain conditions it has been given the ability to reproduce asexually. A bracket fungus must be prepared for any eventuality.[14]

11 | A WALK IN THE FOREST

Three summers ago I had the good fortune to visit Haida Gwaii. On a sunny August afternoon, near the old village of *Naay Kun,* at the north end of the islands, my sister and I decided to hike the trail to Cape Fife, a ten-kilometre walk through an almost silent green forest. The trail is narrow and twists uphill and downhill. Underfoot, thirsty roots criss-cross, and from time to time we encountered a fallen log over a black, loamy, almost primeval pond. The forest floor is undulating moss, often a foot thick. We'd turn a corner and come upon dark pools rimmed with colourful lichen. As we went deeper, and the world of the combustion engine faded away, the forest and its topiary mosses took on a glow of otherworldliness. Birds are often quiet in August; in this forest they seemed to have vanished. Once or twice I caught one fluttering up and disappearing behind a distant hummock of moss that turned out to be a decaying log. To judge by the undergrowth, we seemed to be passing through miniature climate zones. I noticed then that many of the trees and fallen logs had become hosts to bracket fungi; to be specific, to *G. applanatum.* In the fresh, gentle air these

fungi appeared to be less damaged or irregular than those I've seen in the south. (Bracket fungi often show signs of being chipped or bored or bitten into.) So exotic and flawless were some of these specimens – and their peerless, glowing, ivory undersides – that I raised my camera to see if I could translate their sensual contours into a photograph.

As one might imagine, the underside of a bracket fungus is always in shadow and almost impossible to photograph successfully. I needed better light and was circling one of the trees adjacent to the narrowing path. I caught sight of something attached to the trunk, about a metre off the ground, which looked like a tiny human fungus figure hanging on for dear life. It had a head and a body and looked like an elongated puffball pinched in the middle. Could it be the model for the Fungus Man? The puffy body? The round, puffy head? I could easily imagine this little manikin coming to life. Perhaps a fungus like this was the inspiration for Edenshaw's helmsman, although I saw only one on our hike. But it was not a circular, plate-like bracket fungus. It didn't have an underside on which a bird, with a stick, might draw a human or avian shape. In its way it was already a figure, a homunculus.

I kept on trying to take photographs of the undersides of what I was beginning to think of as "ghost bread" on the trees that bordered the trail, fixated on the idea that the fleshy undersides offered the best explanation for why the Fungus Man was related to the creation of women. Often a vertical row of bracket fungi looked like steps ascending into the sky. And they did resemble platters. Then it occurred to me to photograph their tops. The nearest specimens were more than two metres off the ground, so I held the camera in my right hand, lifted it high into the air above a fungus and, after giving it a moment to focus, released the shutter. I adjusted the angle and pressed the shutter release again, then looked at the screen. It was only from above that the secret of the bracket fungus revealed itself. It resembled a clamshell, with growth rings.

It might be blue, or brown, but there was no mistaking that elemental shape.

Of course! A clamshell!

Is there a more venerable euphemism for the part of the female anatomy Raven and *Galaga snaanga* risked their lives to bring ashore?

Raven's choice of a bracket fungus stood more fully revealed. To approach the *tsaw* – to be successful despite the distractions of the powerful force on the reef – you may need someone or something that looks and thinks like a *tsaw*. A bird is useless in this department. Alone among the bracket fungi, only *G. applanatum*, however, possesses the physical attributes of the clamshell, and would, by the logic of sympathetic magic, possess the *tsaw* wisdom required to capture one or two of the desired objects out on the foaming reef. By animating a bracket fungus, Raven must have thought that he'd found the perfect combination: flesh without the weakness of flesh. He was mistaken about *Galaga snaanga*'s susceptibility to the erotic pull of *Tsaw Gwaay.yaay*, but human beings can be grateful that he took a gamble on an unlikely hero, one who served him loyally.

Daughter of the moon, half-submerged on the border between earth, sea, and sky, the clamshell seems to be at the heart of the Haida story of origin. In several significant argillite works by *Da.a xiigang*, which are equivalent to oral histories, small faces peer out from inside shells. It is said that Raven heard their voices and coaxed them out into the light. This history will be familiar to those who have had the opportunity to study the monumental yellow cedar sculpture entitled *The Raven and the First Men* in the Museum of Anthropology at the University of British Columbia. This iconic work, the creation of Bill Reid and a team of carvers that included Haida artists Reg Davidson; *Guujaaw*, Gary Edenshaw; James Hart; Kim Kerrigan; George

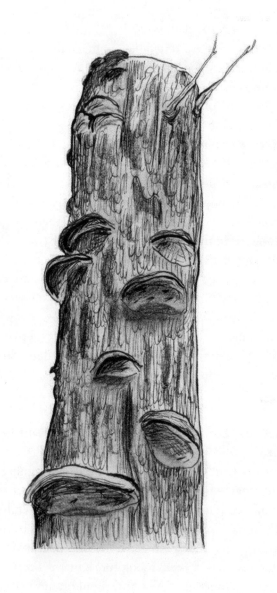

Illus. 7. Bracket fungi ascending a tree trunk

Norris; and George Rammell, was created for the opening of the new museum in 1980.[1] It was modelled on a small boxwood carving completed by Reid in 1970 called *The Raven Discovering Mankind in a Clamshell.*[2] The miniature shell included a female ancestor, identifiable by her labret.[3] At the unveiling of *The Raven and the First Men*, Reid "acknowledged that the work was the direct outcome of [Charles Edenshaw's] treatment of the same theme, and I can only hope that it does him credit."[4]

Reid regarded his great-uncle *Da.a xiigang* as the "Rosetta stone" of Haida art, although at one point, early on, he suggested that *Da.a xiigang* was perhaps "too influenced by the *London Illustrated News.*"[5] I tend to think that *Da.a xiigang*'s borrowing of nineteenth- and twentieth-century European and American motifs allowed him to remain fresh and inventive, although I'm sympathetic to Reid's concerns about the loss of tradition. James Hart, who apprenticed with Reid, reminds us that the arrival of Europeans provided a heady mix of new and occasionally beneficial influences: "Charlie was born during a time of great excitement in Haida History. Contact with outsiders, new things, metal, all the changes, Christianity, preachers, smallpox, new laws ... still Haida law, Haida Way. So much."[6]

At the UBC Museum of Anthropology, in a rotunda designed by architect Arthur Erickson so that visitors may circle the sculpture, the Raven crouches atop what Reid calls "a gigantic clamshell." His wings are held out protectively, almost maternally, and his feathered back is completed at the tail by a face that is partly human, partly supernatural hawk.[7] He seems unusually attentive for a bird whose spontaneous appetites typically overrule his heart. Perhaps he is listening intently, for there is something about him of the bird that cocks its head to better hear the underground progress of a worm. Does he hear a voice? In what language? Beneath him, the shell has opened a crack to reveal the heads and tails of its human occupants.

In collaboration with Robert Bringhurst, Reid adapted and expanded on the discovery of the clamshell in a text published

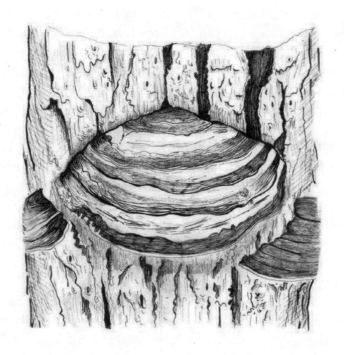

Illus. 8. Bracket fungus with growth rings

by the museum to accompany the sculpture's installation. In this account, entitled "The Raven and the First Men," Raven finds only men in the clamshell, and soon tires of them. He flies them to the North Island and deposits them near a series of rocks covered in "large but soft-lipped molluscs known as red chitons." The men impregnate the chitons, which, nine months later give birth to the first Haida infants.[8]

In their telling, Reid and Bringhurst chose not to include *Galaga snaanga*, although his analogical likeness is certainly acknowledged in the great yellow-cedar clamshell at the Museum of Anthropology. The sculpture preserves the memory of the Old Mother of the tides, the clamshell mother who dwells in the ever-changing, nutrient-rich border between the land and the sea, where foot, feather, and fin convene. Could it be that, in her analogical manifestation as the bracket-fungus helmsman on *Da.a xiigang*'s platters, it is the old clamshell mother who smilingly steadies the canoe so that Raven may delicately spear two *tsaw* for the women waiting to receive their sexual power? It would only be right and fitting. I find myself wondering what it would mean to acknowledge a clamshell as the origin of the human world. One thing is abundantly clear: Haida science, as articulated in the art and oral histories, has for millennia been far more progressive than European science, having long ago embraced evolutionary thinking over superstition.

12 | CLAMSHELL OR COCKLESHELL?

It was with an homage to the clamshell mother that I had intended to conclude this little book, pleased to think that I'd discovered in the forests of Haida Gwaii the bracket-fungus analogue that had been hiding in plain sight. I sent a draft to Alan Hoover for his comments, and he reminded me that in *Da.a xiigang*'s account of the Haida origin story, as recorded by Franz Boas in 1897, Raven pecks open not a clam but a cockle. Both are bivalves, part of the large class known as Pelecypoda, and while they share a resemblance they inhabit different families. Cockles belong to the family Cardiidae; their shells have deep grooves that radiate out from the hinge. Clams generally have a smoother, often wider shell, with growth lines that follow the lip. Many of the familiar clams on the east and west coasts of North America belong to the family Veneridae, a name that should not be surprising. Littleneck clams on the east coast belong to the genus *Venus*.

But if Raven had pecked open a cockle on that beach, and not a clam, wouldn't Bill Reid have asked his assistants to carve a cockle? Had *Da.a xiigang* been mistaken? Was Bill

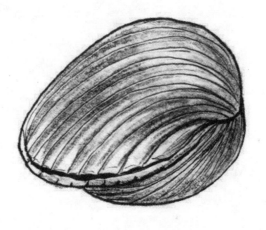

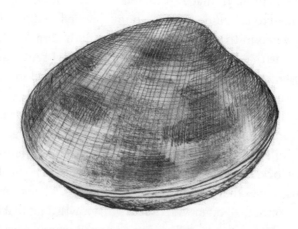

Illus. 9. Cockleshell (*top*)

Illus. 10. Clamshell (*bottom*)

Reid mistaken? *Da.a xiigang*'s story of the first men appears, third hand, in John Swanton's *Haida Texts and Myths, Skidegate Dialect*. In order to compile as complete a narrative as possible, Swanton had a habit of stitching together related elements of the same narrative as told by different people. He appended *Da.a xiigang*'s story of the first men to the "Story of the House-point Families" by Tom Stevens of the *Naay Kun K̲iigawaay* Raven clan of *Naay Kun*. "The following short story," he wrote, "obtained by Professor Boas from Charlie Edenshaw, chief of the *StA'stas* at Masset, is added for purposes of comparison and as containing supplementary material."[1] In an earlier note, Swanton had explained that *Da.a xiigang* "spent his earlier years at Skidegate, so I am not certain whether it is more like the story as told at Skidegate or as told at Masset. I am inclined to think, however, that it approaches the form in which it was told by the people of Rose spit." He adds as well that *Da.a xiigang*'s stories were "obtained in English by Prof. Franz Boas," a note I will return to.[2] *Da.a xiigang*'s account of the discovery of the first men, as it was transmitted in English by Boas, was three sentences long: "At that time the Raven traveled all over the earth, and one day he found a cockle which was being thrown about by the waves. He heard a noise inside the shell. He went near to see what it was. He hid nearby and discovered many children in the cockleshell. He opened it and found many people. Then he made towns …"[3]

Now, it would seem that *Da.a xiigang* would be as close as one can come to being an authority on the shell that Raven discovered. If he told Franz Boas it was a cockle, it must have been a cockle. On the lid of a magnificent, late-nineteenth-century argillite chest attributed to him – once known as the Jelliman chest and now called *The Origin of Mankind* – *Da.a xiigang* perched a three-dimensional figure of Raven in almost human form on top of what looks like a clamshell with a cockleshell fringe.[4] Perhaps the decision to depict a clamshell shape was the result of the need to solve a practical problem; the claws / human

feet of Raven must be planted on an even surface. A heavily ribbed surface with a cockle's bulge would result in a hazardous footing for the little figure whose position is already vulnerable. Alan Hoover, who has closely inspected the chest, confirms, however, that the shell is intended to be a cockle: "Attached directly to the lid top is a carved bivalve, identified as a cockle by the band of convex ribbing around the edge of the upper valve and the concave fluting on the upper surface of the lower valve." [5] On one end of the chest, *Da.a xiigang* appears to have carved a likeness of Konankada.

Like Raven on the platters, Raven on top of the chest has avian and human characteristics, although his human attributes are more in evidence. He has a human face, a head of hair, wings, a tail, and a large nose that suggests a beak. A beak also appears to issue from his stomach. Beneath him, in a row, five human heads emerge from within the shell, looking up. Their eyes are open. In his arms, Raven, with surprising tenderness, holds what looks like a human child in his arms, awkwardly bent over the beak in his belly. The child is face down, and its closed eyes are carved in downward-curving crescents, indicating that it has died. The six humans conform to the number of men in the shell according to oral history collected by James Deans and published in 1899 in his *Tales from the Totems of the Hidery*. His account hints at a deeper tragedy.

Deans was told that Raven copulated with a cockleshell at *Naay Kun* and returned nine months later, no doubt filled with happy anticipation. [6] The six young men who crawled out of the shell were his sons. I can only conclude that the portrait of Raven on top of the chest with a dead child in his arms is of a father mourning. Was *Da.a xiigang* recalling his own grief at the loss of his children? How could he not be? And how could he not be recalling the children who had perished in the epidemics, relocations, and hunger during his lifetime? I regard this extraordinary object, *The Origin of Mankind*, as a deeply personal work, and a commentary by *Da.a xiigang* on

the historical period he and his family had only recently lived through. There does not appear to be any recorded information about when the chest was made, or for whom he may have made it. Could it be related to the loss of his son Robert by drowning in 1896, a loss that deeply affected him?

The origin of mankind may also be understood as the origin of dissolution and death, and of the grief we carry within us. Alan Hoover provides a further interpretation, linking the sculpture to the structural imagination of human culture: "The complete sculpture, then, can be 'read' as follows: Raven piercing the cockle suggests conception; the five emerging faces represent human birth; the dead child is the image of human death. Raven's transformation from human to bird is the result of the birth of human beings; by creating human-form, Raven created bird-form."[7] Time and history will move to the fore. *The Origin of Mankind* is charged with an irreparable sense of regret and grief. I'm not aware of a more profound and emotionally complex work of Northwest Coast art than this small argillite chest in which *Da.a xiigang* appears to have stored the sorrows of his heart.

As for the type of shell that gave birth to the first men, one finds only a gentle confusion. Robin Wright, who has closely studied *Da.a xiigang*'s work, describes the shell on the lid of *The Origin of Mankind* as a clamshell.[8] An oval argillite platter attributed to *Da.a xiigang*, carved some time around 1904 and now in the collection of the UBC Museum of Anthropology, seems less ambiguous.[9] Obeying the laws of perspective, nine little human faces peer out of a shell on which the inside lip is fluted like a cockle. The top of the shell has been carved into a face, and judging from the beak and the *V*-shaped cleft in the forehead, it may well represent the face of K̲onan̲kada. One might conclude from the chest and the oval platter that *Da.a xiigang* favoured the cockle over the clam as the womb of the Haida world. Given the presence of both bivalves in the oral histories, the choice of which is inserted into the story of

the first men may often depend on local knowledge, habit, and tradition. But *Da.a xiigang*'s story of the first men contains one more wrinkle. It was not dictated in English, as Boas reported to Swanton, but in Chinook Jargon, the trade language of the Northwest Coast. Boas's account is a translation. And Chinook Jargon does not appear to have a word for "cockle."

Da.a xiigang's story of the first men was recorded while Franz Boas was visiting the cannery town of Port Essington on the Skeena River in 1897. It was the first summer of the Jesup North Pacific Expedition, funded by Morris K. Jesup, president of the board of trustees of the American Museum of Natural History in New York. Boas was the expedition's organizer. The aim of the expedition, in his own words, was "to investigate and establish ethnological relations between the races of America and Asia." [10] Boas was also the curator of the museum's anthropology department, and before arriving in Port Essington he had spent two months in the British Columbia interior conducting "field investigations" that included archaeological digs, skull and body measurements, and the making of plaster-of-Paris facial masks. By comparing cranial and facial casts made in British Columbia to casts prepared on Asian expeditions, Boas and his colleagues hoped to determine the "ethnological relations" between Indigenous populations on both continents. This, they believed, would provide insights into possible migratory routes between Asia and America.

Boas had travelled overland from Spences Bridge to Bella Coola by pack train, and after leaving Port Essington he planned to meet up with George Hunt at Rivers Inlet. His surprise encounter with *Da.a xiigang* at Port Essington in mid-August enabled him to collect drawings and field notes and led to an essay entitled "Facial Paintings of the Indians of Northern British Columbia" in the expedition's first publication. [11] It was one of six articles Boas would publish in 1898. [12]

For a number of years, whenever K̲wii.aang was working at the Cunningham cannery, Da.a xiigang lived and carved in Port Essington.[13] Boas was introduced to him as Da.a xiigang was about to board a ship for Port Simpson (Lax Kw'alaams). In his own words, Boas "quickly engaged him," and they spent almost two weeks together, during which time Da.a xiigang identified from photographs and elaborated on a number of Northwest Coast objects in museum collections in New York; Washington, D.C.; and Ottawa. He also dictated Haida stories and produced a number of "paintings" at Boas's request. In a letter to his wife on August 13, Boas describes their labour together: "My Haida friend takes so long to do a painting that I lose a lot of time. I cannot do anything else while he is doing it, and I have some free time. In between I let him tell me things. Since his Chinook is rather limited, however, the conversation is very difficult."[14]

Boas reproduced some of Da.a xiigang's Port Essington drawings in his influential 1927 text Primitive Art, a work of analysis and classification in search of reliable aesthetic conventions. In its pages, Boas still seems somewhat peevish as he introduces the drawings he'd commissioned from Da.a xiigang thirty years earlier. They clearly had very different concepts of the real. Boas expected naturalistic drawings of living creatures, but Da.a xiigang invariably included formline motifs as well as U forms and ovoids in his sketches. There is a whiff of pique in Boas's captions: "The style has penetrated the picture which was planned as a realistic representation."[15] It's as if Da.a xiigang was being insubordinate, and perhaps he was. My suspicion is that he was teaching Boas about "the real" by representing the world as he saw and experienced it. Boas seemed to want drawings in which the figures were isolated according to the conventions of the retinally organized European sketch. Da.a xiigang employed symbolic conventions that were much more expressive because they focused on the inner spirit and the mechanics of movement – on wing sockets, shoulders, hips, eyes, suggesting three dimensions in two. He offered what the Surrealist André Breton called "the inner image."

I can't help thinking that to the trained Haida eye the conventions of the European naturalistic sketch might look like a superficial guess, reminiscent, perhaps, of the creatures drawn for medieval bestiaries by men who had never seen the animals they portrayed. Boas seems to have been looking for a representative Haida painter and carver who would help him establish an analytical system for Haida art. What he got was a boundary-breaking contemporary artist who was remaking the conventions. Despite his failure to meet with Boas's approval when it came to naturalism, *Da.a xiigang* later received a number of commissions from the American Museum of Natural History and the Field Museum in Chicago for masks, model poles, model houses, and model canoes.[16] There is much to explore at the intriguing intersection of these two hugely influential twentieth-century figures. The professional relationships between Boas and *Da.a xiigang*, and later between Swanton and *Da.a xiigang*, shaped ideas of culture in the twentieth century that continue to resonate to this day.

On August 22, expecting the steamer to arrive within hours, Boas wrote to his wife, telling her that he was trying to wrap up loose ends. The final lines of his letter read: "I want to try to make friend Edensaw finish the story about the Raven. Kiss the children for me. Another five weeks to go."[17] We may never know if *Da.a xiigang* chose to finish "the story about the Raven." Perhaps he was playing the role of Shahrazad for his impatient interlocutor. After all, Raven's journey is not over; he's still travelling. How better to make the point? Or was *Da.a xiigang* being paid by the hour?

When he returned to New York, Boas wrote up an account of their conversations and *Da.a xiigang's* narratives. Unfortunately, he did not archive his original notes, which might have contained *Da.a xiigang's* Chinook Jargon version of the story of the first men, or which would, at least, have included *Da.a xiigang's* Chinook Jargon word for the bivalve in question. Could it be possible, in Boas's translation into English from *Da.a xiigang's*

"rather limited" Chinook Jargon, that the clam was somehow confused with the cockle, or vice versa? As a trade language, Chinook Jargon has a basic, if colourful, vocabulary, and there does not appear to be a clear distinction between the clam and the cockle in the dictionaries currently available.

I made inquiries to see if there are speakers or scholars aware of Chinook Jargon words that distinguish between clams and cockles. The replies were helpful. There appear to be several words for "clams" – some specific to particular types of clam – but none have so far been recorded for "cockles." One of the Chinook Jargon words for "clams" is of interest. *Lukutchee* is borrowed directly from the French noun *la coquille*, the word for "shell." In France, *la coquille* may be applied to any shell, even the hard casing on a nut, and it is the source of the English word "cockle."[18] If I try to reconstruct in my mind the conversation in Port Essington, I can imagine *Da.a xiigang* saying *lukutchee* for "clams" in order to describe the shell in which Raven discovered the children. It's equally possible to imagine Boas listening to *Da.a xiigang*'s Haida-inflected pronunciation, perhaps asking for a clarification, and then writing down, homologically, "cockle." Did he then ask for further clarification, to make sure, or was it all perfectly clear? Did *Da.a xiigang* possibly make a quick sketch to show which shell he intended?

Had *Da.a xiigang* spoken Haida to Boas, there would have been no question about which shell he intended. He had been an artist and an observer of the natural world for almost sixty years. His works in argillite suggest that the shell he saw in his mind possessed properties of both the clam and the cockle. Is it possible that, in telling the story, the clam and the cockle may be interchangeable? A storyteller might choose the shell that occurs most plentifully along the shore where she or he is telling the story. It may be as precise as that. In Skidegate dialect, for example, there are names for at least nine different types of clams. The choice between clam and cockle resides in the abstract as long as it exists in a literary or scientific text, but

I suspect that on the ground, when the history is being relayed, many other factors enter in, all of which must be unerringly true to the listeners, the village, the location, the tradition, and the historical role of the community.

13 | IN TIME

I was first introduced to argillite when I worked in the display department of the Royal British Columbia Museum in Victoria more than forty years ago. I spent most of my time painting walls and distressing displays, but the entire staff of the museum gathered for coffee twice a day, and I listened hungrily to the conversations of the scientists and scholars and technicians from other departments. One day a colleague told me about an argillite cockle in the museum's collection. It had an uncanny likeness, she said, to a real shell. You could hold it in your hand and not know the difference. Except that it was black. I have not forgotten that moment, and in thinking about the little shell since then, reflecting on the life and fate and meaning of objects, it has seemed to me that the cockleshell, with its secret inner life, symbolizes the condition of human consciousness. For the outer world of action and strife, of interpretation, impulse, intellect, and language, also has a helmsman, a silent inner world, which is for the most part unknowable.

It was not until recently that I saw a photograph of the cockleshell my colleague told me about. In the museum's

collection there are, in fact, nine cockles, all of which were once part of the private collection that included the chest known as *The Origin of the World*. Five of them are made of black argillite. Three are in rarely seen red argillite, and one has been carved out of ivory. The largest is almost five centimetres in diameter.[1] All nine are sealed tight so that no one can climb back in should the world outside fail to live up to its promise. Judging by their silence, there is no sign of miraculous children inside waiting to be born and loved. The nine cockleshells – I'm tempted to believe that they were all made by the same hand – suggest more than just a brilliant example of naturalistic craftsmanship. They represent an extended meditation on our insatiable and sometimes melancholy species. Was the carver reflecting on sense of loss and exile one experiences in moments of reflection, or perhaps postpartum grief, or post-coital sadness? The nine cockleshells are as beautiful as the moon. Their sensual grooves are more dramatic than a clam's growth rings. The bulge, hinting at female anatomy, and its flowing, tapering lines of force gathering at the hinge, would be intriguing to a sculptor. Could the carver have been a woman?

It would be pleasing to think, as Wilson Duff suggested to a staff member at the provincial museum more than forty years ago, that *Da.a xiigang* had carved the nine exquisite cockleshells. There is no proof, however, that they came from his hand.[2] Duff noted that Florence Edenshaw Davidson, in response to the *Arts of the Raven* exhibition at the Vancouver Art Gallery in 1967, insisted that "she did not remember [her father] making any chests or imitation cockles."[3]

If he were asked for his opinion, Raven might say that he hasn't much time to think about this sort of thing. Everywhere you look, he might say, time goes on forever, and yet there is never enough of it. The days are too short. As for clams and cockles, they make fine euphemisms, but he is not interested in euphemisms. He is interested in breakfast. Does he get sentimental about the old days? Does he remember that trip to the reef with the bracket

fungus? Not so much, he might say. He's not one to dwell on the past. But then, sometimes, on a stormy night, he does like to hunker down out of the wind on certain roofs and listen to the old stories. Do I hear a touch of wistfulness in his voice? And why does he turn away? Why does he fly off so quickly?

What if oral history carries within it a more profound truth about the world than many people would grant it? What if our conventional idea of the truth is like a child's drawing of the sun compared to the sun itself? What if a deeper truth has been told, retold, and distilled over thousands of years, until each phrase is charged with a blaze of analogical light? What if this is a pre-linguistic truth we carry within ourselves like a chromosome, a truth that was once little more than an electrical charge animating the first ragged cells in the waters of the world's beginning? Perhaps, deeply embedded in muscles and tissues, it is a truth activated by sound, by the human voice, and by song. I would argue that one ought to seek out and listen to this truth whenever possible. One can hear it in *Sgaay*'s recitation of <u>X</u>*uuya* <u>K</u>*aagang.ngas,* and in the words of Mabel Williams. Oral histories are rooted in their own particular geographies, in their own climates, and in their own communities, where they have primal agency. Precision is the key that, paradoxically, unlocks the deeper truth. Once must honour local knowledge. And, as I have learned, one must recognize the role of oral histories – and those recorded in wood, and on argillite and silver – as teachings. They are not relics from the past; they move with us into the future and their relevance is undimmed. Standing on a street or on a beach, one does not experience the speed with which the earth is turning because one is moving at the same speed. It is the same with these histories; they are moving at the same speed as we are, and they retain their inner truth. One can smile

at *Galaga snaanga*'s predicament, and see at the same time that what this story teaches applies at every level and in every aspect of our lives.

What is there left to discover about *Galaga snaanga*? He is obviously the key to Raven's success, but I have wondered why Raven would even need a sidekick. He has any number of gifts and could easily have flown out over the reef on his own to pick up the *tsaw*. *Da.a xiigang* appears to have made an artistic decision to create dramatic tableaux. Had he placed Raven alone in his canoe, with or without the figure below, the scene would have presented little more than a portrait with the suggestion of an allegorical theme. The inclusion of *Galaga snaanga* brings the moment to life. He claims our attention, he looks us directly in the eye, he appeals for mercy. He is like a child on a carnival ride who shares his mounting excitement with a watching parent. He is our witness, and time's witness. He represents each of us. If he were to write his story, it might begin, "Call me *Galaga snaanga*." To return his look is to become implicated, propelled forward by Raven's unspoken desire. In *Galaga snaanga*'s stare, does one detect a warning, or an invitation? Does one experience a shiver of anticipation? *Da.a xiigang*'s platters predict a great adventure, and tell us there will be no turning back.

According to *Sgaay*, as soon as Raven delivered the *tsaw* he carried on with his complicated, ingenious, and sometimes disgraceful adventures. But what of his helmsman? Plucked off the trunk of his hemlock tree, inscribed, jammed into the stern of a canoe, handed a paddle, sent to sea, and encouraged to stay the course while shuddering and reeling from serial orgasms, he must have realized that he would never become a lover or

a father, and that he would never return to his tree.

He had begun as a forest spirit, committed to cycles of opportunistic parasitism and slow decay. His task complete, he vanished from sight, never having known the love he made possible.

There was a moment aboard that canoe when everything could have been lost, when the world as we know it would have been stillborn. One figure, *Galaga snaanga*, stood between success and failure. I like to think that *Da.a xiigang* gave him human form in order to honour his steadfastness and his courage, virtues essential to the survival of every community and nation. *Galaga snaanga* did not give in. I have come to see him as the spirit of resistance. Thanks to *Da.a xiigang*, his spirit will take root in the imaginations of all who encounter these astonishing works. To paraphrase Ludwig Wittgenstein, "Images are also deeds."[4]

To invite the gods ruins our relationship with them but sets history in motion. A life in which the gods are not invited isn't worth living. It will be quieter, but there won't be any stories. And you could suppose that these dangerous invitations were in fact contrived by the gods themselves, because the gods get bored with men who have no stories.[1]

—ROBERTO CALASSO
The Marriage of Cadmus and Harmony

CODA

Researching something else entirely, I encountered the word "amadou." In both French and English it refers to tinder or punk. Amadou is traditionally prepared by collecting and drying bracket fungus, usually *Fomes fomentarius*, formerly known as *Ungulina fomentaria* or *Polyporus fomentarius*. When the top layer of this fungus is pounded, boiled, and dried, it makes excellent fuel for lighting fires and fuses. At one time amadou was used to carry embers from one location to another. It has also been employed as a sponge for medicinal and cosmetic purposes. It's extremely absorbent, and is apparently perfect for ridding dry flies of excess water while fishing.

Amadou derives from the Latin *amator*, or "lover," so named because of the intensity with which it burns once it catches fire. It entered French through the Provençal, and finds itself today at the heart of *amadouer*, "to coax." There cannot possibly be an etymological lineage or cultural or historical link between amadou and *Galaga snaanga*, although it's pleasing to be aware that bracket fungus was indispensable prior to the invention of safety matches, synthetic sponges, and the chemical water-repellents now favoured by fly fishermen. I especially like to imagine the courtly *Galaga snaanga* in breeches and frockcoat, scrubbed and coiffed – an impassioned lover in the Age of Romance. For if he was not an "amateur" in the stern of that canoe, on a mission of love, or coming to the assistance of love, or, more properly, to assist at the birth of love – and suffering in return love's ecstasies and indignities – then no one deserves that title.

ACKNOWLEDGMENTS

Many thanks to Marian Penner Bancroft; Dempsey Bob; John Broadhead; Hugh Brody; Susanna Browne; Neil Campbell; James Clifford; Christos Dikeakos; Karen Duffek; Greg Gibson; *Gid7ahl-Gudsllaay, Lalaxaaygans,* Terri-Lynn Williams-Davidson; Sarah Hill; Alan Hoover; Bill McLennan; Marie Mauzé; Ann-Marie Metten; Cindy Mochizuki; Shazia Hafiz Ramji; Les Smith; and Kevin Williams for their generous and thoughtful assistance. I'm especially grateful to Alan Hoover for sending me images of the argillite cockles, information about past exhibitions, and documents related to the Jelliman collection; to the cartographer John Broadhead, who generously and patiently reviewed the spelling of place names to ensure consistency with modern Haida orthographies; and to *Gid7ahl-Gudsllaay, Lalaxaaygans,* Terri-Lynn Williams-Davidson, for setting me on the right course.

A NOTE ON ORTHOGRAPHY

With a few exceptions, the Haida words in *Entering Time* conform to contemporary orthographical systems in use by Haida speakers. The sources for the Haida names and place names include the Skidegate Haida Language Glossary (Skidegate Haida Immersion Project, 2016) and the *Dictionary of Alaskan Haida* (Sealaska Heritage Institute, 2010). Many thanks to *Gid7ahl-Gudsllaay, Lalaxaaygans,* Terri-Lynn Williams-Davidson and John Broadhead for their assistance.

NOTES

PROLOGUE

1. Jacques Derrida, *Monolingualism of the Other; or, the Prosthesis of Origin*, trans. Patrick Mensah (Stanford: Stanford University Press, 1998), 55.

2. Truth and Reconciliation Commission of Canada, *Canada's Residential Schools: The History, Part 2, 1939 to 2000, Final Report of the Truth and Reconciliation Commission of Canada*, Volume 1 (Montreal and Kingston: McGill-Queen's University Press, 2015), 19. The phrase is from a report by J.E. Andrews, principal of the Presbyterian residential school in Kenora, Ontario, written in 1953.

3. See Chris Arnett, *The Terror of the Coast: Land Alienation and Colonial War on Vancouver Island and the Gulf Islands, 1849–1863* (Vancouver: Talonbooks, 1999).

4. Information about the journey by Marius Barbeau and Wolfgang Paalen to Haida Gwaii can be found in interviews with Barbeau available in the Canadian Museum of History cultural studies archives, Fonds: Carmen Roy (Acq. 2000-F0003), Dossier: « Les Mémoires de Marius Barbeau » (verbatim interview transcript in French). Please see the following two dossiers: 1957–58, 164–327, Box 624.f.10; and 1957–58, 492–652, Box 624.f.12.

5. Wolfgang Paalen, "Totem Art," Amerindian Number, *Dyn* (Mexico City) 4–5 (1943): 17.

6. Gustav Regler, *Wolfgang Paalen* (New York: Nierendorf Editions, 1946), 32. Most scholars agree that Paalen was the primary author of Regler's monograph.

7. Paalen, "Totem Art," 17.

8. Regler, *Wolfgang Paalen*, 11–12.

9. Ibid., 24–26.

10. André Breton, "Oceania" (1948), in André Breton, *Free Rein (La clé des champs)*, trans. Michel Parmentier and Jacqueline D'Amboise (Lincoln: University of Nebraska Press, 1995), 172.

11. Wolfgang Paalen, letter to William A. Newcombe, July 30, 1940, in Colin Browne, *I Had an Interesting French Artist to See Me This Summer: Emily Carr and Wolfgang Paalen in British Columbia* (Vancouver: Vancouver Art Gallery and Figure 1, 2016), 69.

12. Aldona Jonaitis, "Traders of Tradition: The History of Haida Art," in *Robert Davidson: Eagle of the Dawn*, ed. Ian M. Thom (Vancouver: Vancouver Art Gallery and Douglas & McIntyre, 1993), 9.

13. Paalen, "Totem Art," 18. By the time Paalen printed this article he'd met with the formidable George Gustav Heye, founder and director of the Museum of the American Indian in New York. Heye's primary rule for his buyers and collectors was: "No Tourist Material." Despite this purist instinct, his *aide-mémoire* to his collectors tellingly makes no mention of recording the creators' names, or of the locations where objects were made or acquired. Mary Jane Lenz, "No Tourist Material: George Heye and His Golden Rule," *American Indian Art Magazine* 29, no. 4 (Autumn 2004): 86–95, 105.

14. Paalen, *Dyn* 4–5: opposite 1. When Vancouver musicologist Dr. Ida Halpern was preparing the liner notes for her first Folkways recording, *Indian Music of the Pacific Northwest Coast* (1967), she included a reference to the difference of opinion about the history and provenance of the totem pole: "Some claim it is of recent origin, native to British Columbia. Others point to the totems of New Zealand and of the Polynesians. Opposing viewpoints on the age of the totems are held by Marius Barbeau, who claims white man's influence, and by Wolfgang Paalen, who believes they are pre-white." There was little written information about the Northwest Coast available at the time. She may have been attracted to Paalen's theories and to the reports of his first-hand experiences; she had certainly read "Totem Art." Perhaps they met in Vancouver in late August or early September 1939, two exiled Viennese Jews looking for a safe haven. See notes accompanying *Indian Music of the Pacific Northwest Coast*, collected and recorded by Dr. Ida Halpern, introduction and notes by Dr. Ida Halpern (New York: Folkways Records, Album FE4523, 1967), 9.

15. Miguel Covarrubias, *The Eagle, the Jaguar, and the Serpent: Indian Art of the Americas* (New York: Alfred A. Knopf, 1967), 183. Page 41 of the volume shows an ink drawing of a Haida silver bracelet that was at the time of first publication owned by Alice Rahon Fitzgerald, Paalen's first wife. It's possible that it was acquired when they were in British Columbia in 1939. With its twinned formlines and its subject matter, the Sea Bear, it does share a likeness to certain bracelets attributed to or inspired by Charles Edenshaw.

16. Regler, *Wolfgang Paalen*, 24–26.

17. Nika Collison, "Creating for Culture: Edenshaw's Haida Roots and Cultural Transformations," in *Charles Edenshaw*, ed. Robin K. Wright and Daina Augaitis, with Haida advisers Robert Davidson and James Hart (Vancouver: Vancouver Art Gallery; London: Black Dog Publishing, 2013), 26–27.

18. Chief 'Idansuu, James Hart, "Chief's Foreword," in *Charles Edenshaw*, ed. Wright et al., 10.

19. Leslie Drew and Douglas Wilson, *Argillite: Art of the Haida* (North Vancouver: Hancock House, 1980), 245–55, 288–91. See Bill McLennan and Karen

Duffek, "Placing Style: A Look at Charles Edenshaw's Bracelets Through Time," in *Charles Edenshaw*, ed. Wright et al., 127–39. See also Aaron Glass, ed., *Objects of Exchange: Social and Material Transformation on the Late Nineteenth-Century Northwest Coast* (New York: Bard Graduate Center: Decorative Arts, Design History, Material Culture, 2010), 92–96, 176–79; Robin K. Wright, "Two Haida Artists from Yan: Will John Gwaytihl and Simeon Stilthda Please Step Apart?" in *American Indian Art Magazine* 23, no. 3 (Summer 1998): 42–57; and Robin K. Wright, *Northern Haida Master Carvers* (Seattle: University of Washington Press; Vancouver: Douglas & McIntyre, 2001), vii, 3–5.

20. George F. MacDonald, *Haida Art* (Seattle: University of Washington Press, 1996), 219.

21. *Guujaaw*, Gary Edenshaw, "This Box of Treasures," in *All That We Say Is Ours: Guujaaw and the Reawakening of the Haida Nation*, by Ian Gill (Vancouver: Douglas & McIntyre, 2009), viii.

1 | FOR THE PERPETUATION OF THE WORLD

1. Charles F. Newcombe, *Guide to Anthropological Collection in the Provincial Museum* (Victoria: King's Printer, 1909), 8, 10, 12. Today, the traditional village of Massett, or Old Massett, is spelled with two *t*s. The commercial village of Masset is spelled with a single *t*.

2. Douglas Cole, *Captured Heritage: The Scramble for Northwest Coast Artifacts* (Vancouver: Douglas & McIntyre, 1985), 195.

3. Franz Boas, *Primitive Art* (New York: Dover, 1955), 212. The chapter from which this description is taken, "Art of the North Pacific Coast of North America," is a revised version of an essay first published in 1897 by the American Museum of Natural History entitled "The Decorative Art of the Indians of the North Pacific Coast of America." Edenshaw would have been in his late fifties in 1897. Both Boas and Newcombe refer to him as Charles Edensaw.

4. Collison, "Creating for Culture," 25.

5. Wright, *Northern Haida Master Carvers*, 6.

6. Collison, "Creating for Culture," 25–26.

7. Chief *'Idansuu*, James Hart, "Chief's Foreword," 10.

8. *Guud San Glans*, Robert Davidson, "Da.a xiigang, Charles Edenshaw, 'Master Carpenter'," in *Charles Edenshaw*, ed. Wright et al., 107.

9. Steven C. Brown, *Native Visions: Evolution in Northwest Coast Art from the Eighteenth through the Twentieth Century* (Seattle and Vancouver: Seattle Art Museum and Douglas & McIntyre, 1998), 3.

10. *Gid7ahl-Gudsllaay, Lalaxaaygans*, Terri-Lynn Williams-Davidson, "How Raven Gave Females Their Tsaw," in *Charles Edenshaw*, ed. Wright et al., 61. Juan Pérez was the captain of the Spanish warship *Santiago*, which anchored off the northern tip of Haida Gwaii at what is now called

Langara Island (*K'iis Gwayee*) in July 1774.

11. Ibid. The steersman is a character found in the world's oldest narratives. He is the keeper of the gate, the protector, and the one who ferries the fallen hero across the water from the sorrows of the present to the mysteries of the afterlife. Think of the Achaean boatman, Charon, who transports souls across the swampy Acheron to Hades. Gilgamesh, the King of Uruk, seeks solace after the death of his friend Enkidu by asking the ferryman Ur-shanabi to transport him across the flood to eternal life. The brave helmsman Baios is ordered by Odysseus – and what man is more like Raven than Odysseus – to keep the ship steady as they pass the whirlpool of Charybdis. It is a decision that will condemn some but not all his sailors to a gruesome sacrifice in six-headed Scylla's stinking cave. In Robert Fagles's translation, Odysseus cries out:

> You, helmsman, here's your order – burn it in your mind –
> the steering-oar of our rolling ship is in your hands.
> Keep her clear of that smoke and surging breakers,
> Head for those crags or she'll catch you off guard,
> She'll yaw over there – you'll plunge us all in ruin.

Homer, *The Odyssey*, trans. Robert Fagles, intro. and notes Bernard Knox (New York: BCA, 2003), 278, lines 236–40. George Chapman's translation of *The Odyssey*, completed and published in 1614–1615, cannot be improved upon for sheer poetic achievement. Odysseus's command speaks to the helmsman's skill:

> In particular then,
> I told our pilot, that past other men
> He most must bear firm spirits, since he sway'd
> The continent that all our spirits convey'd,
> In his whole guide of her. He saw there boil
> The fiery whirlpools that to all our spoil
> Inclos'd a rock, without which he must steer,
> Or all our ruins stood concluded there.

Chapman's Homer: The Iliad and The Odyssey, trans. George Chapman, intro. Jan Parker (London: Wordsworth's Classics, 2000), 652, lines 320–27.

12. The term "salmon-trout's-head" is used to describe a design element that consists of an ovoid with inner ovoids and an inner eye. It was introduced by Bill Holm in his 1965 book *Northwest Coast Indian Art: An Analysis of Form*. In the "Preface to the 50th Anniversary Edition," he writes: "My goal in inventing terminology was always to create really descriptive words. That I sometimes failed in this, I regret. For example, the term salmon-trout's-head was lifted bodily from George Emmons' list of terms given him by Tlingit weavers. (Emmons, 1907: Fig. 559). I tend now to

call this and related design elements elaborated inner ovoids, since they almost never represent a fish's head." Bill Holm, "Preface to the 50th anniv ed.," in *Northwest Coast Indian Art: An Analysis of Form*, 50th Anniversary Ed. (Seattle: Bill Holm Center for the Study of Northwest Coast Art in association with the University of Washington Press, 2015), xxi.

13. *Gid7ahl-Gudsllaay, Lalaxaaygans*, Williams-Davidson, "How Raven Gave Females Their Tsaw," 61. I am grateful to Mabel Williams for the name *Galaga snaanga*. At first I found it difficult to think of this heroic figure as "ugly," but in a way it heightens the improbability of his success, which is crucial to the story. He really is the last one you'd expect to be successful.

14. Jordan Lachler, *Dictionary of Alaskan Haida* (Juneau: Sealaska Heritage Institute, 2010), 348.

15. *Gid7ahl-Gudsllaay, Lalaxaaygans*, Terri-Lynn Williams-Davidson, "The Power of Narrative *Gyaehlandáa*," in *Charles Edenshaw*, ed. Wright et al., 42.

16. *Gid7ahl-Gudsllaay, Lalaxaaygans*, Williams-Davidson, "How Raven Gave Women Their *Tsaw*," 61; and personal communication, November 28, 2016.

17. John Reed Swanton, *Haida Texts and Myths, Skidegate Dialect, Recorded by John R. Swanton* (Washington: Smithsonian Institution, Bureau of American Ethnology Bulletin 29, 1905), 126.

18. *Gid7ahl-Gudsllaay, Lalaxaaygans*, Williams-Davidson, "How Raven Gave Women Their *Tsaw*," 61.

19. *Gid7ahl-Gudsllaay, Lalaxaaygans*, Williams-Davidson, "The Power of Narrative Gyaehlandáa," 42.

20. *Gid7ahl-Gudsllaay, Lalaxaaygans*, Williams-Davidson, "How Raven Gave Females Their *Tsaw*," 61.

21. William Carlos Williams, *Paterson*, rev. ed., prepared by Christopher Mac-Gowan (New York: New Directions, 1995), 4.

22. Walter Benjamin, "Categories of Aesthetics" (1919–1920), in *Walter Benjamin: Selected Writings, Volume 1, 1913–1926*, ed. Marcus Bullock and Michael W. Jennings, trans. Rodney Livingstone (Cambridge, MA, and London: Harvard University Press, 1996), 221.

2 | RAVEN

1. Wilson Duff, with contributory articles by Bill Holm and Bill Reid, *Arts of the Raven: Masterworks by the Northwest Coast Indian* (Vancouver: Vancouver Art Gallery, 1967), n.p.

2. Wright, "Charles Edenshaw and Melting Glaciers," 155; Robin K. Wright, "Two Haida Artists from Yan," 42. A succinct analysis by anthropologist Peter Macnair of Edenshaw's techniques and innovations may be found in the catalogue for the Royal British Columbia Museum's 1971 exhibition *The Legacy: Tradition and Innovation in Northwest Coast Indian Art*. See Peter L. Macnair, "Art and Artists in a Changing Society," in Peter L. Macnair, Alan L. Hoover, and Kevin Neary, *The Legacy: Tradition and*

 Innovation in Northwest Coast Indian Art, 2nd ed. (Victoria: Royal British
 Columbia Museum, 2007), 63–81.

3. Swanton, *Haida Texts and Myths,* 146.

4. Alan L. Hoover, "Charles Edenshaw and the Creation of Human Beings,"
 in *American Indian Art Magazine* 8, no. 3 (Summer 1983): 67.

5. MacDonald, *Haida Art,* 7.

6. Henry Tate, *The Porcupine Hunter and Other Stories: The Original Tsimshian
 Texts of Henry Tate,* ed. Ralph Maud (Vancouver: Talonbooks, 1993), 123.

7. Arthur Green, "Teachings of the Hasidic Masters," in *Back to the Sources:
 Reading the Classic Jewish Texts,* ed. Barry W. Holtz (New York: Simon
 & Schuster, 2006), 361–401. Yehudah Leib Alter lived from 1847 to 1905.

8. Robert Davidson, "The World Is as Sharp as the Edge of a Knife," in *Robert
 Davidson: A Voice from the Inside,* ed. Derek Simpkins (Vancouver: Derek
 Simpkins Gallery of Tribal Art, 1992), 7.

9. John R. Swanton, *The Haida of Queen Charlotte Islands by John R. Swanton,*
 in *Memoirs of the American Museum of Natural History,* vol. VIII (Leiden,
 Netherlands: E. J. Brill, 1905), 137, 145; and Wright, *Northern Haida Master
 Carvers,* 273–74. Swanton's text is a reprint of *Contributions to the Ethnology
 of the Haida,* originally published as Part 1 of Volume V of Franz Boas,
 ed., *The Jesup North Pacific Expedition* (New York: Memoir of the American
 Museum of Natural History, 1905).

10. Bill McLennan and Karen Duffek, *The Transforming Image: Painted Arts
 of Northwest Coast First Nations* (Vancouver: Douglas & McIntyre,
 2007), 113–14.

11. MacDonald, *Haida Art,* 66–67.

12. Ibid., 67–91. MacDonald reproduces images of fourteen of these masks in
 Haida Art, including one on the front cover of the dust jacket.

13. McLennan and Duffek, "Placing Style," 131; and Wright, *Northern Haida
 Master Carvers,* 246–47.

14. Ibid. (both McLennan and Duffek, and Wright).

15. Wright, *Northern Haida Master Carvers,* 290–91.

16. Ibid., 234, 355.

17. Ibid., 84.

18. Thomas H. Ainsworth, "The Art of the Haidas," in *The Art, Historical, and
 Scientific Association Museum and Art Notes* (Vancouver), second series,
 1, no. 3 (September 1950): 16–17. Ainsworth's unwarranted characteriz-
 ation of Edenshaw's tools seems to have been designed to add a note of
 "colourful" primitivism to the scene. One of Edenshaw's silver engrav-
 ing tools, with a bone handle, is shown in the Vancouver Art Gallery
 Charles Edenshaw catalogue (19); others are also shown (113). It's clear
 that he cherished his tools. Like most sculptors, he would have created
 and refined the tools he needed, and they would have been made with
 the same precision and attention to detail that went into his finished

works. The following year, in July 1883, Lord Lorne, on behalf of Queen Victoria, signed a proclamation urging Indigenous people to "abandon the Custom" of the potlatch. It was followed in 1885 by the Dominion government's legislated suppression of the potlatch, which has come to be known as the "Potlatch law." See Douglas Cole and Ira Chaikin, *An Iron Hand Upon the People: The Law Against the Potlatch on the Northwest Coast* (Vancouver: Douglas & McIntyre, 1990), 16.

19. See Wright et al., *Charles Edenshaw*.

20. Drew and Wilson, *Argillite,* 263.

21. Newcombe, "Introductory," in *Guide to Anthropological Collection in the Provincial Museum* (Victoria: King's Printer, 1909).

22. Ibid., title page verso.

3 | DA.A XIIGANG

1. Margaret B. Blackman, *During My Time: Florence Edenshaw Davidson, A Haida Woman,* rev. and enlarged ed. (Vancouver: Douglas & McIntyre, 1992), 69–70; and Wright, *Northern Haida Master Carvers,* 173.

2. Blackman, *During My Time,* 53, 70.

3. Ibid., 70.

4. Robin K. Wright and Mandy Ginson, "Chronology," 223. *Ginaawaan* was a Kaigani Haida chief from the village of *Hlankwa'áan* (Klinkwan) on Prince of Wales Island, Alaska.

5. Blackman, *During My Time,* 72.

6. Ibid., 63–64.

7. Ibid., 68.

8. Wright, *Northern Haida Master Carvers,* 174.

9. Collison, "Creating for Culture," 21.

10. Robert Davidson, "Reclaiming Haida Culture," in *The Spirit Within: Northwest Coast Native Art from the John H. Hauberg Collection,* ed. Helen Abbott et al. (Seattle: Seattle Art Museum, 1995), 97.

11. Blackman, *During My Time,* 72.

12. Ibid., 75–76.

13. Ibid., 86.

14. Chief *'Idansuu,* James Hart, "Chief's Foreword," 10.

15. Wright, *Northern Haida Master Carvers,* 286, 335.

16. Karen Duffek, *Bill Reid: Beyond the Essential Form,* foreword by Michael M. Ames (Vancouver: University of British Columbia Press and UBC Museum of Anthropology, Museum Note No. 19, 1993), 4–5. See also Bill Reid, "Curriculum Vitae 1," in *Solitary Raven: The Essential Writings of Bill Reid,* ed. with commentary and notes by Robert Bringhurst, afterword by Martine Reid, 2nd expanded ed. (Vancouver: Douglas & McIntyre, 2009), 116–17.

17. The term "imperialism," used to describe the national enterprise of empire building, began to take on a positive note in the West in the 1880s. See Timothy H. Parsons, *The Rule of Empires: Those Who Built Them, Those Who Endured Them, and Why They Always Fall* (Oxford: Oxford University Press, 2010), 297.

18. Tokutomi Sohō, *The Future Japan* (1886), quoted in Pankaj Mishra, *From the Ruins of Empire: The Intellectuals Who Remade Asia* (New York: Farrar, Straus and Giroux, 2012), 3. This condemnation of Western imperialism in *The Future Japan* by Tokutomi Sohō (1863–1957) was uncompromising.

19. Collison, "Creating for Culture," 21.

20. Emily Carr, *Klee Wyck* (Vancouver: Douglas & McIntyre, 2003; originally published Toronto: Oxford University Press, 1941), 53.

21. Doris Shadbolt, *The Art of Emily Carr* (Toronto: Clark, Irwin; North Vancouver: Douglas & McIntyre, 1979), 80, 81, 204.

22. Carr, *Klee Wyck*, 54.

23. Cole and Chaikin, *An Iron Hand Upon the People*, 56.

24. Marianne Jones, "Guud San Glans: Eagle of the Dawn," in *Robert Davidson: Eagle of the Dawn*, ed. Ian M. Thom (Vancouver: Vancouver Art Gallery andh Douglas & McIntyre, 1993), 126.

25. Cole and Chaikin, *An Iron Hand Upon the People*, 56–58; and Blackman, *During My Time*, 55, 59.

26. Blackman, *During My Time*, 66, 144.

27. Robert Bringhurst, *A Story as Sharp as a Knife: The Classical Haida Mythtellers and Their World*, 2nd ed. (Vancouver: Douglas & McIntyre, 2011), 448.

28. Blackman, *During My Time*, 144.

29. Ibid., 87.

30. Ibid., 79.

4 | TRADE

1. Jackson Lears, "The Long Con," review of *The Age of Acquiescence: The Life and Death of American Resistance to Organized Wealth and Power* by Steve Fraser. *London Review of Books* 37, no. 14 (July 16, 2015): 28. According to Fraser, in the late 1800s, "the richest 1 percent [of Americans] owned 51 per cent of all real and personal property, while the bottom 44 per cent came away with 1.1 per cent."

2. Blackman, *During My Time*, 84.

3. MacDonald, *Haida Art*, 131.

4. An advertisement for D. Cochrane's store (Groceries, Dry Goods, Hardware) in the *Queen Charlotte Islander* newspaper for Monday, November 18, 1912, written in romanized Chinook Jargon, promises that if a boat's engine needs parts Cochrane will order them from Vancouver immediately and will not rob you. Chinook Jargon website. chinookjargon.com. Blog

posting September, 26, 2016. The text reads: *"Tillicum, Spose mika engine cockshut, Cochrane hyak mamook chahko chee iktas kopa Vancouver, tenas mahkook. Mika cumtux Cochrane halo kapswalla."*

5. Daina Augaitis et al., eds., *Raven Travelling: Two Centuries of Haida Art* (Vancouver: Vancouver Art Gallery and Douglas & McIntyre, 2008), 125.

6. Wright, *Northern Haida Master Carvers*, 99.

7. See ibid., 156; and McLennan and Duffek, "Placing Style," 135.

8. Wright, *Northern Haida Master Carvers*, 106.

9. Ainsworth, "The Art of the Haidas," 19. On the same page, Ainsworth adds a note regarding the chemical analysis of argillite. Its composition is said to be as follows: silica, 44.6 percent; alumina, 36.61 percent; peroxide of iron, 8.46 percent; water, 7.15 percent; carbonaceous material, 3.18 percent; with a trace of lime.

10. Peter L. Macnair and Alan L. Hoover, *The Magic Leaves: A History of Haida Argillite Carving*, 2nd ed. (Victoria: Royal British Columbia Museum, 2002), 23–24.

11. Karen Duffek, "The Present Moment: Conversations with *guud san glans*, Robert Davidson," in Karen Duffek, ed. *Robert Davidson: The Abstract Edge*, ed. Karen Duffek. Museum Note No. 38 (Vancouver and Ottawa: Museum of Anthropology at the University of British Columbia and National Gallery of Canada, 2004), 42.

12. Wright, *Northern Haida Master Carvers*, 275–77.

13. Robert Campbell, *In Darkest Alaska: Travel and Empire Along the Inside Passage* (Philadelphia: University of Pennsylvania Press, 2007), 166.

14. Cole, *Captured Heritage*, 196.

15. Ibid., 197.

16. *Frohman Trading Co.: Alaska, California, and Northern Indian Baskets and Curios* (Portland: Binford & Mort., 1902), 3.

17. Ainsworth, "The Art of the Haidas," 16.

18. Ibid., 6–11. In calculating the relative value in 2015 of a U.S. dollar in 1902, one must consider more than the simple purchasing power of the same dollar today. The website "Measuring Work" estimates that if the standard of living had remained as it was in 1902, the price of a one dollar object would, in 2015, be US$28.40. The value of that object in 2015 terms would be US$68.30. The skilled-labour value of the object would be at least US$206.00, based on production worker compensation. See "Seven Ways to Compute the Relative Value of a U.S. Dollar Amount – 1774 to Present" on the "Relative Values – U.S. $" page of the Measuring Worth website. www.measuringworth.com.

19. Emily Carr, *Sister and I in Alaska* (Vancouver: Figure 1, 2014; diary recorded 1907, not previously published), n.p. Journal page 35. "St. Juno" was the name given by Emily Carr and her sister to an imposing, self-important woman residing in their hotel in Sitka, Alaska.

20. Paula Blanchard, *The Life of Emily Carr* (Vancouver and Toronto: Douglas & McIntyre, 1988), 132.

21. Macnair, "From the Hands of Master Carpenter," in Daina Augaitis et al., eds., *Raven Travelling: Two Centuries of Haida Art*, 100.

22. MacDonald, *Haida Art*, 219.

23. Hoover, "Charles Edenshaw: His Art and Audience," *American Indian Art Magazine* 20, no. 3 (Summer 1995): 45.

24. McLennan and Duffek, "Placing Style," 133.

25. Ibid., 135.

26. Blackman, *During My Time*, 80.

27. Robin K. Wright, "*Hlgas7agaa:* Haida Argillite," in *The Spirit Within: Northwest Coast Native Art from the John H. Hauberg Collection.* ed. Helen Abbott et al. (Seattle: Seattle Art Museum, 1995), 144.

5 | THREE ARGILLITE PLATTERS

1. See Wright et al., *Charles Edenshaw*, 58–60.

2. Wendi Norris, *Philosopher of the Possible: Wolfgang Paalen* (San Francisco: Gallery Wendi Norris, 2013), 30, 36.

3. Hoover, "Charles Edenshaw and the Creation of Human Beings," 67; and Alan L. Hoover, "Charles Edenshaw and the Development of Narrative Structure in Nineteenth-Century Haida Art," in *Charles Edenshaw,* ed. Wright et al., 71.

4. Drew and Wilson, *Argillite,* 206.

5. Macnair, "From the Hands of Master Carpenter," 94.

6. Bringhurst, "The Audible Light in the Eyes: In Honor of Claude Lévi-Strauss," in *Coming to Shore: Northwest Coast Ethnology, Traditions, and Visions,* ed. Marie Mauzé et al. (Lincoln: University of Nebraska Press, 2004), 177.

7. Wright et al., *Charles Edenshaw*, 59–60; and Macnair, "From the Hands of Master Carpenter," 95.

8. Bringhurst, "The Audible Light in the Eyes," 178.

9. Wright, "*Hlgas7agaa*: Haida Argillite," 137. See also Hoover, "Charles Edenshaw and the Creation of Human Beings," 67.

10. McLennan and Duffek, "Placing Style," 207.

11. See "Cane Ferrule, pre-1929," in *Charles Edenshaw,* Wright et al., 213 caption; and Hoover, "Charles Edenshaw and the Creation of Human Beings," 67.

12. Hoover, "Charles Edenshaw and the Creation of Human Beings," 66–67.

13. Ibid.

14. McLennan and Duffek, "Placing Style," 207.

15. Drew and Wilson, *Argillite,* 206.

16. McLennan and Duffek, "Placing Style," 207.

17. Dempsey Bob, text written to accompany the exhibition *I Had an Interesting French Artist to See Me This Summer: Emily Carr and Wolfgang Paalen in British Columbia,* Vancouver Art Gallery, June 1 to November 13, 2016, curated by Colin Browne. The full text reads: "Our carvers were true artists, great artists, and all great art goes into abstraction. The Surrealists were the first ones to recognize this. What they saw was the freedom – the freedom of forms, the freedom of ideas. One story could be anything: a bowl, a mask, a totem pole, that's how creative they were. The Surrealists were inspired by the life in those old pieces. It was the spiritual they were after. The art was powerful." Many thanks to Dempsey Bob.

6 | BELOW THE CANOE

1. MacDonald, *Haida Art,* 8.
2. Ibid.
3. McLennan and Duffek, "Placing Style," 122.
4. *Gid7ahl-Gudsllaay, Lalaxaaygans,* Williams-Davidson, "How Raven Gave Females Their Tsaw," 61; and "The Power of Narrative *Gyaehlandáa,*" 42.
5. *Gid7ahl-Gudsllaay, Lalaxaaygans,* Terri-Lynn Williams-Davidson, personal communication, December 5, 2016.
6. Blackman, *During My Time,* 29.
7. A person familiar with the European theatrical tradition can't help but be reminded of the linked masks that represent Tragedy and Comedy.
8. MacDonald, *Haida Art,* 11.
9. Ibid., quoting Emmons's 1907 text "The Chilcat Blanket, with Notes on the Blanket by Franz Boas."
10. We know the cylinders spread out to form large land masses from Swanton, *Haida Texts and Myths,* 111–12. "The Islands at the Boundary of the World" is from Robert Bringhurst and Ulli Steltzer, *The Black Canoe: Bill Reid and the Spirit of Haida Gwaii,* 2nd ed. (Vancouver and Toronto: Douglas & McIntyre, 1995), 7.
11. Swanton, *Haida Texts and Myths,* 112. More recently, the name of the archipelago with its 150 beautiful, life-sustaining islands, has been simplified to "Haida Gwaii."
12. Bringhurst and Steltzer, *The Black Canoe,* 64–67, 166. Wright, *Northern Haida Master Carvers,* 125, 145. Variant spellings include *Gunàkadèt, Gonankadet, Gonakada, Qo'naqAdA, qu'nequde,* and *Qo'naqad.*
13. McLennan and Duffek, "Placing Style," 129.
14. MacDonald, *Haida Art,* 11.
15. Wright, *Northern Haida Master Carvers,* 142–45. Albert Edward Edenshaw's "Myth House" (*K'iigangng*) was located in the village of *K'yuusda 'Lngee* (Kiusta) at the northern end of Haida Gwaii. A *sk'il* is a supernatural being.
16. Antone Evan, "Raven," in *Coming to Light: Contemporary Translations of*

the *Native Literatures of North America,* ed. and intro. Brian Swann (New York: Random House, 1994), 97.

17. Blackman, *During My Time,* 177. Sadly, the longhouse was targeted by an arsonist and burned to the ground in 1981.

18. Wright, "*Hlgas7agaa:* Haida Argillite," 142.

7 | THE BRACKET-FUNGUS STEERSMAN

1. See Aldona Jonaitis, ed., *Chiefly Feasts: The Enduring Kwakiutl Potlatch* (New York: American Museum of Natural History; Seattle: University of Washington Press; Vancouver: Douglas & McIntyre, 1991), 109. I am grateful to Alan Hoover for referring me to the feast-dish lids.

2. Michael Nicoll Yahgulanaas, "Raven Kept Walking," in *Old Growth,* ed. Liz Park (Vancouver: Red Leaf, 2011), 149.

3. Gid7ahl-Gudsllaay, Lalaxaaygans, Williams-Davidson, "How Raven Gave Females Their Tsaw," 61.

4. Swanton, *Haida Texts and Myths,* 129.

5. Bringhurst and Steltzer, 57–58. A second bronze casting titled *The Spirit of Haida Gwaii, the Jade Canoe* is displayed in the International Terminal at Vancouver International Airport.

6. As another example, one might consider the young man in Titian's *Venus with an Organist and Cupid* (1550–1555).

7. Louis Aragon and André Breton, "The Fiftieth Anniversary of Madness," in André Breton, *What Is Surrealism: Selected Writings,* ed. and intro. Franklin Rosemont (New York: Pathfinder, 2008), Book 2, 424. This brief article was first published in *La Révolution Surréaliste* 11 (March 1928), and was reprinted in English in the Surrealist issue of the journal *This Quarter* in September 1932.

8. Sigmund Freud, *An Autobiographical Study,* trans. James Strachey (London: Hogarth Press and Institute of Psycho-Analysis, 1935), 21–22.

9. Swanton, *Haida Texts and Myths,* 126–27.

10. Gid7ahl-Gudsllaay, Lalaxaaygans, Williams-Davidson, "Weaving Together Our Future: The Interaction of Haida Laws to Achieve Respectful Co-existence," *Indigenous Legal Orders and the Common Law,* Paper 6.2, 2012, 6.2.1–6.2.2.

11. Gid7ahl-Gudsllaay, Lalaxaaygans, Williams-Davidson, "How Raven Gave Females Their Tsaw," 61. The literal translation of *Tsaw Gwaay.yaay* is "Vagina Island" or, more modestly, "Pudendum Island." The expression *xaawlagihl* – "to become sweet" – refers to achieving orgasm.

12. Ibid.

13. Ibid.

14. Gid7ahl-Gudsllaay, Lalaxaaygans, Terri-Lynn Williams-Davidson, personal communication, December 5, 2016.

8 | RAVEN TRAVELLING / XUUYA KAAGANG.NGAS

1. Bringhurst, *A Story as Sharp as a Knife*, 2nd ed. (2011), 75.

2. Ibid., 76. *Sgaay* was born ca. 1827 and died ca. 1905.

3. Ibid., 69.

4. Ibid., 72.

5. In his introduction to *Haida Texts and Myths, Skidegate Dialect*, Swanton writes, "My interpreter was Henry Moody, who belongs to the principal family of Skedans, Those-Born-at-Qa'gials, and has since become its chief." See Swanton, *Haida Texts and Myths*, 5. Moody (ca. 1871–1945) was of the *Gak'yaals Kiigaway* Raven clan of *K'uuna* (Skedans). His father, *Gumsiiwa*, Job Moody, was of the *Staa'stas Xàaydaraay* Eagle clan of *Hlkinul Llnagaay* (Cumshewa) and was a hereditary chief. See John Enrico, ed. and trans., *Skidegate Haida Myths and Histories*, collected by John R. Swanton (Skidegate, B.C.: Queen Charlotte Islands Museum Press, 1995), 9–10. Cumshewa is where Carr first sketched *Big Raven*.

6. Ibid., 33.

7. Charles Hill-Tout, "Haida Stories and Beliefs," *Report on the Ethnological Survey of Canada*, Appendix I (Ottawa: Ethnological Survey of Canada, 1898), 5.

8. See Enrico, *Skidegate Haida Myths and Histories*, 183.

9. Ghandl of the *Qayahl Llaanas, Nine Visits to the Mythworld*, trans. Robert Bringhurst (Vancouver: Douglas & McIntyre, 2000), 17–18.

10. *Skaay* of the *Qquuna Qiighawaay, Being in Being: The Collected Works of a Master Haida Mythteller*, ed. and trans. Robert Bringhurst (Vancouver: Douglas & McIntyre, 2001), 332. The second edition of Bringhurst's *A Story as Sharp as a Knife* (2011) reproduces a detail from the Chicago platter on its cover. In terms of chronology, Bringhurst proposes that the Chicago platter was made first, followed by the Seattle platter, and finally the Dublin platter. (389).

11. Swanton, *Haida Texts and Myths*, 126. Swanton prefaces his version of "Raven Traveling" with "[Told by John Sky of Those-Born-at-Skedans]." In his notes, Swanton suggests that the "Snowbird" is another name for the Oregon junco (148).

12. Swanton, *Haida Texts and Myths*, 126.

13. Ibid., 148.

14. Ibid., 126.

15. Enrico, *Skidegate Haida Myths and Histories*, 74–75.

16. Swanton, *Haida Texts and Myths*, 127.

17. Bringhurst, *A Story as Sharp as a Knife*, 2nd ed. (2011), 225.

18. Enrico, *Skidegate Haida Myths and Histories*, 63.

19. Gid7ahl-Gudsllaay, *Lalaxaaygans*, Williams-Davidson, "How Raven Gave Females Their Tsaw," 61.

20. Cole, *Captured Heritage*, 188–92.

21. Hoover, "Charles Edenshaw and the Creation of Human Beings," 64.

22. Macnair, "From the Hands of Master Carpenter," 96. Macnair writes: "When they first emerged from the clamshell humans were neither male nor female. To differentiate them, Raven set out in his canoe, steered by trusty Fungus Man, to spear chitons, which he then placed on the unsexed proto-women to create female genitalia."

23. Hoover, "Charles Edenshaw and the Creation of Human Beings," 63–64.

24. Lachler, 78, 508.

9 | WHY FUNGUS MAN?

1. Bringhurst, *A Story as Sharp as a Knife*, 2nd ed. (2011), 70.

2. André Breton, "Ascendant Sign (1947)," in *Free Rein (La clé des champs)*, trans. Michel Parmentier and Jacqueline d'Amboise (Lincoln: University of Nebraska Press, 1995), 105. I have adapted the translation. Please see André Breton, "Signe Ascendant (1947)" in *Signe Ascendant* (Paris: nrf/ Éditions Gallimard, 2013), 8.

3. William Blake, "The Marriage of Heaven and Hell," Plate 3 (engraved ca. 1790), in *The Poetry and Prose of William Blake*, rev. ed., ed. David Erdman, commentary by Harold Bloom (Garden City, NY: Doubleday, 1970), 34.

4. Gid7ahl-Gudsllaay, Lalaxaaygans, Williams-Davidson, "How Raven Gave Females Their Tsaw," 61.

5. Swanton, *Haida Texts and Myths*, 126.

6. Enrico, *Skidegate Haida Myths and Histories*, 63.

7. Haim Nahman Bialik, "Revealment and Concealment in Language" (1915), *Revealment and Concealment: Five Essays*, afterword by Zali Gurevitch (Jerusalem: Ibis Editions, 2000), 16.

8. Ibid., 20.

9. Bringhurst, *A Story as Sharp as a Knife: The Classical Haida Mythtellers and Their World*, 1st ed. (Vancouver: Douglas & McIntyre, 1999), 282; and Bringhurst, *A Story as Sharp as a Knife*, 2nd ed. (2011), 281.

10. *Skaay* of the *Qquuna Qiighawaay*, *Being in Being*, 336. This translation also appears in Bringhurst's essay "The Audible Light in the Eyes: In Honor of Claude Lévi-Strauss." See Mauzé et al., *Coming to Shore*, 179. In his preface to *Being in Being*, Bringhurst explains that he made "revisions and corrections" to the translations as he continued with his research. "As a result," he writes, "there are minor inconsistencies between translations in this volume [*Being in Being*] and the excerpts published two years earlier in the first edition of *A Story as Sharp as a Knife* (1999). The words sometimes differ slightly, and the line numbers do not always jibe. I hope these incidental variations will cause no inconvenience" (7). As noted, the lines relating to the creation of *Galaga snaanga* in the first edition of *A Story as Sharp as a Knife* remain the same in the second edition (2011).

11. Swanton, *Haida Texts and Myths*, 233.

12. Bringhurst, *A Story as Sharp as a Knife*, 2nd ed. (2011), 281.

13. Swanton, *Haida Texts and Myths*, 126.

14. Enrico, *Skidegate Haida Myths and Histories*, 63.

10 | THE POLYPORES

1. I'm grateful to Christos Dikeakos for drawing my attention to the paintings of Northwest Coast crest figures on individual bracket fungi by Alex Alexie (or Alexcee). Alex was the grandson of Frederick Alexie (or Alexcee), whose father was Iroquois and whose mother was Tsimshian. A gifted *halaayt* carver of ceremonial regalia and religious icons for churches, Frederick Alexie was born at Port Simpson (*Lax Kw'alaams*) in 1853 and died during the 1940s. His work was included in the 1927 *Exhibition of Canadian West Coast Art: Native and Modern* in Ottawa. Marius Barbeau celebrated him as a "primitive" artist: "The totem-like features and plastic treatment of the figures shown here belong partly to the art of the North West Coast Indians and partly to the conceptions of the white people within the fold of the church. This blend of two cultures in Alexie's carvings is a rare accident at the frontiers of two worlds" (Barbeau 1945, 22). See Ronald William Hawker, "Frederick Alexie: Euro-Canadian Discussions of a First Nations' Artist." Information on Alex Alexie is scarce, but we can assume that he sold his conk paintings to tourists cruising the coast in the 1920s and 1930s and in curio shops in British Columbia. It is impossible to know how many of these bracket-fungus crest paintings are in existence today. They were painted with conviction and careful attention to detail. Like his grandfather Frederick, Alex also seems to have made art at the "frontiers of two worlds."

2. Robert A. Blanchette, Brian D. Compton, Nancy J. Turner, and Robert L. Gilbertson, "Nineteenth Century Shaman Grave Guardians Are Carved *Fomitopsis officinalis* Sporophores," *Mycologia* 84, no. 1 (1992): 123. The basidiocarp is the spore-bearing underside of certain fungi.

3. Ibid., 119.

4. *Gid7ahl-Gudsllaay, Lalaxaaygans*, Williams-Davidson, "How Raven Gave Females Their Tsaw," 61.

5. Blanchette et al., 119.

6. Ibid., 123.

7. Ibid.

8. *Economic Gain Spatial Analysis*, RFP EGSA-1 (*Non-Timber Forest Products*), *Revised Final Report* (Bowen Island, B.C.: Cognetics International Research Inc., March 2004), 28.

9. Wright, "*Hlgas7agaa*: Haida Argillite," 141.

10. *Economic Gain Spatial Analysis*, 29.

11. McLennan and Duffek, "Placing Style," 207.

12. Bill McLennan, personal communication, January 29, 2015.

13. In his note on Dionysus's phallus, Roberto Calasso observes that it's "more hallucinogenic than coercive. It is close to a fungus, or a parasite in nature, or to the toxic grass stuffed in the cavity of the thyrsus" (Calasso, *The Marriage of Cadmus and Harmony*, trans. Tim Parks [New York: Vintage Books, 1994], 44–45). Dionysus, one is given to understand, flowed into women and made their parts sing like musical instruments.

14. William Shakespeare, *Twelfth Night*, III.i.46, in *The Complete Works*, general eds. Stanley Wells and Gary Taylor, eds. Stanley Wells, Gary Taylor, John Jowett, and William Montgomery, intro. Stanley Wells, compact edition (Oxford: Clarendon Press, 1991), 703.

11 | A WALK IN THE FOREST

1. Alan L. Hoover, "Master of Patronage," in *Bill Reid and Beyond: Expanding on Modern Native Art*, ed. Karen Duffek and Charlotte Townsend-Gault (Vancouver: Douglas & McIntyre, 2004), 96.

2. Duffek, *Bill Reid*, 45.

3. Ibid., 42.

4. Hoover, "Master of Patronage," in Duffek and Townsend-Gault, 95.

5. Doris Shadbolt, *Bill Reid* (Seattle: University of Washington Press, 1986), 118.

6. Chief 'Idansuu, James Hart, "Chief's Foreword," 10.

7. Duffek, *Bill Reid*, 44.

8. Bill Reid and Robert Bringhurst, *The Raven Steals the Light*, 2nd paperback ed., drawings by Bill Reid, stories by Bill Reid and Robert Bringhurst, intro. Claude Lévi-Strauss (Vancouver: Douglas & McIntyre, 1996), 35–36. A note on the copyright page reads: "An earlier version of *The Raven and the First Men* appeared in Museum Note 8 published by the University of British Columbia Museum of Anthropology, 1980."

12 | CLAMSHELL OR COCKLESHELL?

1. Swanton, *Haida Texts and Myths*, 320.

2. Ibid., 147.

3. Ibid., 320. Without straining for a comparison, it's interesting to reflect on the birth of Helen, the daughter of Nemesis (Necessity). Desperate to escape the persistent advances of Zeus, Nemesis transformed herself into a number of different creatures, but Zeus was persistent. She took the shape of a wild goose and hid from him. Zeus disguised himself as a swan and, with Aphrodite's assistance, he appealed to the goose for protection. She took him in, and that night, while Nemesis was sleeping, Zeus raped her. The violent coupling produced a swan's egg that was taken from Nemesis by Hermes and planted in Leda's womb in Sparta.

(The egg's shell was composed of the foam out of which Aphrodite was born. It had risen to the surface of the ocean in two white rings after Uranus's testicles, severed by Kronos, fell into the sea.) One account suggests that the egg, made of dried and hardened foam, was thrown into a "swampy place." In Leda's case, when the egg hatched, a perfectly formed, miniature Helen stepped out. In a different account voices are heard from inside the egg, and, when the shell breaks, as well as Helen, the twins Castor and Pollux emerge. See, for a profound and engaging interpretation, Calasso, 121–22, 125–26, 201.

4. Wright et al., *Charles Edenshaw*, 2–4.

5. Hoover, "Charles Edenshaw and the Creation of Human Beings," 63. The dimensions of the chest are 17 cm by 45.5 cm by 29 cm. See Wright et al., *Charles Edenshaw*, 242. The chest is now in the collection of the Royal British Columbia Museum in Victoria, B.C.

6. Hoover, "Charles Edenshaw and the Creation of Human Beings," 63.

7. Ibid.

8. Wright, *Northern Haida Master Carvers*, 274.

9. Wright et al., *Charles Edenshaw*, 41–43.

10. Cole, *Captured Heritage*, 147.

11. Cole, *Franz Boas*, 193–94.

12. Franz Boas, *Kwakiutl Ethnography,* ed. and intro. Helen Codere (Chicago: University of Chicago Press, 1966), 426.

13. Rolf Knight, *Indians at Work: An Informal History of Native Labour in British Columbia, 1858–1930*, rev. ed. (Vancouver: New Star Books, 1996), 191.

14. Franz Boas, *The Ethnography of Franz Boas: Letters and Diaries of Franz Boas Written on the Northwest Coast from 1886 to 1931,* compiled and ed. Ronald P. Rohner, intro. Ronald P. Rohner and Evelyn C. Rohner, trans. Hedy Parker (Chicago: University of Chicago Press, 1969), 223, 228.

15. Boas, *Primitive Art*, 71, 158.

16. Aldona Jonaitis, "Franz Boas, John Swanton, and the New Haida Sculpture at the American Museum of Natural History," in *The Early Years of Native American Art History: The Politics and Scholarship of Collecting*, ed. Janet Catherine Berlo (Seattle: University of Washington Press, 1992), 32–39.

17. Boas, *The Ethnography of Franz Boas*, 230.

18. According to the Chinook Jargon website maintained by David Douglas Robertson, the words for "clam" or "clams" cited in the Chinook Jargon blog were taken from a 1978 dissertation (University of Kansas) by Samuel V. Johnson entitled "Chinook Jargon: A Computer-Assisted Analysis of Variation in an American Indian Pidgin." The French word for "cockle" is "la coque"; for "clam," "la palourde," which does not seem to have entered into the Jargon vocabulary. The English word "clam" appears in the sixteenth century and is derived from an Old English term for "clamp," which has a Germanic origin.

13 | IN TIME

1. See also Macnair and Hoover, *The Magic Leaves*, 108.

2. Two argillite cockles from the collection of the Royal British Columbia Museum were exhibited in 1962 at the Seattle World's Fair, where their provenance is listed as: "W. A. Newcombe Collection from the Jelliman Collection. Haida, Masset, Queen Charlotte Islands." The description reads: "These shells are carved of slate (argillite), the smaller one in a reddish color. They are perfect imitations of the natural form. The pieces do not indicate any useful function." See also Erna Gunther, *Northwest Coast Indian Art: An Exhibit at the Seattle World's Fair Fine Arts Pavilion, April 21 to October 21, 1962* (Seattle: Seattle World's Fair, 1962), 93. Two of the argillite cockles were exhibited in the groundbreaking *Arts of the Raven* exhibition at the Vancouver Art Gallery in 1967. In the catalogue, they are labelled as "Clamshells Haida, Numbers 192 and 193." Number 192 is of black slate and 1.75 inches long; Number 193 is of red slate and is 1.5 inches long. They were not included in the exhibition's "Charles Edenshaw: Master Artist" gallery and are not illustrated in the catalogue. See Wilson Duff, with contributory articles by Bill Holm and Bill Reid, *Arts of the Raven: Masterworks by the Northwest Coast Indian*, n.p.

3. E.B. Anderson, *Bird of Paradox: The Unpublished Writings of Wilson Duff* (Surrey, B.C.: Hancock House, 1996), 229–30.

4. In *Philosophical Investigations*, Wittgenstein originally wrote "Words are also deeds." See Ludwig Wittgenstein, *Philosophical Investigations*, trans. G.E.M. Anscombe (Oxford: Blackwell, 1968), 146e.

CODA

1. Calasso, *The Marriage of Cadmus and Harmony*, 387.

REFERENCES

Abbott, Helen, Steven Brown, Lorna Price, and Paula Thurman, eds. *The Spirit Within: Northwest Coast Native Art from the John H. Hauberg Collection.* Seattle: Seattle Art Museum, 1995.

Ainsworth, Thomas H. "The Art of the Haidas." *The Art, Historical, and Scientific Association Museum and Art Notes,* second series (Vancouver, B.C.), 1, no. 3 (September 1950): 16–19.

Anderson, E.B., ed. *Bird of Paradox: The Unpublished Writings of Wilson Duff.* Surrey, B.C.: Hancock House, 1996.

Aragon, Louis, and André Breton. "The Fiftieth Anniversary of Hysteria." In André Breton, *What Is Surrealism: Selected Writings,* Book 2, 424–26.

Arnett, Chris. *The Terror of the Coast: Land Alienation and Colonial War on Vancouver Island and the Gulf Islands, 1849–1863.* Vancouver: Talonbooks, 1999.

Arnold, Augusta Foote. *The Sea-Beach at Ebb-Tide: A Guide to the Study of the Seaweeds and the Lower Animal Life Found between Tide-marks.* New York: Dover, 1968. Originally published New York: The Century Co., 1901.

Augaitis, Daina, Marianne Jones, Peter L. Macnair, and Vince Collison, eds. *Raven Travelling: Two Centuries of Haida Art.* Vancouver: Vancouver Art Gallery and Douglas & McIntyre, 2008.

Barbeau, Marius. Canadian Museum of Civilization, Business Partnerships and Information Management. Archives. Cultural studies. Fonds: Carmen Roy (Acq. 2000-F0003). Dossier: « Les Mémoires de Marius Barbeau » (Verbatim interview transcript in French), 1957–58 (164–327), Box 624.f.10.

———. Canadian Museum of Civilization, Business Partnerships and Information Management. Archives. Cultural studies. Fonds: Carmen Roy (Acq. 2000-F0003). Dossier: « Les Mémoires de Marius Barbeau » (Verbatim interview transcript in French), 1957–58 (492–652), Box 624.f.12.

Benjamin, Walter. "Categories of Aesthetics." In Marcus Bullock and Michael W. Jennings, eds., *Walter Benjamin: Selected Writing, Volume 1, 1913–1926.* Trans. Rodney Livingstone, 220–222. Cambridge, MA, and London: Harvard University Press, 1996.

Berlo, Janet Catherine, ed. *The Early Years of Native American Art History: The Politics and Scholarship of Collecting.* Seattle: University of Washington Press, 1992.

Bialik, Haim Nahman. "Revealment and Concealment in Language" (1915). In *Revealment and Concealment: Five Essays.* Afterword by Zali Gurevitch, 11–26. Jerusalem: Ibis Editions, 2000.

Blackman, Margaret B. "Charles Edenshaw on the Colonial Frontier." In *Objects of Exchange: Social and Material Transformation on the Late Nineteenth-Century Northwest Coast,* edited by Aaron Glass, 49. New York: The Bard Graduate Center: Decorative Arts, Design History, Material Culture, 2010.

———. *During My Time: Florence Edenshaw Davidson, A Haida Woman.* Rev. and enlarged ed. Vancouver: Douglas & McIntyre, 1992.

Blake, William. "The Marriage of Heaven and Hell." Plate 3 (engraved ca. 1790). In David Erdman, ed., *The Poetry and Prose of William Blake,* 34.

Blanchard, Paula. *The Life of Emily Carr.* Vancouver and Toronto: Douglas & McIntyre, 1988.

Blanchette, Robert A., Brian D. Compton, Nancy J. Turner, and Robert L. Gilbertson. "Nineteenth Century Shaman Grave Guardians Are Carved *Fomitopsis Officinalis* Sporophores." *Mycologia* 84, no. 1 (1992): 119–24.

Boas, Franz. *The Ethnography of Franz Boas: Letters and Diaries of Franz Boas Written on the Northwest Coast from 1886 to 1931.* Compiled and ed. Ronald P. Rohner. Intro. Ronald P. Rohner and Evelyn C. Rohner. Trans. Hedy Parker. Chicago: University of Chicago Press, 1969.

———. *Kwakiutl Ethnography.* Ed. and intro. Helen Codere. Chicago: University of Chicago Press, 1966.

———. *Primitive Art.* New York: Dover, 1955.

Bob, Dempsey. Text written to accompany the exhibition *I Had an Interesting French Artist to See Me This Summer: Emily Carr and Wolfgang Paalen in British Columbia.* Vancouver Art Gallery, June 1 to November 13, 2016. Curated by Colin Browne.

Breton, André. "Ascendant Sign (1947)." In *Free Rein (La clé des champs),* 104–107.

———. *Free Rein (La clé des champs).* Trans. Michel Parmentier and Jacqueline d'Amboise. Lincoln: University of Nebraska Press, 1995.

———. "Oceania (1948)." In *Free Rein (La dlé des champs),* 170–74.

———. *Signe Ascendant.* Paris: nrf / Éditions Gallimard, 2013.

———. *What Is Surrealism? Selected Writings.* Ed. and intro. Franklin Rosemont. New York: Pathfinder, 2008.

Bringhurst, Robert. "The Audible Light in the Eyes: In Honor of Claude Lévi-Strauss." In *Coming to Shore: Northwest Coast Ethnology, Traditions, and Visions,* edited by Marie Mauzé, Michael E. Harkin, and Sergei Kan, 163–82.

———. *A Story as Sharp as a Knife: The Classical Haida Mythtellers and Their World.* 1st ed. Vancouver: Douglas & McIntyre, 1999.

———. *A Story as Sharp as a Knife: The Classical Haida Mythtellers and Their World.* 2nd ed. Vancouver: Douglas & McIntyre, 2011.

———, and Ulli Steltzer. *The Black Canoe: Bill Reid and the Spirit of Haida Gwaii.* 2nd ed. Vancouver and Toronto: Douglas & McIntyre, 1995.

Brown, Steven C. *Native Visions: Evolution in Northwest Coast Art from the Eighteenth through the Twentieth Century.* Seattle and Vancouver: The Seattle Art Museum and Douglas & McIntyre, 1998.

Browne, Colin. *I Had an Interesting French Artist to See Me This Summer: Emily Carr and Wolfgang Paalen in British Columbia.* Vancouver: Vancouver Art Gallery and Figure 1, 2016.

Calasso, Roberto. *The Marriage of Cadmus and Harmony.* Trans. Tim Parks. New York: Vintage Books, 1994.

Campbell, Robert. *In Darkest Alaska: Travel and Empire Along the Inside Passage.* Philadelphia: University of Pennsylvania Press, 2007.

Carr, Emily. *Klee Wyck.* Vancouver: Douglas & McIntyre, 2003. Originally published Toronto: Oxford University Press, 1941.

———. *Sister and I in Alaska.* Vancouver: Figure 1, 2014. Diary recorded 1907. Not previously published.

Chief 'Idansuu, James Hart. "Chief's Foreword." In *Charles Edenshaw*, edited by Wright et al., 10.

Chinook Jargon and Northwest Language Contact. With David Douglas Robertson. www.chinookjargon.com.

Chittenden, Newton H. "Hyda Land and People." In *Official Report of the Exploration of the Queen Charlotte Islands.* Victoria: Government of British Columbia, 1884.

Coe, Ralph T. *The Responsive Eye: Ralph T. Coe and the Collecting of American Indian Art.* Foreword Eugene Victor Thaw with contributions by J.C.H. King and Judith Ostrowitz. New York: Metropolitan Museum of Art, and New Haven: Yale University Press, 2003.

Cole, Douglas. *Captured Heritage: The Scramble for Northwest Coast Artifacts.* Vancouver: Douglas & McIntyre, 1985.

———. *Franz Boas: The Early Years, 1858–1906.* Foreword by Ira Chaikin and Alex Long. Vancouver and Toronto: Douglas & McIntyre, 1999.

———, and Ira Chaikin. *An Iron Hand Upon the People: The Law Against the Potlatch on the Northwest Coast.* Vancouver: Douglas & McIntyre, 1990.

Collison, Nika. "Creating for Culture: Edenshaw's Haida Roots and Cultural Transformations." In *Charles Edenshaw*, edited by Wright et al., 21–27.

Covarrubias, Miguel. *The Eagle, the Jaguar, and the Serpent: Indian Art of the Americas.* New York: Alfred A. Knopf, 1967. Originally published New York: Alfred A. Knopf, 1954.

Davidson, Robert. "Reclaiming Haida Culture" [a.k.a. "Reclaiming Haida Tradition"]. In *The Spirit Within: Northwest Coast Native Art from the John H. Hauberg Collection*, edited by Helen Abbott, Steven Brown, Lorna Price, and Paula Thurman, 93–99.

———. "The World Is as Sharp as the Edge of a Knife." In *Robert Davidson: A Voice from the Inside*, edited by Derek Simpkins, 7–10.

Dawson, George. "Vocabulary of the Haida Indians of the Queen Charlotte Islands." In *Report on the Queen Charlotte Islands.* Appendix B. Ottawa: Geological Survey of Canada, 1880.

Derrida, Jacques. *Monolingualism of the Other; or, the Prosthesis of Origin.* Trans. Patrick Mensah. Stanford: Stanford University Press, 1998.

Drew, Leslie, and Douglas Wilson. *Argillite: Art of the Haida*. North Vancouver: Hancock House, 1980.

Duff, Wilson, with contributory articles by Bill Holm and Bill Reid. *Arts of the Raven: Masterworks by the Northwest Coast Indian*. Vancouver: Vancouver Art Gallery, 1967.

Duffek, Karen. *Bill Reid: Beyond the Essential Form*. Foreword by Michael M. Ames. Vancouver: University of British Columbia Press and UBC Museum of Anthropology, Museum Note No. 19, 1993.

———. "The Present Moment: Conversations with *Guud San Glans*, Robert Davidson." In *Robert Davidson: The Abstract Edge*. edited by Karen Duffek, 9–45.

———, ed. *Robert Davidson: The Abstract Edge*. Museum Note No. 38. Vancouver and Ottawa: Museum of Anthropology at the University of British Columbia and National Gallery of Canada, 2004.

———, and Charlotte Townsend-Gault, eds. *Bill Reid and Beyond: Expanding on Modern Native Art*. Vancouver: Douglas & McIntyre, 2004.

Economic Gain Spatial Analysis, RFP EGSA-1 (Non-Timber Forest Products), Revised Final Report. Bowen Island, B.C.: Cognetics International Research Inc., March 2004.

Enrico, John, ed. and trans. *Skidegate Haida Myths and Histories*. Collected by John R. Swanton. Skidegate, B.C.: Queen Charlotte Islands Museum Press, 1995.

The Epic of Gilgamesh: The Babylonian Epic Poem and Other Texts in Akkadian and Sumerian. Trans. and intro. Andrew George. London: Penguin Books, 2003.

Erdman, David, ed. *The Poetry and Prose of William Blake*. Commentary by Harold Bloom. Rev. ed. Garden City, NY: Doubleday, 1970.

Evan, Antone. "Raven." In *Coming to Light: Contemporary Translations of the Native Literatures of North America,* edited and with an introduction by Brian Swann, 97.

Freud, Sigmund. *An Autobiographical Study*. Trans. James Strachey. London: Hogarth Press and Institute of Psycho-Analysis, 1935.

Frohman Trading Co.: Alaska, California and Northern Indian Baskets and Curios. Portland: Binford & Mort., 1902.

Ghandl of the *Qayahl Llaanas. Nine Visits to the Mythworld*. Trans. Robert Bringhurst. Vancouver: Douglas & McIntyre, 2000.

Gid7ahl-Gudsllaay, Lalaxaaygans, Terri-Lynn Williams-Davidson. "How Raven Gave Females Their *Tsaw*." In *Charles Edenshaw*, edited by Wright et al., 61.

———. "The Power of Narrative *Gyaehlandáa*." In *Charles Edenshaw*, edited by Wright et al., 42–43.

———. "Weaving Together Our Future: The Interaction of Haida Laws to Achieve Respectful Co-existence." Vancouver: Continuing Legal Education Society of British Columbia, Indigenous Legal Orders and the Common Law, Paper 6.2, 2012.

Glass, Aaron, ed. *Objects of Exchange: Social and Material Transformation on the Late Nineteenth-Century Northwest Coast*. New York: Bard Graduate Center: Decorative Arts, Design History, Material Culture, 2010.

Godfrey, W. Earl. *The Birds of Canada*. Colour illustrations by John A. Crosby. Line drawings by S.D. MacDonald. Ottawa: National Museum of Canada, Bulletin No. 203, Biological Series No. 73, 1966.

Green, Arthur. "Teachings of the Hasidic Masters." In *Back to the Sources: Reading the Classic Jewish Texts*, edited by Barry W. Holtz, 361–401.

Gunther, Erna. *Northwest Coast Indian Art: An Exhibit at the Seattle World's Fair Fine Arts Pavilion*. April 21 to October 21, 1962. Seattle: Seattle World's Fair, 1962.

Guud San Glans, Robert Davidson, "Da.a xiigang, Charles Edenshaw, 'Master Carpenter'," In *Charles Edenshaw*, edited by Wright et al., 107–113.

Guujaaw, Gary Edenshaw. "This Box of Treasures." In *All That We Say Is Ours: Guujaaw and the Reawakening of the Haida Nation by* Ian Gill, viii. Vancouver: Douglas & McIntyre, 2009.

Hawker, Ronald William. "Frederick Alexie: Euro-Canadian Discussions of a First Nations' Artist." Privately published on academia.edu. January 11, 2016.

Hill-Tout, Charles. "Haida Stories and Beliefs." *Report on the Ethnological Survey of Canada*, Appendix I. Ottawa: Ethnological Survey of Canada, 1898; also published as a monograph London: Spottiswoode, 1898.

Holm, Bill. *Northwest Coast Indian Art: An Analysis of Form*. 50th Anniversary Edition. Seattle: Bill Holm Center for the Study of Northwest Coast Art in Association with the University of Washington Press, 2015.

———. "Will the Real Charles Edenshaw Please Stand Up? The Problem of Attribution in Northwest Coast Indian Art." In *Charles Edenshaw*, edited by Wright et al., 81–89.

Holtz, Barry W., ed. *Back to the Sources: Reading the Classic Jewish Texts*. New York: Simon & Schuster, 2006.

Homer. *Chapman's Homer: The Iliad and The Odyssey*. Trans. George Chapman. Intro. Jan Parker. London: Wordsworth's Classics, 2000.

———. *The Odyssey*. Trans. Robert Fagles. Intro. and notes by Bernard Knox. New York: BCA, 2003.

Hoover, Alan. L. "Charles Edenshaw: His Art and Audience." *American Indian Art Magazine* 20, no. 3 (Summer 1995): 44–53.

———. "Charles Edenshaw and the Creation of Human Beings." *American Indian Art* 8, no. 3 (Summer 1983): 62–67, 80.

———. "Charles Edenshaw and the Development of Narrative Structure in Nineteenth-Century Haida Art." In *Charles Edenshaw*, edited by Wright et al., 67–73.

———. "Master of Patronage." In *Bill Reid and Beyond: Expanding on Modern Native Art*, edited by Karen Duffek and Charlotte Townsend-Gault, 93–107.

Indian Music of the Pacific Northwest Coast. Collected and recorded by Dr. Ida Halpern. Intro. and notes by Dr. Ida Halpern. New York: Folkways Records, Album FE4523, 1967.

Jonaitis, Aldona, ed. *Chiefly Feasts: The Enduring Kwakiutl Potlatch*. New York: American Museum of Natural History; Seattle: University of Washington Press; Vancouver: Douglas & McIntyre, 1991.

———. "Franz Boas, John Swanton, and the New Haida Sculpture at the American Museum of Natural History." In *The Early Years of Native American Art History: The Politics and Scholarship of Collecting*, edited by Janet Catherine Berlo, 22–61.

———. "Traders of Tradition: The History of Haida Art." In *Robert Davidson: Eagle of the Dawn*, edited by Ian M. Thom, 3–23.

Jones, Marianne. "Guud San Glans: Eagle of the Dawn." In *Robert Davidson: Eagle of the Dawn,* edited by Ian M. Thom, 125–30.

Knight, Rolf. *Indians at Work: An Informal History of Native Labour in British Columbia, 1858–1930*. Rev. ed. Vancouver: New Star Books, 1996.

Kloyber, Christian, ed. *Wolfgang Paalen's* Dyn*: The Complete Reprint*. Vienna and New York: Springer-Verlag, 2000.

Lachler, Jordan. *Dictionary of Alaskan Haida.* Juneau: Sealaska Heritage Institute, 2010.

Lears, Jackson. "The Long Con," review of *The Age of Acquiescence: The Life and Death of American Resistance to Organized Wealth and Power* by Steve Fraser. *London Review of Books* 37, no. 14 (July 16, 2015): 28.

Lenz, Mary Jane. "No Tourist Material: George Heye and His Golden Rule." *American Indian Art Magazine* 29, no. 4 (Autumn 2004): 86–95, 105.

MacDonald, George F. *Haida Art*. Seattle: University of Washington Press, 1996.

———. *Haida Monumental Art: Villages of the Queen Charlotte Islands*. Foreword and graphics by Bill Reid. Commentary by Richard J. Huyda. Vancouver: UBC Press, 2014.

Macnair, Peter. "Art and Artists in a Changing Society." In *The Legacy: Tradition and Innovation in Northwest Coast Indian Art*, edited by Peter Macnair, Alan L. Hoover, and Kevin Neary, 63–81.

———. "From the Hands of Master Carpenter." In *Raven Travelling: Two Centuries of Haida Art*, edited by Daina Augaitis, Marianne Jones, Peter L. Macnair, Vince Collison, 82–125.

———, and Alan L. Hoover. *The Magic Leaves: A History of Haida Argillite Carvings.* 2nd ed. Victoria: Royal British Columbia Museum, 2002.

———, Alan L. Hoover, and Kevin Neary. *The Legacy: Tradition and Innovation in Northwest Coast Indian Art*. 2nd ed. Victoria: Royal British Columbia Museum, 2007.

Mauzé, Marie, Michael E. Harkin, and Sergei Kan, eds. *Coming to Shore: Northwest Coast Ethnology, Traditions, and Visions*. Lincoln: University of Nebraska Press, 2004.

McLennan, Bill, "A Matter of Choice." In *Bill Reid and Beyond: Expanding on Modern Native Art,* edited by Karen Duffek and Charlotte Townsend-Gault, 37–43.

———, and Karen Duffek. "Placing Style: A Look at Charles Edenshaw's Bracelets through Time." In *Charles Edenshaw,* edited by Wright et al., 127–49.

———, and Karen Duffek. *The Transforming Image: Painted Arts of Northwest Coast First Nations*. Vancouver: Douglas & McIntyre, 2007.

Measuring Worth: A Service for Calculating Relative Worth Over Time. Website developed by Lawrence Officer and Samuel H. Williamson. measuring worth.com.

Mishra, Pankaj. *From the Ruins of Empire: The Intellectuals Who Remade Asia*. New York: Farrar, Straus and Giroux, 2012.

Newcombe, Charles F. *Guide to Anthropological Collection in the Provincial Museum*. Victoria: King's Printer, 1909.

Norris, Wendi. *Philosopher of the Possible: Wolfgang Paalen*. San Francisco: Gallery Wendi Norris, 2013.

Paalen, Wolfgang. "Totem Art." Amerindian Number. *Dyn* (Mexico City) 4–5 (1943).

Parsons, Timothy H. *The Rule of Empires: Those Who Built Them, Those Who Endured Them, and Why They Always Fall*. Oxford: Oxford University Press, 2010.

Reid, Bill. "Curriculum Vitae 1." In *Solitary Raven: The Essential Writings of Bill Reid*. Edited with commentary and notes by Robert Bringhurst. Afterword by Martine Reid. 2nd expanded ed., 113–21. Vancouver: Douglas & McIntyre, 2009.

———, and Robert Bringhurst. *The Raven Steals the Light*. Drawings by Bill Reid. Stories by Bill Reid and Robert Bringhurst. Intro. Claude Lévi-Strauss. 2nd paperback ed. Vancouver: Douglas & McIntyre, 1996.

Regler, Gustav. *Wolfgang Paalen*. New York: Nierendorf Editions, 1946.

Shadbolt, Doris. *The Art of Emily Carr*. Toronto: Clark, Irwin; North Vancouver: Douglas & McIntyre, 1979.

———. *Bill Reid*. Seattle: University of Washington Press, 1986.

Shakespeare, William. *Twelfth Night*. In *The Complete Works*. General eds. Stanley Wells and Gary Taylor. Eds. Stanley Wells, Gary Taylor, John Jowett, and William Montgomery. Intro. Stanley Wells. Compact ed. Oxford: Clarendon Press, 1991.

Simpkins, Derek, ed. "Reaching for New Peaks." In *Robert Davidson: A Voice from the Inside*, 5. Vancouver: Derek Simpkins Gallery of Tribal Art, 1992.

Skaay of the Qquuna Qiighawaay. *Being in Being: The Collected Works of a Master Haida Mythteller*. Ed. and trans. Robert Bringhurst. Vancouver: Douglas & McIntyre, 2001.

Sohō, Tokutomi. *The Future Japan*. Trans. Sinh Vinh. Edmonton: University of Alberta Press, 1989. Originally published 1886.

Swann, Brian, ed. and intro. *Coming to Light: Contemporary Translations of the Native Literatures of North America*. New York: Random House, 1994.

Swanton, John Reed. *Haida Texts and Myths, Skidegate Dialect, Recorded by John R. Swanton*. Washington: Smithsonian Institution, Bureau of American Ethnology Bulletin 29, 1905.

———. *The Haida of Queen Charlotte Islands by John R. Swanton*. Volume VIII of *Memoirs of the American Museum of Natural History*. Leiden, Netherlands: E.J. Brill, 1905. Swanton's text is a reprint of *Contributions to the Ethnology of the Haida*, originally published as Part I in Volume V of Franz Boas, ed., *The Jesup North Pacific Expedition*. New York: Memoir of the American Museum of Natural History, 1905.

Tate, Henry. *The Porcupine Hunter and Other Stories: The Original Tsimshian Texts of Henry Tate.* Newly transcribed from the original manuscripts and annotated by Ralph Maud. Vancouver: Talonbooks, 1993.

Thom, Ian M., ed. *Robert Davidson: Eagle of the Dawn.* Vancouver: Vancouver Art Gallery and Douglas & McIntyre, 1993.

Todorov, Tzvetan. *On Human Diversity: Nationalism, Racism, and Exoticism in French Thought.* Trans. Catherine Porter. Cambridge, MA: Harvard University Press, 1993.

Townsend-Gault, Charlotte, Jennifer Kramer, and Ki-Ke-In, eds. *Native Art of the Northwest Coast: A History of Changing Ideas.* Vancouver: UBC Press, 2013.

Truth and Reconciliation Commission of Canada. *Canada's Residential Schools: The History, Part 2, 1939 to 2000. Final Report of the Truth and Reconciliation Commission Commission of Canada*, Volume 1. Montreal and Kingston: McGill-Queen's University Press, 2015.

Williams, William Carlos. *Paterson.* Rev. ed. Prepared by Christopher MacGowan. New York: New Directions, 1995.

Wittgenstein, Ludwig. *Philosophical Investigations.* Trans. G.E.M. Anscombe. Oxford: Blackwell, 1968.

Wright, Robin K. "Charles Edenshaw and Melting Glaciers." In *Charles Edenshaw,* edited by Wright et al., 15.

———. "*Hlgas7agaa:* Haida Argillite." In *The Spirit Within: Northwest Coast Native Art from the John H. Hauberg Collection,* edited by Helen Abbott, Steven Brown, Lorna Price, and Paula Thurman, 130–41.

———. *Northern Haida Master Carvers.* Seattle: University of Washington Press; Vancouver: Douglas & McIntyre, 2001.

———. "Two Haida Artists from Yan: Will John Gwaytihl and Simeon Stilthda Please Step Apart?" *American Indian Art Magazine* 23, no. 3 (Summer 1998): 42–57, 106–107.

———, and Daina Augaitis, with Haida advisers Robert Davidson and James Hart. *Charles Edenshaw.* Vancouver: Vancouver Art Gallery; London: Black Dog, 2013.

———, and Mandy Ginson, "Chronology." In *Charles Edenshaw,* edited by Wright et al., 222–29.

Yahgulanaas, Michael Nicoll. "Raven Kept Walking." In *Old Growth, edited by Liz Park.,* 149–70. Vancouver: Red Leaf, 2011.

ABOUT THE AUTHOR

Colin Browne is the author of a number of poetry collections, including *Abraham* (1987); the critically acclaimed collection of poetry *Ground Water* (2002), nominated for a Governor General's Literary Award and a Dorothy Livesay Poetry Prize; *The Shovel* (2007), shortlisted for the 2008 ReLit Award; *The Properties* (2012), nominated for a Dorothy Livesay Poetry Prize; and, most recently, *The Hatch* (2015). He was an editor of *Writing* magazine and co-founder of the Kootenay School of Writing, the Praxis Centre for Screenwriters, and the Art of Documentary workshops. Browne's films include *Linton Garner: I Never Said Goodbye* (2003), *Father and Son* (1992), and *White Lake* (1989), nominated for a Genie Award for Best Feature-Length Documentary. He participated in the restoration and reconstruction of Edward S. Curtis's 1914 drama *In the Land of the Head Hunters*, filmed in British Columbia. His current work explores the history and legacy of the Surrealist fascination with the Indigenous art of the Pacific Northwest Coast and includes the essay "Scavengers of Paradise," written for the Vancouver Art Gallery's Surrealist exhibition, *The Colour of My Dreams* (2011). Most recently, he was guest curator for the Vancouver Art Gallery's 2016 exhibition, *I Had an Interesting French Artist to See Me This Summer: Emily Carr and Wolfgang Paalen in British Columbia*. Browne recently retired from teaching and is now Professor Emeritus at Simon Fraser University's School for the Contemporary Arts.